CLIP ART
IMAGE GALLERY
500 MODEL POSES

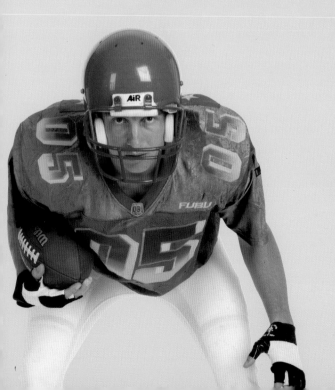

CLIP ART
IMAGE GALLERY
500 MODEL POSES

CLIP ART
IMAGE GALLERY
500 MODEL POSES

the ultimate library of professional-quality photo poses
all on white backgrounds with clipping masks.

Calvey Taylor-Haw

Clip Art Image Gallery: 500 Model Poses

First edition for the United States, its territories and dependencies, and Canada published in 2005 by Barron's Educational Series, Inc.

All inquiries should be addressed to:
Barron's Educational Series, Inc.
250 Wireless Boulevard
Hauppauge, NY 11788
www.barronseduc.com

International Standard Book No. 0-7641-7828-8

Library of Congress Catalog Card No. 2004110794

This book was conceived, designed, and produced by:
ILEX, Cambridge, England

ILEX Editorial, Lewes:

Publisher: Alastair Campbell

Executive Publisher: Sophie Collins

Creative Director: Peter Bridgewater

Managing Editor: Tom Mugridge

Editor & Author: Adam Juniper

Design Manager: Tony Seddon

Design: The Lanaways

Junior Designer: Jane Waterhouse

ILEX Research, Cambridge:

Development Art Director: Graham Davis

Technical Art Director: Nicholas Rowland

Minimum requirements:
To use the disc, you will need a computer with Mac OS 7.6 or later, or Microsoft Windows 3.1 or later, with a CD-ROM drive. Any program compatible with JPEG files will open the images. The masks are stored as TIFF files, and to use them you will need an image editor, for example, Photoshop 5 and up.

For more information about this title, please visit:
www.web-linked.com/modpus

Manufactured in China

9 8 7 6 5 4 3 2 1

contents

step-by-step guide

Detailed demonstrations—from experienced, talented digital artists and designers—of how to get the best from the images on the accompanying CD, with tips on a wide range of appropriate techniques such as placing images on backgrounds, splicing several images together, adding splashes of color, cropping and enlarging images, incorporating your company logo, and applying dramatic lighting effects. The guide also includes essential technical information on the best ways to output images for both print and Web use, with simple and clear information on all matters concerning color manipulation and resolution.

image gallery

A complete illustrated listing of all the images on the CD. Each image is chronicled by "search criteria," or keywords, under which it can be located on the disc. These criteria include: model name(s), mood, aspect, position, appearance, expression, characteristics, and physical actions.

introduction
500 exciting poses to instantly liven up your design work

Struggling to make your work look good and come in on budget? Then you're lucky: you're already holding the answer in your hands. This CD contains 500 images, stored as high quality, industry-standard JPEG files that will work in any popular software package, Mac or PC.

Not only have we provided the images, but also top quality masks. If you're a designer, you'll have no trouble getting started—you'll find all the images on the disc together with their masks for the extra creativity they offer.

But even if you've never touched a computer except to send an e-mail or letter, then you'll still be able to use these shots; over the next few pages you'll get an idea of what you can do by following simple instructions.

Microsoft Windows

When you first use the disc with some versions of Microsoft Windows, you will be offered a series of options. Which options you get depends on which software you have installed. If you plan to import graphics using another application, for example, choose "Take no action" and use the *File > Open* command in that application.

Left: One of the image folders as it appears under Microsoft Windows XP, with the thumbnail view selected.

Below: The contents of the disc under Apple's Mac OS X as it appears when the disc is first opened.

disc structure

The supplied CD is arranged so that you can quickly locate files using this book, or simply by searching the CD using the method described on page 10. The folders are arranged as shown in this diagram.

License agreement
Important legal information

List of poses
A handy quick reference, with brief descriptions of all the images

Images and masks
All the pictures

Image folders
The core resource, images and masks, divided into folders corresponding to the sections in this book

001.jpg
The images are stored as JPEG files with the same numbers as shown in this book

001_Mask.tif
The mask files are stored as LZW-compressed TIFF files with the same number as their corresponding image files, plus the text "_Mask"

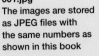

file formats

jpeg, tiff, gif? cmyk, rgb? they might sound like a mouthful, but they're worth getting right

Not all computer image files are created equal, and they are stored in a number of different ways, or "file formats." The images supplied with this book, for example, are

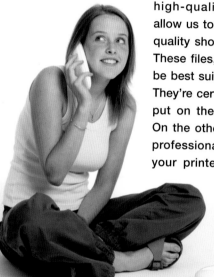

high-quality JPEGs, which allow us to squeeze 500 photo-quality shots onto a single CD. These files, however, might not be best suited to your purpose. They're certainly too detailed to put on the Web, for example. On the other hand, if you have professional printing in mind, your printer might prefer you to supply a press-ready file. Luckily, it's simple to convert your chosen image.

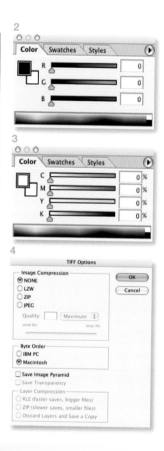

1 Before you change the file, you'll need a final purpose in mind. Here we've got an image of a teenager on the phone (when aren't they?) to use in both a leaflet and on the Web.

2 Under most circumstances, you'll want to leave your file in the Red, Green, and Blue (RGB) color mode it was supplied in. This is how color is represented on computers, and most home printer software or bureaux will convert to CMYK as they print.

3 If your printer requests it, you can convert the image using the *Image > Mode* menu. The file will now describe the image in terms of CMYK, the Cyan, Magenta, Yellow, and Black (Key)—the "process color" system that printers use.

4 For professional press purposes, it's best to save the file as a TIFF, which is the most universally recognized image format. Click *File > Save As...* and select *TIFF* from the *Format* menu. Select *None* in the *Image Compression* area for a universally compatible TIFF.

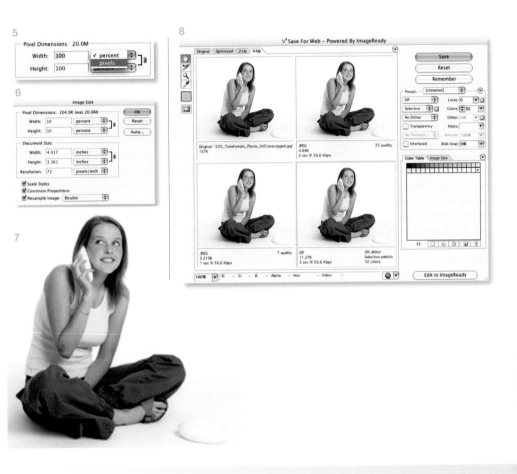

5 For the web site, a smaller copy is needed. The file needs to be smaller (made of fewer pixels) because screen resolution is much lower than that of printers. Starting from the original RGB file, click *Image > Image Size....*

6 In the *Image Size* dialog, ensure that *Resample* is checked, then enter new dimensions in the topmost *Width* and *Height* fields. Select pixels from the drop-down measurements menu to enter an exact width or height. Click *OK.*

7 Click *View > Actual Pixels* to view your newly scaled image in the same size it will appear on web pages. If you're not happy, undo and try different settings in *Image Size.*

8 Click *File > Save For Web....* From here you have the opportunity to make compromises on file size and quality, and compare them before saving the file.

metadata search
if you know what you want, let the computer do the searching

Every image on the CD can be seen by flicking through this volume; but if you've already got the CD in the drive, you might find it even faster to use an image browser. Photoshop includes a File Browser feature for this very purpose, but there are plenty of others on the market. All make use of the standard metadata that we've included with every file on the disc.

In just a few clicks you can find the picture you need from a simple keyword, be it a particular model or a certain pose.

1 Open your file browser. If you're using Photoshop, you can click the button toward the right-hand end of the toolbar to open the File Browser.

2 Insert the CD-ROM and use the *Folders* pane (normally top left) to select the Model Poses CD.

3 You can browse the folders on the CD. The images appear as "thumbnails" within their folders. If you click on one of the images, it is highlighted.

4 Look in the *Metadata* pane. Scroll down to find a description of the image and a list of keywords associated with the image.

4

4a

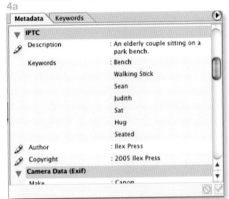

Metadata	Keywords	
▼ **IPTC**		
Description	: An elderly couple sitting on a park bench.	
Keywords	: Bench	
	Walking Stick	
	Sean	
	Judith	
	Sat	
	Hug	
	Seated	
Author	: Ilex Press	
Copyright	: 2005 Ilex Press	
▼ **Camera Data (Exif)**		
Make	: Canon	

5

6

7

8

464_Grandfather_Chair_... 466_Grandfather_Chair_... 467_Grandparents_Wheel... 468_Grandparents_Wheel...

476_Grandparents_Chess... 477_Grandparents_Chess...

multiple searches

You can search for multiple items at once by clicking the plus icon at the end of your first criterion and adding additional criteria.

5 To search for an image using these keywords, click on the search button in the *File Browser* toolbar.

6 Select *Keywords* from the *Criteria* drop-down menu. (You could also choose *Description*.) If you're searching the whole disc, remember to check the *Include All Subfolders* option.

7 Type the word you're searching for into the text field (initially marked *enter text*) and press the *Search* button.

8 The File Browser will display all the images that fit your criteria. To start again, click on the folder drop-down menu (marked *Search Results*) and repeat from Step 2.

masks and paths
the starting point to using these poses creatively is to mask away their backgrounds

There are two ways of cutting a subject away from the shadows of its background: a mask or a clipping path. The former has a soft, subtle edge represented in terms of degrees of transparency, which can work against any background. The latter is a sharp line traced around the edge.

While both have their uses, masks can be harder to create. Luckily, for every image on the CD, there is an accompanying mask to pick out just the subject from its shadows and background. All that's required is to attach it.

1 Find the image you wish to use on the CD and open it in Photoshop.

2 Open the *Masks* folder within the folder of images on the CD.

3 Open the mask file, which has the same name as the original, but with the word "Mask" appended.

4 With the mask file still selected, open the *Channels* palette (normally tucked behind the *Layers* palette).

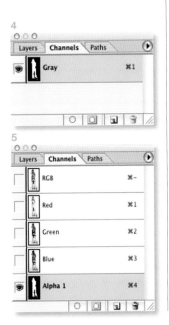

5 Holding the Shift key, drag the Mask (gray channel) onto the original image.

6 To view the mask over the original image, click the eye icon to the left of the RGB channel.

7 When saving the image, ensure you use a file format that includes alpha channels, like TIFF. Click *File > Save As...* and check that TIFF is selected in the *Format* field and *Alpha Channels* is checked.

8 Not all page-layout applications recognize alpha channels. If yours does not, you'll need to create a clipping path (*see pages 14-15*).

clipping paths
crisp, clean cut-outs for colorful and exciting page designs

Masks are great in image-editing software, but sometimes the sharp, clean lines of clipping paths are better. Also, as a clipping path is just a mathematically described line, it takes up less space, and can be attached to more file types, including JPEGs.

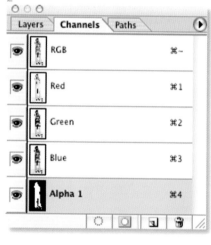

1 Open the image you'd like to create a clipping path for and merge it with its mask, as described on pages 12-13.

2 Select the *Alpha Channel* in the *Channels* palette.

3 Click the *Load Channel as Selection* button at the bottom left of the *Channels* palette.

4 Open the *Paths* palette (by default located below the *Layers* and *Channels* palettes).

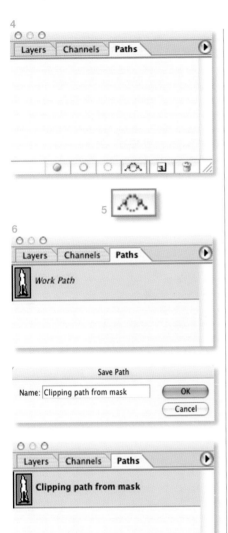

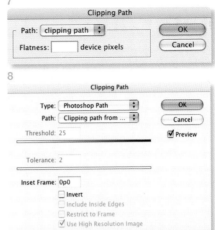

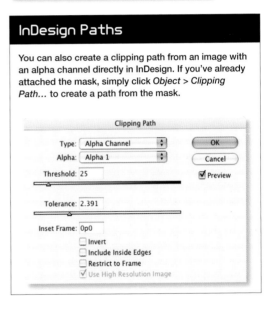

InDesign Paths

You can also create a clipping path from an image with an alpha channel directly in InDesign. If you've already attached the mask, simply click *Object > Clipping Path...* to create a path from the mask.

5 With the selection from Step 3 still active, click the *Make Path* button at the bottom of the palette.

6 A "Work Path" will appear in the *Paths* palette. Double-click on it to give it a more appropriate name.

7 If your layout software doesn't support Photoshop paths, you'll need to convert it by choosing *Clipping Path* from the *Path* palette's pop-up menu, and leaving the *Flatness* field blank.

8 Save your image in an appropriate format (JPEG, TIFF, etc.) and the path will be attached. Other software will find it by the name you gave it.

location, location, location

spice up location photos by adding model poses to the foreground

Trying to make somewhere look good? If you've got some boring pictures that need spicing up, why not add one, or more, models to it? Alternatively, add a background to make one of the poses suit your project better. Either way, it takes just a few steps to place a model onto another picture.

1

3

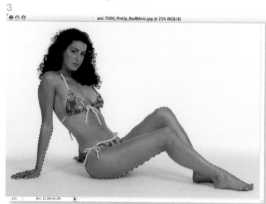

2

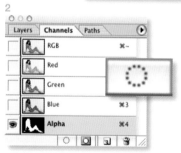

3a

1 Open your choice of model pose and your target background image.

2 Attach the model's mask as in Steps 1-5 on pages 12-13 and, with the mask channel selected, click the *Load Channel As Selection* button at the bottom of the *Channels* palette.

3 Switch back to the *Layers* palette and select the *Background* layer.

4 With the *Move* tool selected, click inside the selected model (not the *Layers* palette) and drag to the open background image.

4

4a

5

5a

W: 40 | H: 40.0%

5b

6

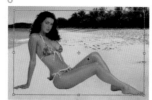

6a

7

Layers | Channels | Paths

Normal | Opacity: 100%

Lock: | Fill: 100%

Layer 1

Background

7a

Brush: 150 | Mode: Multiply | Opacity: 8%

7b **7c**

both sides now

Depending on your background, it might help to select *Layer > Matting > Remove White Matte* after you scale and position your model onto the background.

8

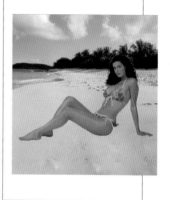

5 The model will appear as a new layer. Select *Edit > Free Transform* to adjust the size. You can use the corner handles (holding the Shift key), or type a size into the *Tool Options* bar.

6 Reposition by dragging near the center. When you're happy, click the tick icon. If necessary, flip using *Edit > Transform > Flip Horizontal*.

7 Switch to the background layer, and select the *Brush* tool and a soft-edged brush. Set the foreground color as black and the blend mode to *Multiply*.

8 At a low opacity, paint shadows beneath your model. Make them darker nearer areas of "contact," but don't be too precise— a hazy shadow is more convincing.

fabulous fashion?

There's no need to let our models dictate your color scheme. If their clothes, or their props, don't fit in with your plans, why not change them? With most image-editing software you'll find it's easy to select a garment and change the color. You can be as soft and subtle, or as vibrant and vivid, as you like.

3

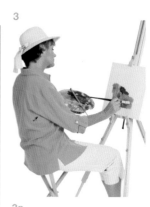

1

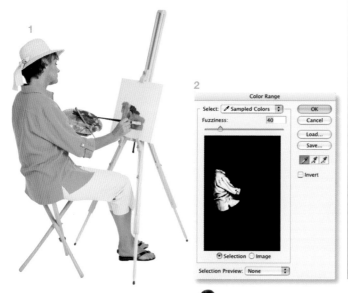

2

3a

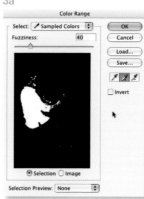

tie-dye

Of course there is no need to stop at changing the *Hue*. It's also possible to select an area (as in Steps 2-4), then apply effects using the *Layers* palette. Here, for example, this bohemian pattern was added by creating a new layer with the selection still active, then filling with the *Graduated Fill* tool. The final step, to preserve the shading, was to make the fill layer's blending mode *Multiply*.

1 Open the image in your favorite image editor. We're using the industry standard Photoshop here, but there is plenty of choice out there.

2 Since we're only looking to change part of the image, we need to make a selection. The best tools for selecting an area of color are the *Magic Wand* tool or, better still, Photoshop's *Select > Color Range...* function.

3 This tool works by selecting colors similar to the one you click on, anywhere in the image. Don't worry about that for now—simply click anywhere on your target garment. If it doesn't seem to be selecting enough, hold Shift as you click. This builds up the selection, which you can monitor in the *Color Range* dialog box.

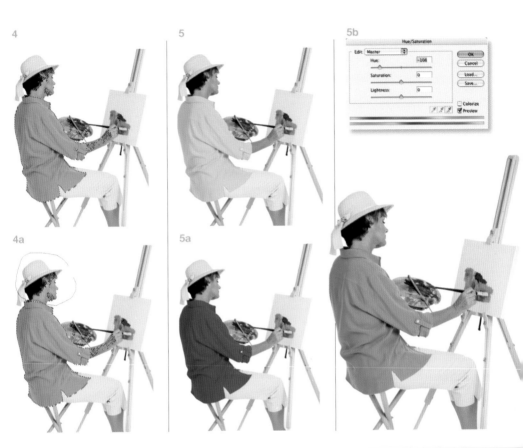

4 Once you've selected the garment, you'll probably find a few other areas of the image are selected too. Using the *Lasso* tool, and holding the Alt key as you do, you can draw rough circles around these areas and they'll disappear.

5 Now we can adjust the color, safe in the knowledge we're only affecting the right bit. Create a new *Hue/ Saturation Adjustment Layer* and adjust the sliders as you like. The *Hue* is the most significant here, and caution should be exercised adjusting the others because the tone must remain consistent with the rest of the image. Luckily, the effect is instantly previewed.

6 When you created the *Adjustment Layer*, Photoshop automatically masked it according to your earlier selection. You can see this in your *Layers* palette.

7 Save your final image. You might need to use *Save > Save As...* to choose a file format (such as TIFF) that is acceptable to your page-layout software.

runarounds

how to flow your text around images for smooth, organic design that pleases the eye

There's no need to be constrained by the traditional columns and rectangles that have been the stuff of page layout since the movable type press was invented in 1436. While it might look very dignified on a newspaper, it'll hardly make your pages stand out from the crowd.

An alternative approach is to use the lines from your artwork as guidelines, and every picture on the CD includes a clipping mask for just this purpose.

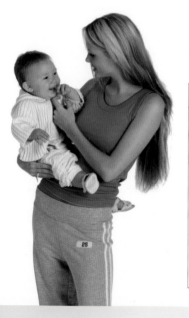

1 Here is a page in need of further illustration. Sure we could drop in a square picture; but because the page makes use of white space, it'd be a shame not to keep the loose feel.

2 Insert a standard rectangular frame where you want your image to be.

3 Select your image and make its mask an alpha channel, as shown on pages 12-13. You can call it "Clipping Mask."

4 Import the newly merged image into the frame. In InDesign, click *File > Place* to bring up the import dialog.

3

4

5

6

7

8

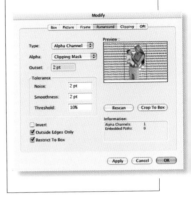
5 When you place it, you might see nothing but the top corner of the image. Scale it to the proportions you want. Remember to use the *Scale Proportionally* tool or your model will get too fat or thin.

6 To get the text to flow around your image, you need to set your software to use the clipping mask. In InDesign, use the *TextWrap* palette; in QuarkXPress, *Item > Clipping*.

7 If things don't look right, check to ensure that the frames are layered in the correct order using the *Object > Arrange* menu.

8 Sometimes you might not like the way the text has flowed. You can control it by placing clear frames (set to *Bounding-box Wrap*) over areas where you don't want text.

adding to images
liven up your company artwork with our models

Some of the poses in this book are positively crying out for the addition of artwork publicizing your company or venture, whether a design like this Adobe Illustrator file, or an image file, or even a photo from your digital camera.

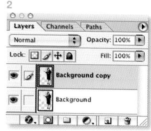

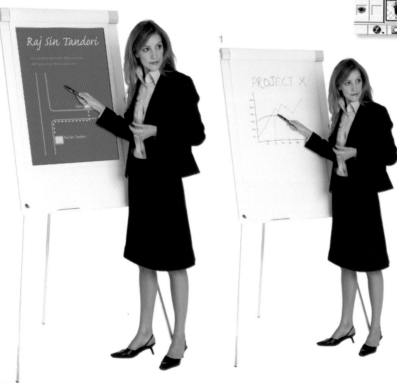

1 Open the model pose of your choice and, if you want to use the image as a cut-out, apply the mask as shown on pages 12-13.

2 Make a duplicate of the background layer by clicking *Layer > Duplicate layer* or using the *Layers* palette.

3 On the new top layer, open the *Extract* filter (*Filter > Extract...*) and zoom in on the arm, because only this part needs extracting.

4 Select the *Edge Highlighter* tool and draw a rough line around the edge of the arm. Ensure it forms a complete shape, then fill it with the *Fill* tool.

3

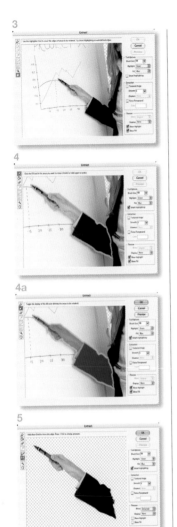

4

4a

5

6

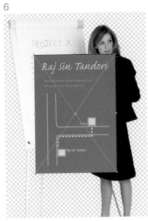

7

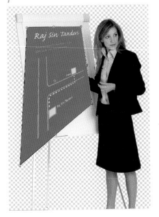

8

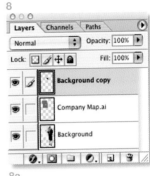

8a

8b

5 Click *Preview* and, if you feel any changes are needed, use the *Cleanup* and *Edge Touchup* tools to make any last changes before clicking *Extract*.

6 Click *File > Place* and locate the artwork you wish to use. Initially, place it so that it is noticeably too large on the page.

7 Use *Edit > Free Transform* and, holding ⌘ (Mac) or Control (Windows) as you do, drag the corners so that your artwork looks in good perspective.

8 Move the extracted arm layer above the new artwork and, if necessary, add a soft drop-shadow (taking care to get the angle correct).

holding hands
let's work together

People do not work in isolation, so these images don't need to, either. Our models have been posed so that they can interact with other characters, simply by being lined up next to each other.

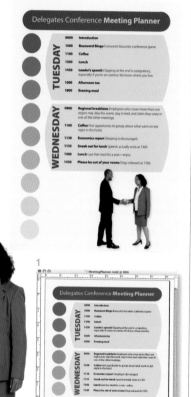

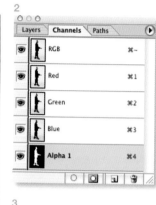

1 This dreary agenda could do with livening up—and, because it's talking about meetings, it would be a shame to restrict ourselves to a single image.

2 Select your images and attach their masks in an image editor, as described on pages 12-13.

3 In InDesign (or your preferred application) add a frame and import your image.

4 Select the *Scale Content* tool option and type the appropriate size for your image.

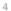

4

4a

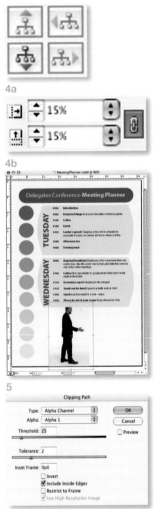

4b

5

6

7a

8

7

5 Set the clipping path to follow the alpha channel you have already added.

6 Add the other image you selected in the same way, taking care to choose exactly the same size when you scale it.

7 Click and drag from the horizontal ruler at the top to draw a guide, and use this to line up your characters. The line will not print.

8 As a finishing touch, why not add a soft drop-shadow?

perfect presentations
getting the image right will help you get your message across

In a presentation, you need to get the audience on your side. It's not a good idea to frustrate them with hard-to-read typefaces, unnecessarily flashy graphics, or tired clip art they've seen before. But a picture truly is worth a thousand words, so simply select an appropriate picture and, by making your words emerge from behind it, subtly weave it into your show.

1

Providing for Later Life

- It's vital to plan for later life.
- What is the minimum you could sustain your lifestyle on?
- What is the maximum you can afford to pay each month?
- Is there a gap?

2

3

Resolutions

Many projectors describe their resolution in terms of three letters.

This is the number of pixels for six common sizes.

Adapter	Resolution
VGA	640 x 480
SVGA	800 x 600
XGA	1024 x 768
SXGA	1280 x 1024
SXGA+	1400 x 1050
UXGA	1600 x 1200

Image Size

Pixel Dimensions: 1.23M (was 25.6M)
Width: 560 pixels
Height: 768 pixels

Document Size:
Width: 7.781 inches
Height: 10.667 inches
Resolution: 72 pixels/inch

☑ Scale Styles
☑ Constrain Proportions
☑ Resample Image: Bicubic

OK
Reset
Auto...

1 Check your projector's optical resolution, because this is the best resolution to tailor your slides to (see box, above).

2 Open your chosen image and apply the mask to remove the background, as in the example on pages 12-13.

3 Scale the image so that the longest side matches the equivalent resolution—in this example the height is reduced to 768 for an XGA presentation. Then save the image as a PNG file.

4 Using PowerPoint, create a new slide with room for a graphic.

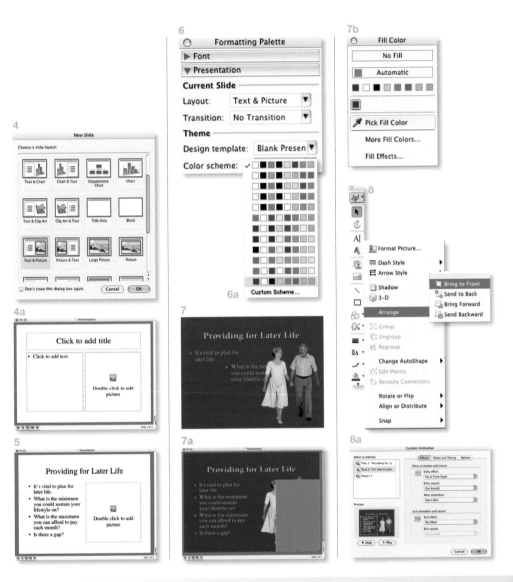

5 Add your text and open the PNG file you created (PNG is preferable because it includes transparency).

6 Select a color scheme that is appropriate for your image, and typefaces that go well together.

7 To have your text appear from behind the image, make the image at least as tall as the text, then draw a rectangle over it. Make the rectangle the same color as the background.

8 Place the image above the rectangle using the draw tools, then set up the animation so the words "fly in" from the right using the *Customize...* button on the *Animation* toolbox.

1001

size 229 x 344 mm
9.01 x 13.55 inches
2,704 x 4,064 pixels
resolution 300 ppi
mode RGB

families

search criteria
- Mother
- Baby
- Green
- Family
- Happy
- Holding
- Charlotte
- Alex

1002

size	204 x 204 mm
	8.02 x 12.78 inches
	2,407 x 3,833 pixels
resolution	300 ppi
mode	RGB

families

search criteria
- Mother
- Baby
- Green
- Happy
- Holding
- Charlotte
- Alex

1003

size 229 x 344 mm
9.01 x 13.55 inches
2,704 x 4,064 pixels
resolution 300 ppi
mode RGB

families

search criteria

- **Mother**
- **Baby**
- **Green**
- **Family**
- **Happy**
- **Holding**
- **Charlotte**
- **Alex**

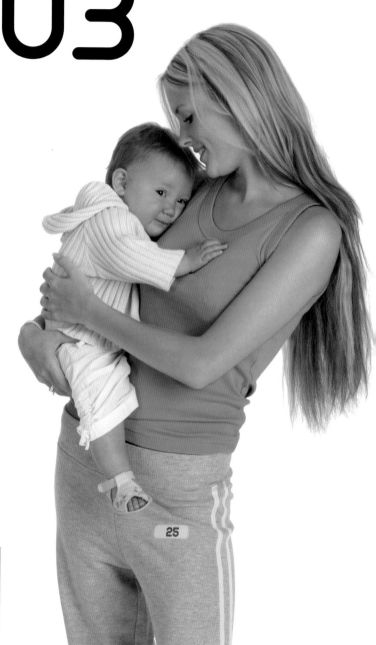

1004

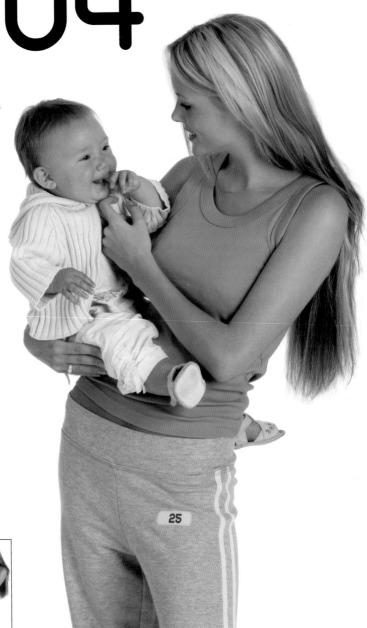

size	210 x 306 mm
	8.28 x 12.05 inches
	2,483 x 2,483 pixels
resolution	300 ppi
mode	RGB

families

search criteria
- Mother
- Baby
- Green
- Family
- Happy
- Holding
- Tickle
- Charlotte
- Alex

1005

size 229 x 344 mm
9.01 x 13.55 inches
2,704 x 4,064 pixels
resolution 300 ppi
mode RGB

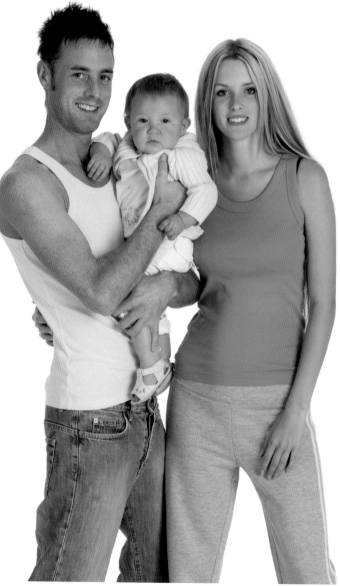

families

search criteria
- **Family**
- **Father**
- **Mother**
- **Brother**
- **Sister**
- **Couple**
- **Happy**
- **Holding**
- **Charlotte**
- **Alex**
- **Rich**

1006

size 223 x 255 mm
8.78 x 10.03 inches
2,633 x 3,010 pixels
resolution 300 ppi
mode RGB

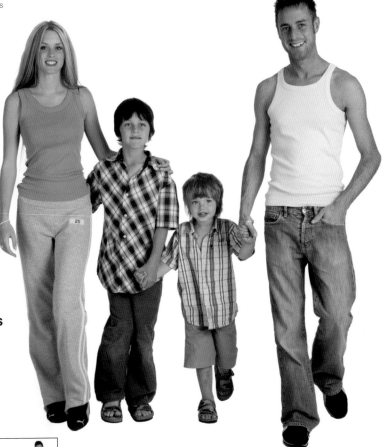

families

search criteria

- Family
- Father
- Mother
- Brother
- Sister
- Couple
- Happy
- Children
- Sons
- Holding hands
- Walking
- Charlotte
- Elliot
- James
- Rich

1007

size 229 x 344 mm
9.01 x 13.55 inches
2,704 x 4,064 pixels
resolution 300 ppi
mode RGB

families

search criteria

- **Family**
- **Mother**
- **Sister**
- **Baby**
- **Smiling**
- **Holding**
- **Abby**
- **Fiona**

1008

size 197 x 330 mm
7.76 x 13.01 inches
2,328 x 3,903 pixels
resolution 300 ppi
mode RGB

families

search criteria

- Family
- Father
- Baby
- Holding
- Happy
- Smiling
- Ben
- Fiona

1009

size 229 x 344 mm
9.01 x 13.55 inches
2,704 x 4,064 pixels
resolution 300 ppi
mode RGB

families

search criteria
- Family
- Father
- Mother
- Baby
- Couple
- Holding
- Ben
- Abby
- Fiona

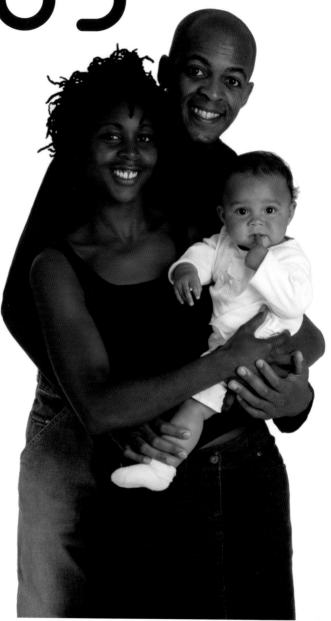

1010

size 229 x 344 mm
9.01 x 13.55 inches
2,704 x 4,064 pixels
resolution 300 ppi
mode RGB

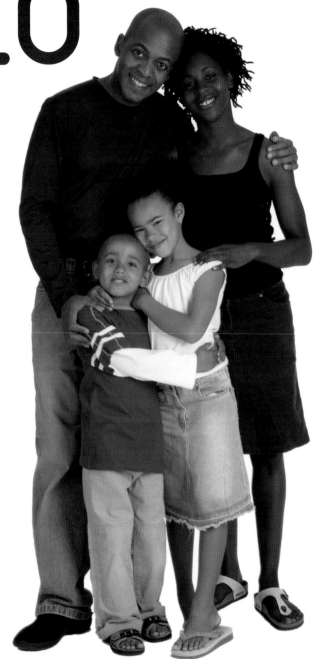

families

search criteria

- Family
- Father
- Mother
- Brother
- Sister
- Son
- Daughter
- Children
- Ben
- Abby
- Timmy
- Letisha

1011

size 179 x 191 mm
7.04 x 7.51 inches
2,112 x 2,252 pixels
resolution 300 ppi
mode RGB

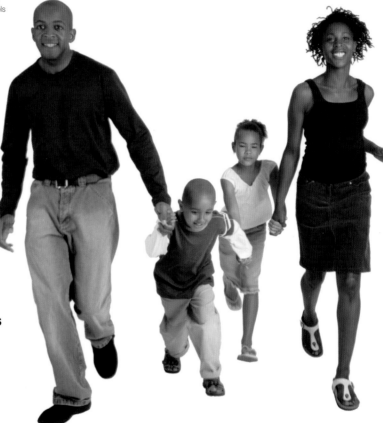

families

1012

size 173 x 179 mm
6.83 x 7.04 inches
2,048 x 2,112 pixels
resolution 300 ppi
mode RGB

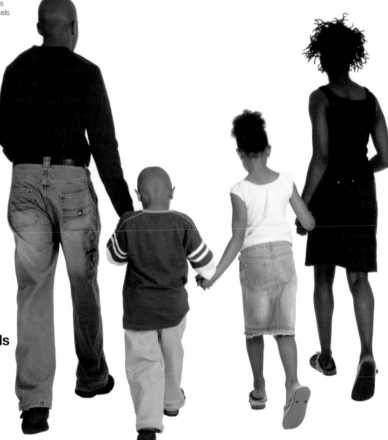

families

search criteria
- Family
- Father
- Mother
- Brother
- Son
- Daughter
- Children
- Walking
- Back
- Holding hands
- Ben
- Abby
- Timmy
- Letisha

1013

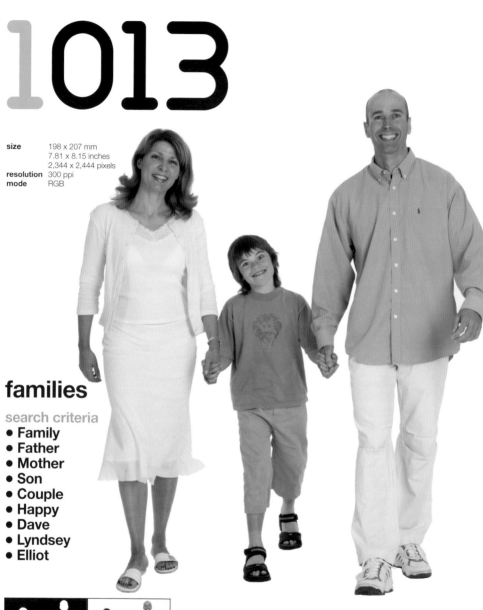

size	198 x 207 mm
	7.81 x 8.15 inches
	2,344 x 2,444 pixels
resolution	300 ppi
mode	RGB

families

search criteria
- Family
- Father
- Mother
- Son
- Couple
- Happy
- Dave
- Lyndsey
- Elliot

1014

size 204 x 313 mm
8.02 x 12.31 inches
2,406 x 3,694 pixels
resolution 300 ppi
mode RGB

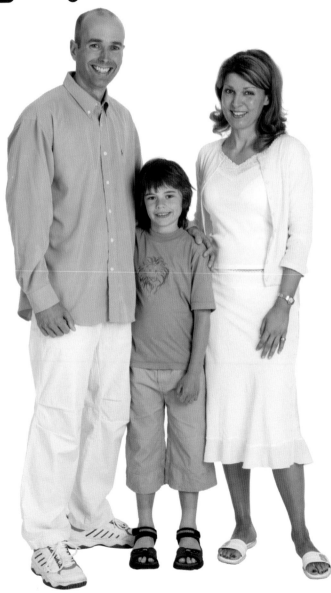

families

search criteria

- **Family**
- **Father**
- **Mother**
- **Son**
- **Couple**
- **Happy**
- **Lyndsey**
- **Dave**
- **Elliot**

1015

size 229 x 344 mm
9.01 x 13.55 inches
2,704 x 4,064 pixels
resolution 300 ppi
mode RGB

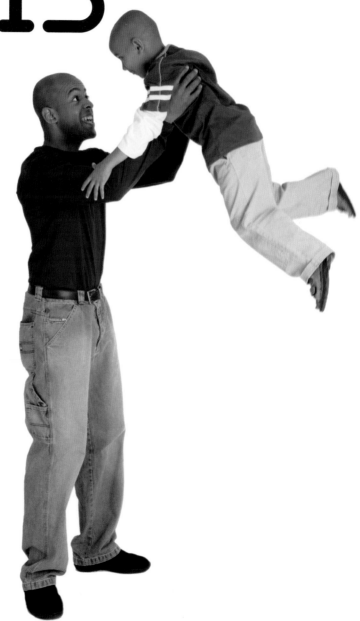

families

search criteria
- Family
- Father
- Throwing
- Holding
- Happy
- Playing
- Smiling
- Ben
- Timmy

1016

size 132 x 297 mm
5.20 x 11.70 inches
1,560 x 3,510 pixels
resolution 300 ppi
mode RGB

families

search criteria
- Family
- Father
- Hiding
- Happy
- Smiling
- Playing
- Crouching
- Ben
- Timmy

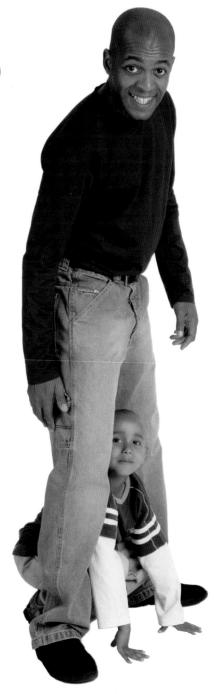

1017

size 191 x 337 mm
 7.52 x 13.25 inches
 2,256 x 3,976 pixels
resolution 300 ppi
mode RGB

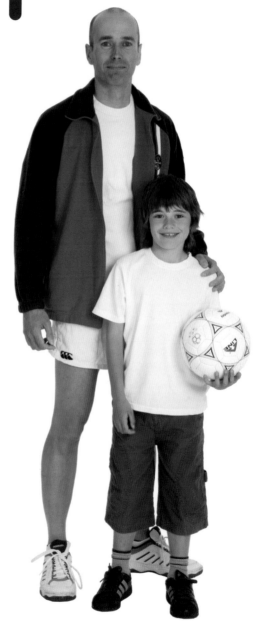

families

search criteria
- **Family**
- **Father**
- **Son**
- **Soccer**
- **Football**
- **Team**
- **Dave**
- **Elliot**

1018

size 208 x 276 mm
8.18 x 10.85 inches
2,454 x 3,256 pixels
resolution 300 ppi
mode RGB

families

search criteria
- Family
- Father
- Son
- Soccer
- Tackle
- Football
- Dave
- Elliot

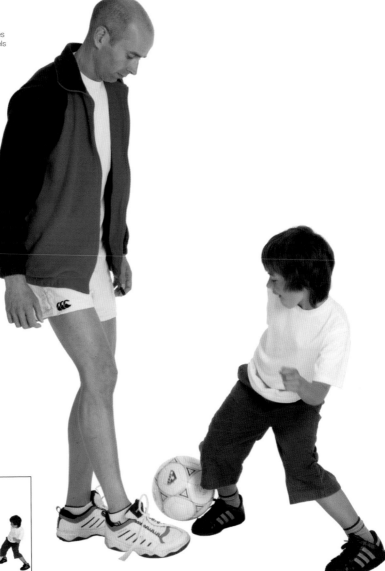

1019

size 229 x 216 mm
9.00 x 8.52 inches
2,700 x 2,556 pixels
resolution 300 ppi
mode RGB

families

search criteria

- Family
- Father
- Mother
- Brother
- Sister
- Children
- Couple
- Happy
- Bench
- Dave
- Lyndsey
- Elliot
- Amy

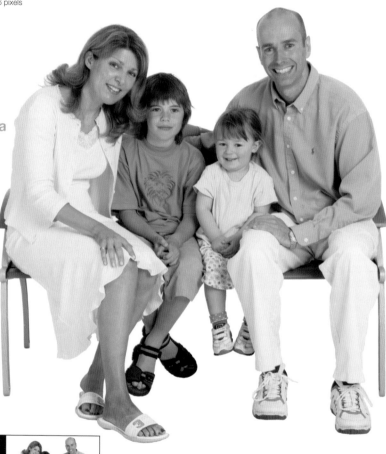

1020

size 250 x 226 mm
9.84 x 8.88 inches
2,952 x 2,664 pixels
resolution 300 ppi
mode RGB

families

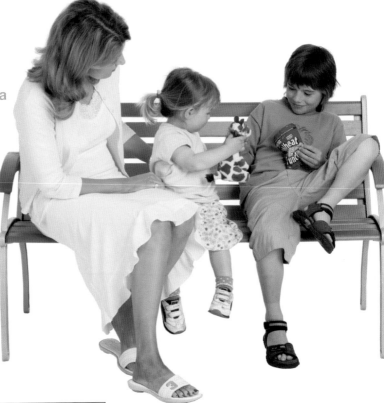

search criteria
- Family
- Mother
- Brother
- Sister
- Children
- Happy
- Bench
- Toy
- Lyndsey
- Elliot
- Amy

1021

size	264 x 212 mm
	10.38 x 8.33 inches
	3,115 x 2,500 pixels
resolution	300 ppi
mode	RGB

families

search criteria

- Family
- Father
- Son
- Child
- Video game
- Bench
- Dave
- Elliot

1022

size 171 x 269 mm
6.74 x 10.59 inches
2,022 x 3,178 pixels
resolution 300 ppi
mode RGB

families

search criteria

- Family
- Father
- Son
- Walking
- Jogging
- Child
- Dave
- Elliot

1023

size 191 x 191 mm
7.52 x 7.53 inches
2,256 x 2,260 pixels
resolution 300 ppi
mode RGB

families

search criteria
- Family
- Grandfather
- Grandmother
- Brother
- Sister
- Happy
- Walking
- Sue
- Bert
- Sally
- Jake

1024

size 188 x 191 mm
7.39 x 7.53 inches
2,216 x 2,260 pixels
resolution 300 ppi
mode RGB

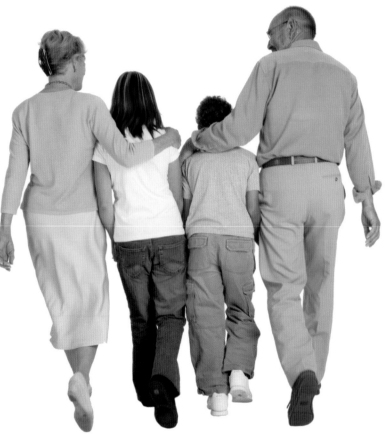

families

search criteria

- Family
- Grandfather
- Grandmother
- Brother
- Sister
- Happy
- Walking
- Back
- Sue
- Bert
- Sally
- Jake

1025

size 228 x 277 mm
8.98 x 10.91 inches
2,693 x 3,274 pixels
resolution 300 ppi
mode RGB

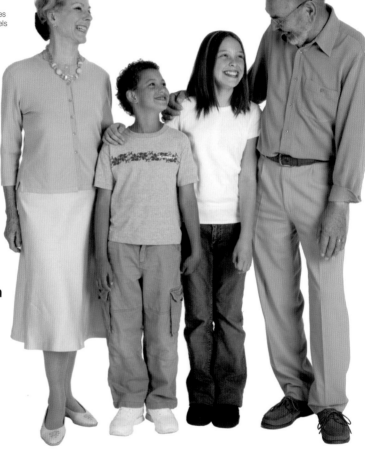

families

search criteria
- Family
- Grandfather
- Grandmother
- Grandchildren
- Brother
- Sister
- Happy
- Walking
- Sue
- Bert
- Sally
- Jake

1026

size 256 x 225 mm
10.09 x 8.87 inches
3,028 x 2,660 pixels
resolution 300 ppi
mode RGB

families

search criteria

- Family
- Grandfather
- Grandmother
- Grandchildren
- Brother
- Sister
- Happy
- Walking
- Bench
- Reading
- Sue
- Bert
- Sally
- Jake

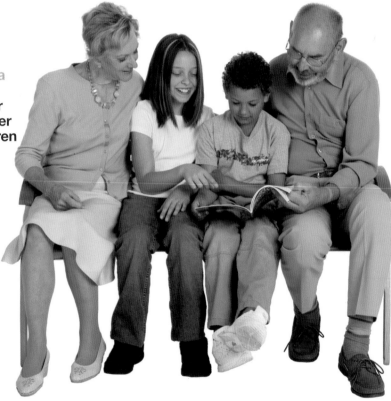

1027

size 258 x 224 mm
10.14 x 8.84 inches
3,043 x 2,651 pixels
resolution 300 ppi
mode RGB

families

search criteria
- Family
- Grandmother
- Granddaughter
- Grandchildren
- Bench
- Happy
- Old
- Young
- Sue
- Sally
- Smiling

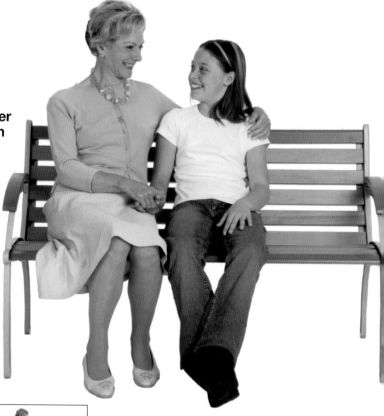

1028

size 242 x 218 mm
9.54 x 8.56 inches
2,863 x 2,569 pixels
resolution 300 ppi
mode RGB

families

search criteria

- Family
- Grandfather
- Grandson
- Grandchildren
- Bench
- Talking
- Old
- Young
- Bert
- Jake
- Walking stick

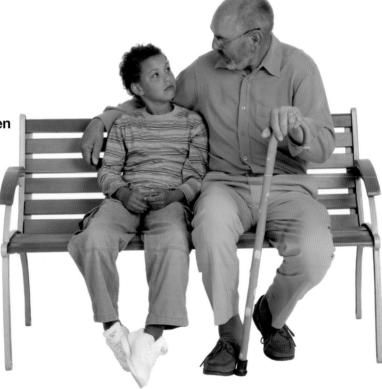

1029

size 171 x 322 mm
6.74 x 12.69 inches
2,022 x 3,808 pixels
resolution 300 ppi
mode RGB

families

search criteria
- Family
- Couple
- Father
- Pregnant
- Mother
- Maternity
- Nigel
- Helen

1030

size	146 x 311 mm
	5.76 x 12.23 inches
	1,728 x 3,670 pixels
resolution	300 ppi
mode	RGB

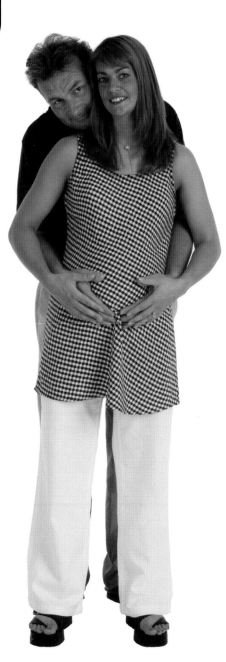

families

search criteria

- Family
- Couple
- Father
- Pregnant
- Mother
- Maternity
- Nigel
- Helen

1031

size 142 x 341 mm
5.60 x 13.43 inches
1,680 x 4,029 pixels
resolution 300 ppi
mode RGB

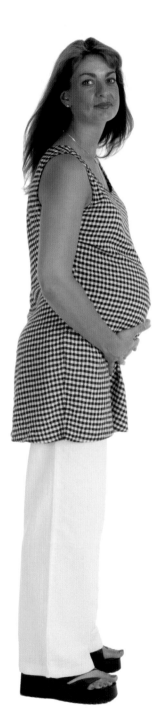

families

search criteria
- **Pregnant**
- **Mother**
- **Maternity**
- **Helen**

2032

size 204 x 279 mm
8.04 x 10.99 inches
2,412 x 3,298 pixels
resolution 300 ppi
mode RGB

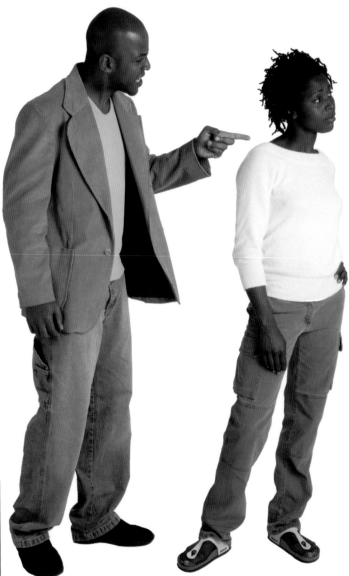

couples

search criteria
- Couple
- Argue
- Conflict
- Aggression
- Point
- Ben
- Abby

2033

size	244 x 280 mm
	9.59 x 11.01 inches
	2,878 x 3,304 pixels
resolution	300 ppi
mode	RGB

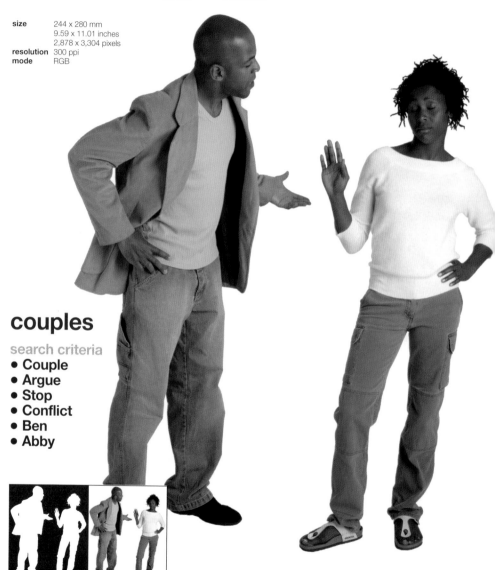

couples

search criteria
- **Couple**
- **Argue**
- **Stop**
- **Conflict**
- **Ben**
- **Abby**

2034

size 217 x 308 mm
8.56 x 12.15 inches
2,567 x 3,646 pixels
resolution 300 ppi
mode RGB

couples

search criteria
- Couple
- Argue
- Ignore
- Reject
- Rich
- Charlotte

2035

size	174 x 297 mm
	6.84 x 11.69 inches
	2,052 x 3,508 pixels
resolution	300 ppi
mode	RGB

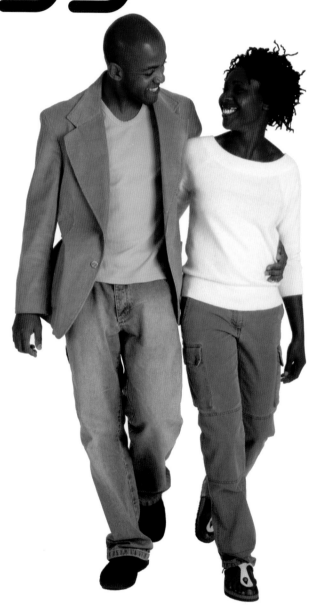

couples

search criteria
- Couple
- Walking
- Love
- Relationship
- Arm-in-arm
- Ben
- Abby

2036

size 153 x 302 mm
6.02 x 11.87 inches
1,806 x 3,562 pixels
resolution 300 ppi
mode RGB

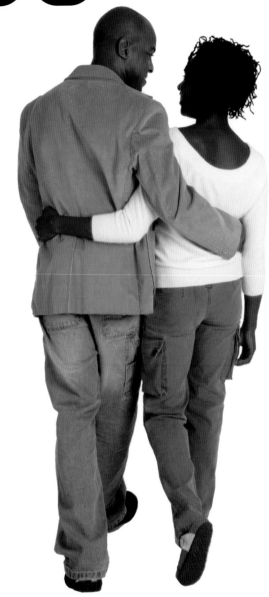

couples

search criteria
- Couple
- Walking
- Love
- Relationship
- Arm-in-arm
- Ben
- Abby
- Back

2037

size 309 x 166 mm
6.52 x 12.17 inches
1,956 x 3,652 pixels
resolution 300 ppi
mode RGB

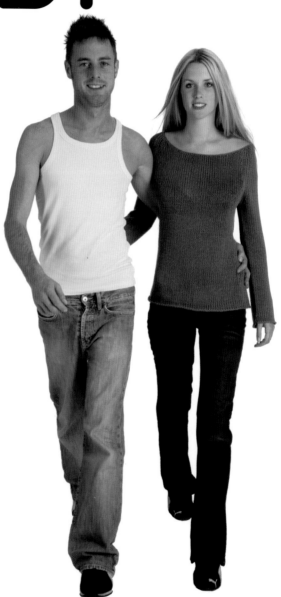

couples

search criteria
- Couple
- Walking
- Love
- Relationship
- Arm-in-arm
- Rich
- Charlotte

2038

size 209 x 303 mm
8.24 x 11.93 inches
2,472 x 3,580 pixels
resolution 300 ppi
mode RGB

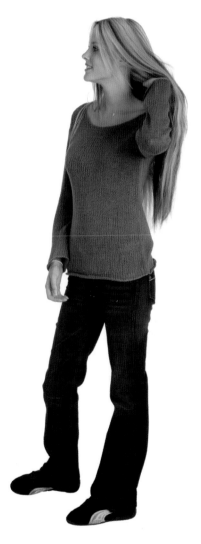

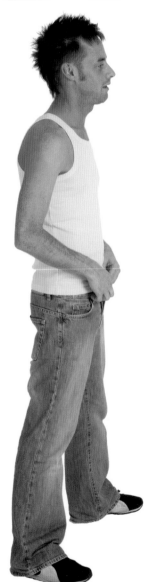

couples

search criteria
- Couple
- Chatting
- Preening
- Flirting
- Love
- Relationship
- Standing
- Rich
- Charlotte

2039

size 130 x 331 mm
5.10 x 13.03 inches
1,530 x 3,910 pixels
resolution 300 ppi
mode RGB

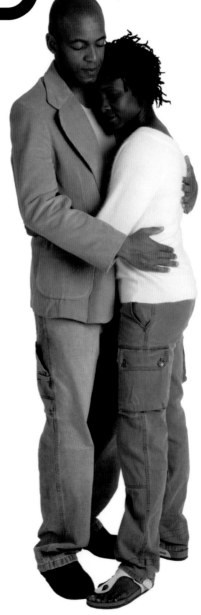

couples

search criteria

- Couple
- Hug
- Content
- Comfort
- Love
- Relationship
- Ben
- Abby

2040

size 190 x 290 mm
7.48 x 11.41 inches
2,244 x 3,424 pixels
resolution 300 ppi
mode RGB

couples

search criteria
- Couple
- Dance
- Smiling
- Flirting
- Look
- Love
- Relationship
- Ben
- Abby

2041

size 319 x 201 mm
12.57 x 7.9 inches
3,772 x 2,369 pixels
resolution 300 ppi
mode RGB

couples

search criteria
- Man
- Woman
- Couple
- Body language
- Café
- Coffee
- Holly
- Gareth

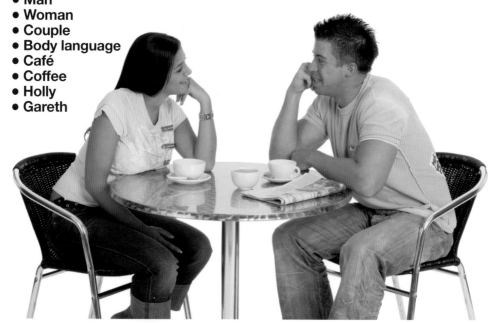

2042

size 226 x 215 mm
8.88 x 8.47 inches
2,665 x 2,540 pixels
resolution 300 ppi
mode RGB

couples

search criteria
- Man
- Woman
- Couple
- Love
- Relationship
- Bench
- Rich
- Charlotte

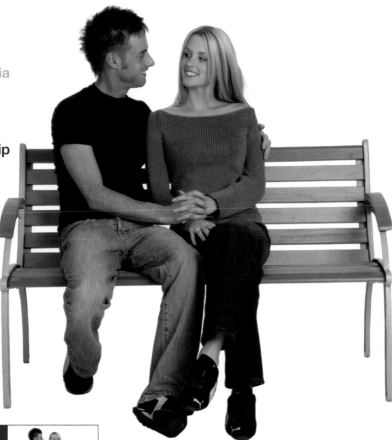

2043

size 246 x 219 mm
 9.68 x 8.63 inches
 2,904 x 2,588 pixels
resolution 300 ppi
mode RGB

couples

search criteria
- **Man**
- **Woman**
- **Couple**
- **Reading**
- **Happy**
- **Bench**
- **Rich**
- **Charlotte**

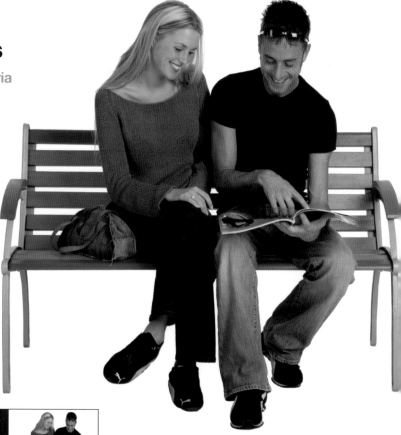

2044

size 221 x 215 mm
8.72 x 8.45 inches
2,616 x 2,536 pixels
resolution 300 ppi
mode RGB

couples

search criteria

- **Man**
- **Woman**
- **Couple**
- **Bored**
- **Make-up**
- **Bench**
- **Charlotte**
- **Rich**

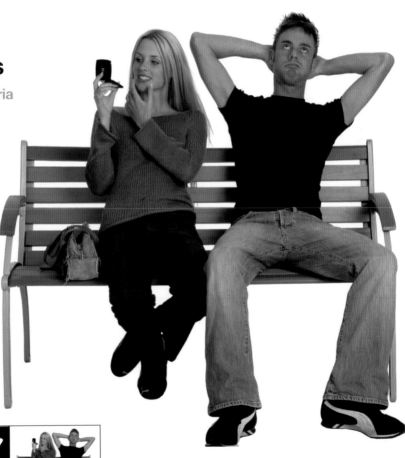

2045

size 185 x 331 mm
7.28 x 13.03 inches
2,184 x 3,909 pixels
resolution 300 ppi
mode RGB

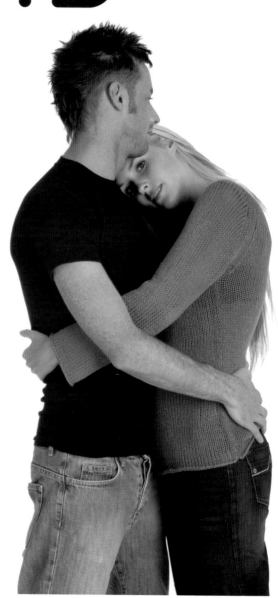

couples

search criteria
- **Couple**
- **Hug**
- **Love**
- **Relationship**
- **Content**
- **Comfort**
- **Rich**
- **Charlotte**

2046

size · 190 x 334 mm
7.48 x 13.13 inches
2,243 x 3,939 pixels
resolution 300 ppi
mode RGB

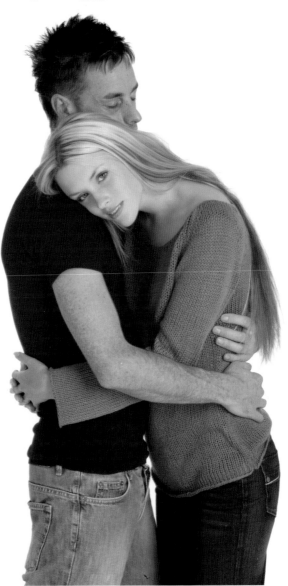

couples

search criteria

- Couple
- Hug
- Love
- Relationship
- Content
- Comfort
- Rich
- Charlotte

2049

size 149 x 326 mm
5.88 x 12.85 inches
1,764 x 3,856 pixels
resolution 300 ppi
mode RGB

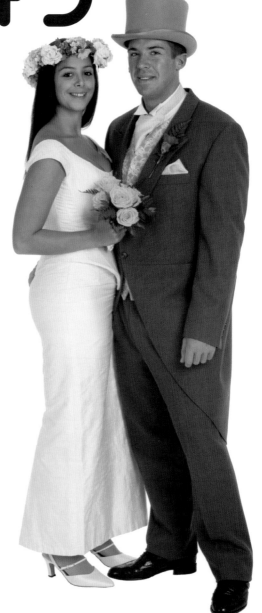

couples

search criteria
- Couple
- Wedding
- Love
- Marriage
- Bride
- Groom
- Holly
- Gareth

2050

size 163 x 327 mm
6.42 x 12.87 inches
1,926 x 3,862 pixels
resolution 300 ppi
mode RGB

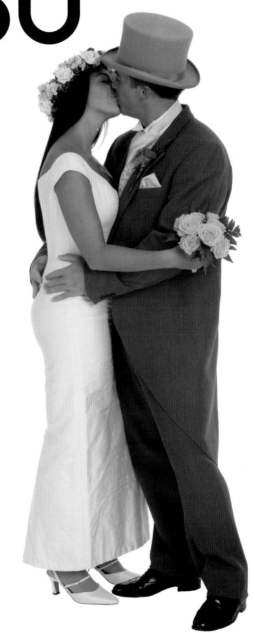

couples

search criteria
- Couple
- Wedding
- Love
- Marriage
- Bride
- Groom
- Kiss
- Holly
- Gareth

2051

size	208 x 294 mm
	8.18 x 11.59 inches
	2,453 x 3,478 pixels
resolution	300 ppi
mode	RGB

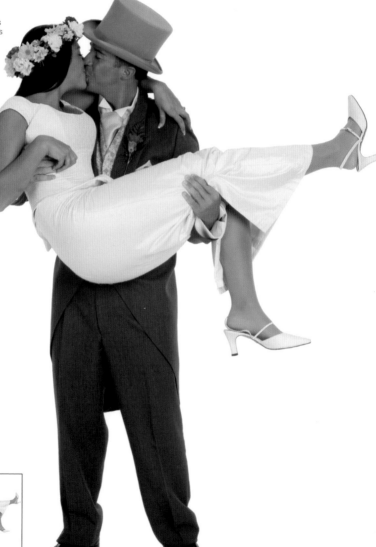

couples

search criteria
- Couple
- Wedding
- Love
- Marriage
- Bride
- Groom
- Kiss
- Carry
- Threshold
- Holly
- Gareth

2052

size 147 x 326 mm
5.78 x 12.83 inches
1,734 x 3,850 pixels
resolution 300 ppi
mode RGB

couples

search criteria
- **Boy**
- **Girl**
- **Teens**
- **Couple**
- **Love**
- **Relationship**
- **Hold**
- **Kylie**
- **Stuart**

2053

size 143 x 261 mm
5.62 x 10.27 inches
1,686 x 3,082 pixels
resolution 300 ppi
mode RGB

couples

search criteria
- Boy
- Girl
- Teens
- Couple
- Love
- Relationship
- Hold
- Kylie
- Stuart

2054

size 162 x 283 mm
6.36 x 11.15 inches
1,908 x 3,346 pixels
resolution 300 ppi
mode RGB

couples

search criteria

- Boy
- Girl
- Teens
- Couple
- Love
- Relationship
- Hold
- Back
- Kylie
- Stuart

2055

size 185 x 314 mm
7.28 x 12.35 inches
2,184 x 3,706 pixels
resolution 300 ppi
mode RGB

couples

search criteria
- **Boy**
- **Girl**
- **Teens**
- **Couple**
- **Love**
- **Relationship**
- **Holding hands**
- **Happy**
- **Kylie**
- **Stuart**

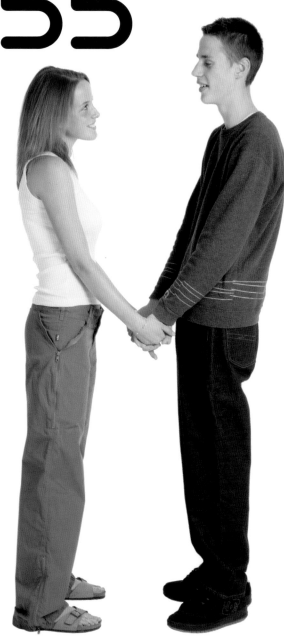

2056

size 212 x 304 mm
 8.36 x 11.95 inches
 2,508 x 3,586 pixels
resolution 300 ppi
mode RGB

couples

search criteria

- Boy
- Girl
- Teens
- Couple
- Body language
- Love
- Flirting
- Talking
- Happy
- Kylie
- Stuart

2057

size 219 x 277 mm
8.64 x 10.89 inches
2,591 x 3,268 pixels
resolution 300 ppi
mode RGB

couples

search criteria

- Boy
- Girl
- Teens
- Couple
- Chatting
- Talking
- Happy
- Kylie
- Stuart

2058

size 183 x 283 mm
7.2 x 11.15 inches
2,160 x 3,346 pixels
resolution 300 ppi
mode RGB

couples

search criteria
- Boy
- Girl
- Teens
- Couple
- Talking
- Angry
- Conflict
- Kylie
- Stuart

2059

size 242 x 224 mm
9.51 x 8.82 inches
2,853 x 2,645 pixels
resolution 300 ppi
mode RGB

couples

search criteria
- **Boy**
- **Girl**
- **Teens**
- **Couple**
- **Love**
- **Talking**
- **Happy**
- **Bench**
- **Kylie**
- **Stuart**

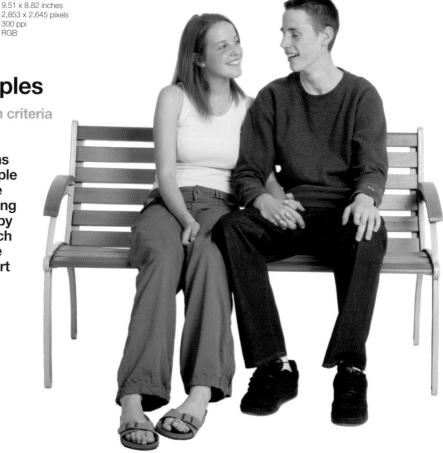

2060

size 254 x 217 mm
9.99 x 8.56 inches
2,998 x 2,568 pixels
resolution 300 ppi
mode RGB

couples

search criteria

- Boy
- Girl
- Teens
- Couple
- Love
- Talking
- Sad
- Concerned
- Bench
- Kylie
- Stuart

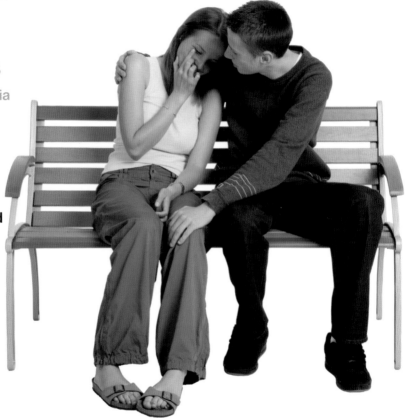

3061

size 255 x 213 mm
10.05 x 8.40 inches
3,016 x 2,520 pixels
resolution 300 ppi
mode RGB

leisure & sport

search criteria
- **Woman**
- **Bench**
- **Sitting**
- **Make-up**
- **Charlotte**

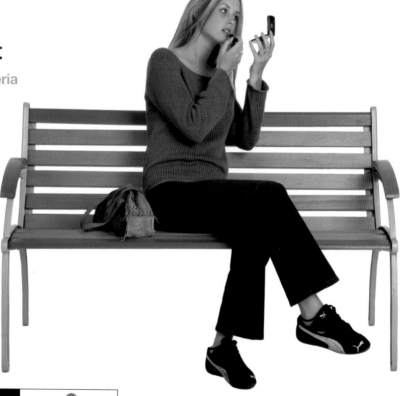

3062

size 257 x 211 mm
10.12 x 8.32 inches
3,036 x 2,496 pixels
resolution 300 ppi
mode RGB

leisure
& sport

search criteria
- **Woman**
- **Bench**
- **Sitting**
- **Talking**
- **Phone**
- **Charlotte**

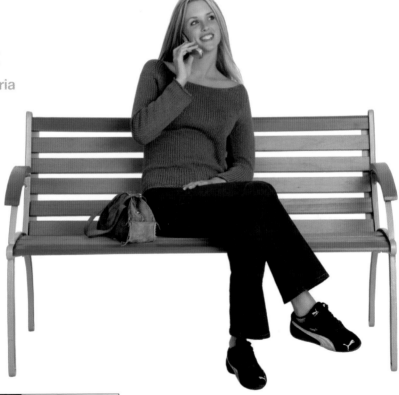

3063

size 248 x 216 mm
9.75 x 8.50 inches
2,926 x 2,550 pixels
resolution 300 ppi
mode RGB

leisure
& sport

search criteria
- **Woman**
- **Bench**
- **Sitting**
- **Reading**
- **Magazine**
- **Charlotte**

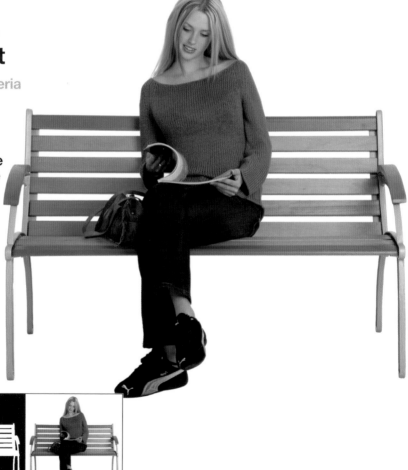

3064

size 238 x 198 mm
9.35 x 7.78 inches
2,806 x 2,334 pixels
resolution 300 ppi
mode RGB

leisure & sport

search criteria

- Man
- Bench
- Sitting
- Talking
- Phone
- Rich

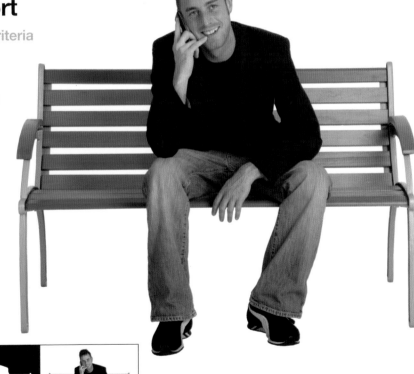

3065

size 240x 214 mm
9.44 x 8.44 inches
2,832 x 2,532 pixels
resolution 300 ppi
mode RGB

leisure
& sport

search criteria

- Man
- Woman
- Bench
- Sitting
- Holding hands
- Resting
- Peaceful
- Ben
- Abby

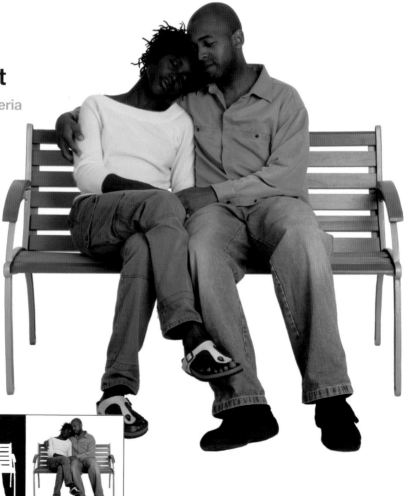

3066

size 229 x 215 mm
9.01 x 8.48 inches
2,704 x 2,544 pixels
resolution 300 ppi
mode RGB

leisure & sport

search criteria
- **Man**
- **Woman**
- **Bench**
- **Sitting**
- **Make-up**
- **Mirror**
- **Resting**
- **Ben**
- **Abby**

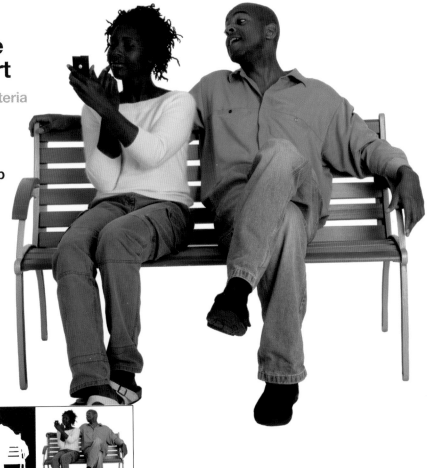

3067

size 242 x 220 mm
 9.51 x 8.68 inches
 2,854 x 2,604 pixels
resolution 300 ppi
mode RGB

leisure & sport

search criteria

- **Woman**
- **Bench**
- **Make-up**
- **Mirror**
- **Abby**

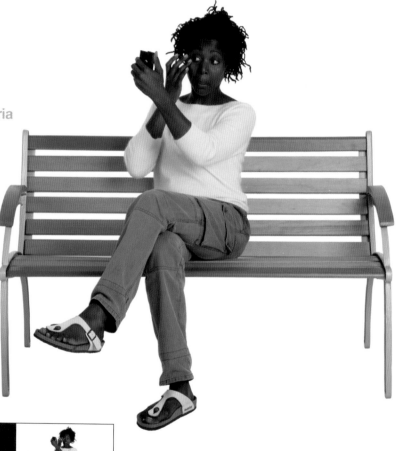

3068

size 244 x 219 mm
9.61 x 8.62 inches
2,884 x 2,586 pixels
resolution 300 ppi
mode RGB

leisure
& sport

search criteria
- Man
- Bench
- Reading
- Magazine
- Relaxing
- Ben

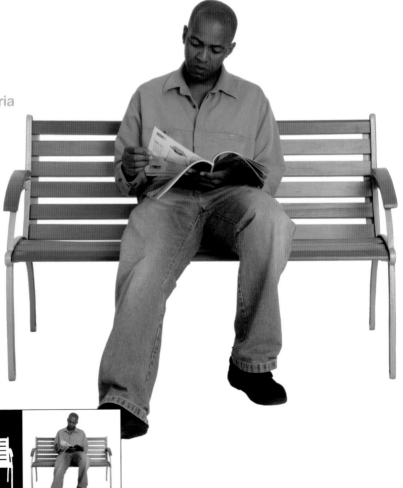

3069

size 316 x 226 mm
12.44 x 8.88 inches
3,732 x 2,664 pixels
resolution 300 ppi
mode RGB

leisure & sport

search criteria
- **Woman**
- **Sewing**
- **Stitching**
- **Repair**
- **Table**
- **Lyndsey**

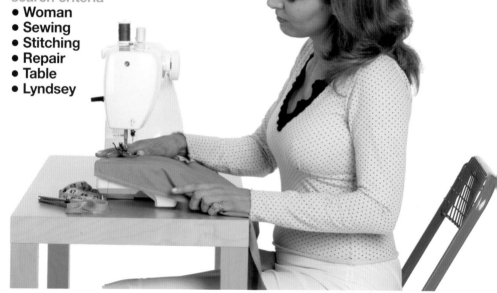

3070

size 229 x 340 mm
9.01 x 13.37 inches
2,704 x 4,011 pixels
resolution 300 ppi
mode RGB

leisure
& sport

search criteria
- **Woman**
- **Sewing**
- **Stitching**
- **Repair**
- **Table**
- **Lyndsey**

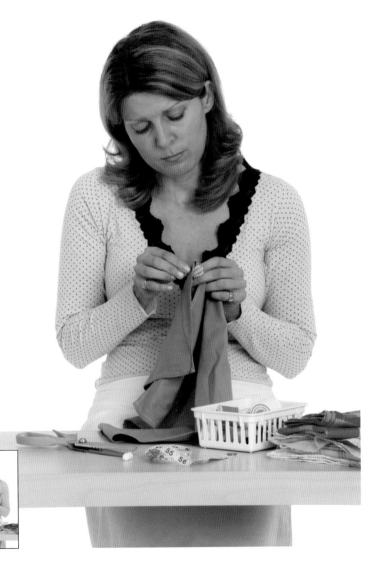

3071

size 216 x 339 mm
8.52 x 13.35 inches
2,556 x 4,005 pixels
resolution 300 ppi
mode RGB

leisure & sport

search criteria

- **Man**
- **Camera**
- **Picture**
- **Menu**
- **Photography**
- **Dave**

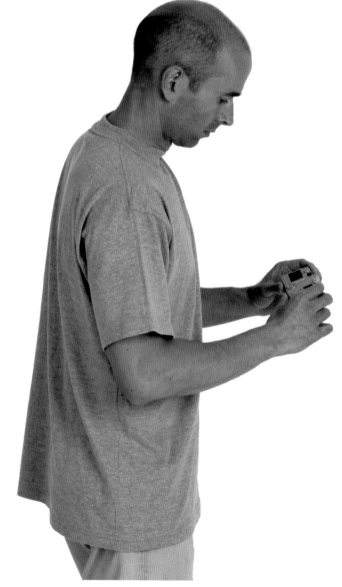

3072

size 311 x 186 mm
12.25 x 7.34 inches
3,676 x 2,201 pixels
resolution 300 ppi
mode RGB

leisure
& sport

search criteria

- Boy
- Girl
- Couple
- Video game
- Console
- Play
- Kylie
- Stuart

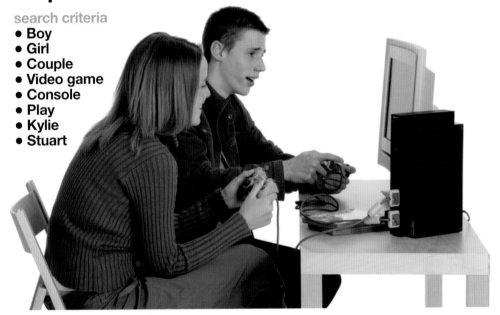

3073

size 281 x 188 mm
11.05 x 7.40 inches
3,316 x 2,219 pixels
resolution 300 ppi
mode RGB

leisure & sport

search criteria
- Boy
- Video game
- Console
- Play
- Stuart

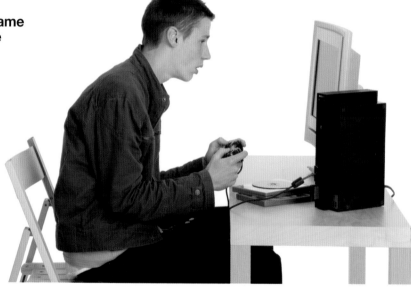

3074

size 281 x 178 mm
 11.05 x 7.00 inches
 3,316 x 2,099 pixels
resolution 300 ppi
mode RGB

leisure
& sport

search criteria
- Girl
- Video game
- Console
- Play
- Kylie

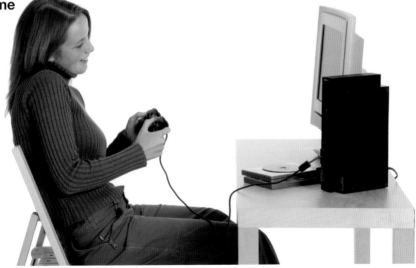

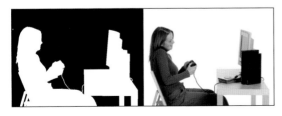

3075

size 331 x 116 mm
 13.01 x 4.57 inches
 3,904 x 1,372 pixels
resolution 300 ppi
mode RGB

leisure
& sport

search criteria

- **Girl**
- **Lying down**
- **Reading**
- **Magazine**
- **Relaxing**
- **Kylie**

3076

size	332 x 124 mm
	13.05 x 4.88 inches
	3,916 x 1,464 pixels
resolution	300 ppi
mode	RGB

leisure & sport

search criteria
- Girl
- Lying down
- Reading
- Magazine
- Relaxing
- Kylie

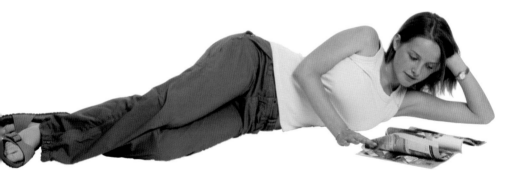

3077

size　　　326 x 193 mm
　　　　　　12.84 x 7.59 inches
　　　　　　3,852 x 2,276 pixels
resolution 300 ppi
mode　　 RGB

leisure
& sport

search criteria
- **Girl**
- **Lying down**
- **Reading**
- **Book**
- **Learning**
- **Letisha**

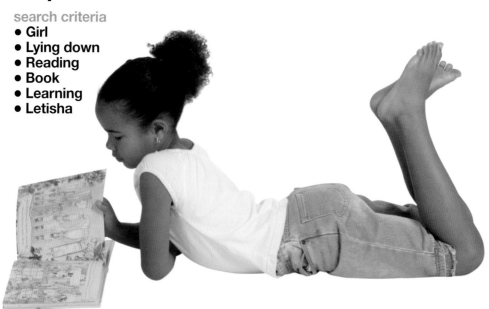

3078

size 222 x 281 mm
8.76 x 11.07 inches
2,627 x 3,322 pixels
resolution 300 ppi
mode RGB

leisure
& sport

search criteria
- **Woman**
- **Painting**
- **Easel**
- **Brush**
- **Art**
- **Mary**

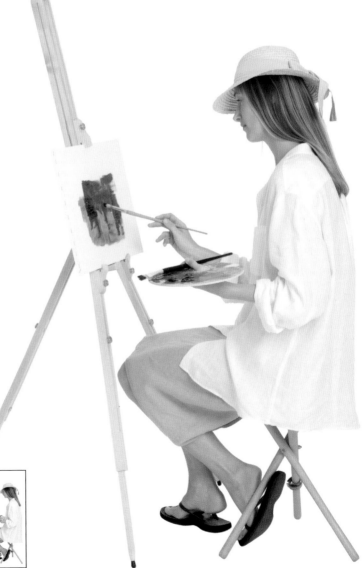

3079

size 169 x 333 mm
 6.66 x 13.11 inches
 1,998 x 3,933 pixels
resolution 300 ppi
mode RGB

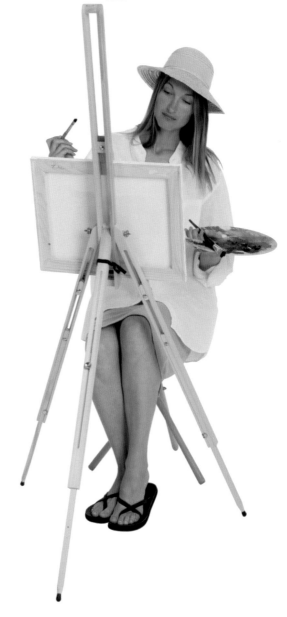

leisure
& sport

search criteria
- **Woman**
- **Painting**
- **Easel**
- **Brush**
- **Art**
- **Mary**

3080

size 185 x 290 mm
 7.28 x 11.41 inches
 2,184 x 3,424 pixels
resolution 300 ppi
mode RGB

leisure & sport

search criteria

- **Woman**
- **Painting**
- **Easel**
- **Brush**
- **Art**
- **Back**
- **Mary**

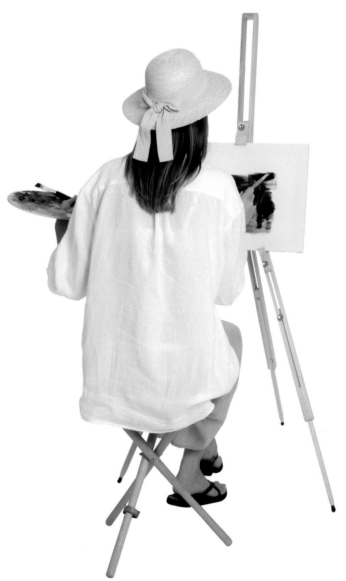

3081

size 220 x 317 mm
8.65 x 12.47 inches
2,596 x 3,742 pixels
resolution 300 ppi
mode RGB

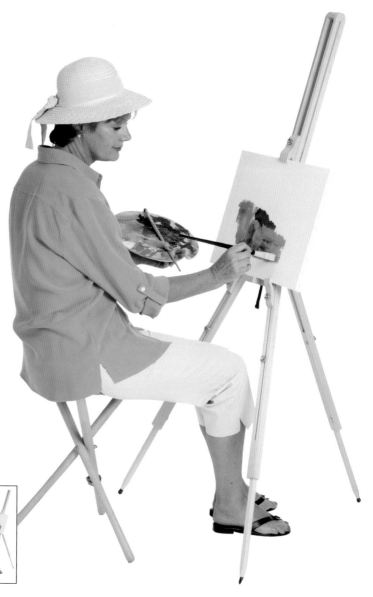

leisure & sport

search criteria
- **Woman**
- **Painting**
- **Easel**
- **Brush**
- **Art**
- **Penelope**

3082

size 196 x 326 mm
7.72 x 12.83 inches
2,316 x 3,850 pixels
resolution 300 ppi
mode RGB

leisure & sport

search criteria
- Woman
- Painting
- Easel
- Brush
- Art
- Back
- Penelope

3083

size 304 x 188 mm
 11.95 x 7.40 inches
 3,586 x 2,219 pixels
resolution 300 ppi
mode RGB

leisure
& sport

search criteria

- **Woman**
- **Flower**
- **Arranging**
- **Vase**
- **Mary**

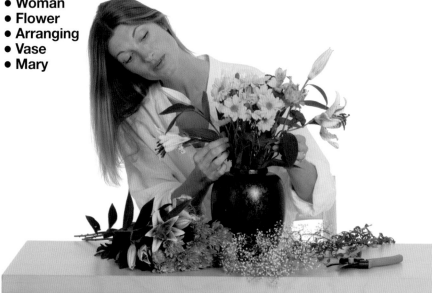

3084

size 300 x 211 mm
11.79 x 8.32 inches
3,538 x 2,495 pixels
resolution 300 ppi
mode RGB

leisure
& sport

search criteria
- **Woman**
- **Flower**
- **Arranging**
- **Vase**
- **Mary**

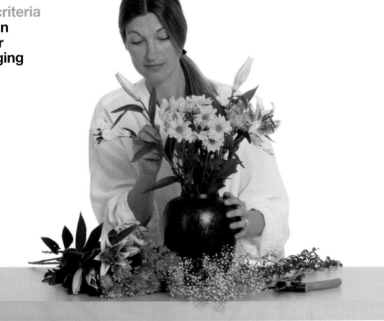

3085

size 193 x 292 mm
7.60 x 11.51 inches
2,280 x 3,453 pixels
resolution 300 ppi
mode RGB

leisure & sport

search criteria
- Sport
- Man
- Boxing
- Jab
- Dexter

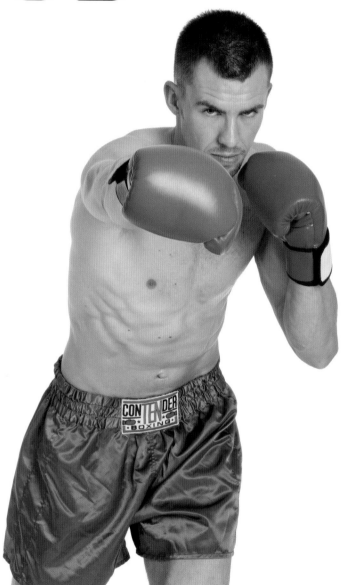

3086

size 157 x 321 mm
6.20 x 12.63 inches
1,860 x 3,790 pixels
resolution 300 ppi
mode RGB

leisure
& sport

search criteria
- **Sport**
- **Man**
- **Golf**
- **Wood**
- **Driver**
- **Backswing**
- **Harry**

3087

size 196 x 331 mm
7.72 x 13.03 inches
2,316 x 3,909 pixels
resolution 300 ppi
mode RGB

leisure & sport

search criteria
- **Sport**
- **Man**
- **Golf**
- **Putt**
- **Harry**

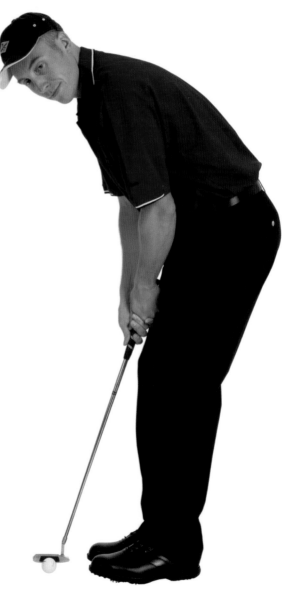

3088

size 201 x 310 mm
7.92 x 12.21 inches
2,376 x 3,664 pixels
resolution 300 ppi
mode RGB

leisure
& sport

search criteria
- **Sport**
- **Man**
- **Golf**
- **Wood**
- **Harry**

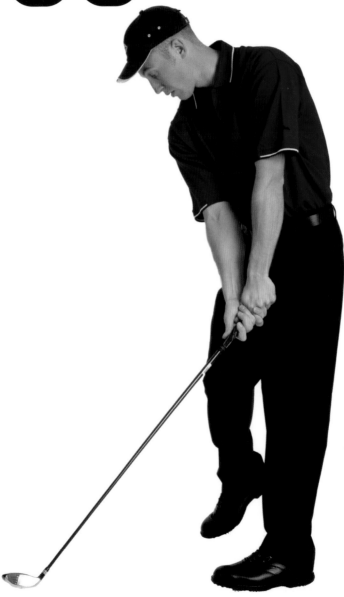

3089

size 203 x 316 mm
7.98 x 12.43 inches
2,394 x 3,730 pixels
resolution 300 ppi
mode RGB

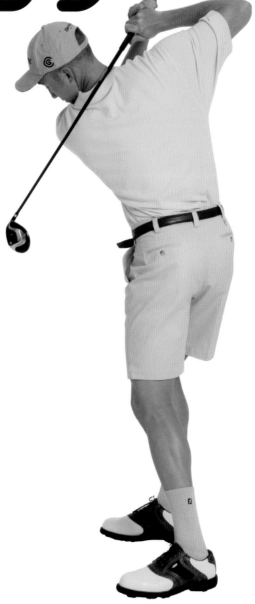

leisure
& sport

search criteria
- **Sport**
- **Man**
- **Golf**
- **Wood**
- **Driver**
- **Backswing**
- **Harry**

3090

size 163 x 332 mm
6.42 x 13.09 inches
1,926 x 3,927 pixels
resolution 300 ppi
mode RGB

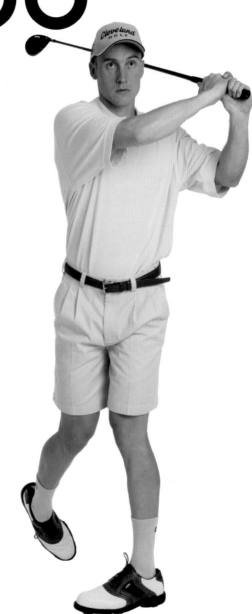

leisure
& sport

search criteria
- **Sport**
- **Man**
- **Golf**
- **Wood**
- **Driver**
- **Follow-through**
- **Harry**

3091

size 207 x 330 mm
8.16 x 12.97 inches
2,448 x 3,892 pixels
resolution 300 ppi
mode RGB

leisure & sport

search criteria
- Sport
- Man
- Golf
- Clubs
- Bag
- Harry

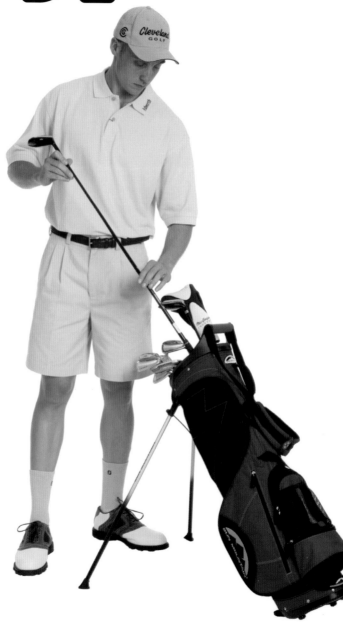

3092

size 198 x 295 mm
7.87 x 11.63 inches
2,334 x 3,490 pixels
resolution 300 ppi
mode RGB

leisure
& sport

search criteria
- Sport
- Man
- Golf
- Clubs
- Bag
- Walking
- Harry

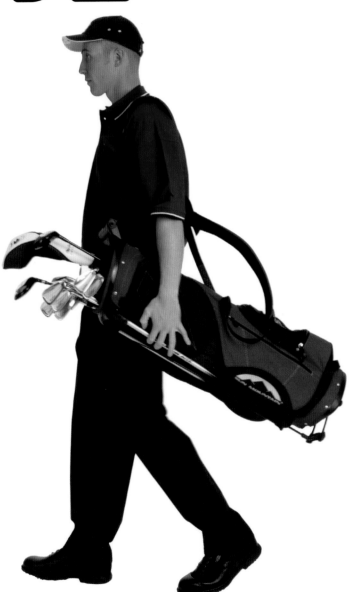

3093

size 194 x 340 mm
7.62 x 13.37 inches
2,286 x 4,010 pixels
resolution 300 ppi
mode RGB

leisure & sport

search criteria
- Sport
- Man
- Golf
- Clubs
- Bag
- Smiling
- Harry

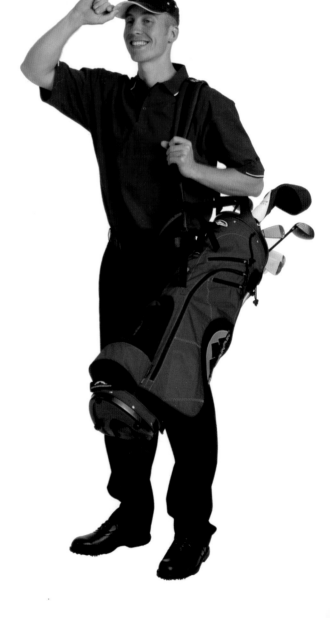

3094

size 183 x 334 mm
7.2 x 13.13 inches
2,160 x 3,940 pixels
resolution 300 ppi
mode RGB

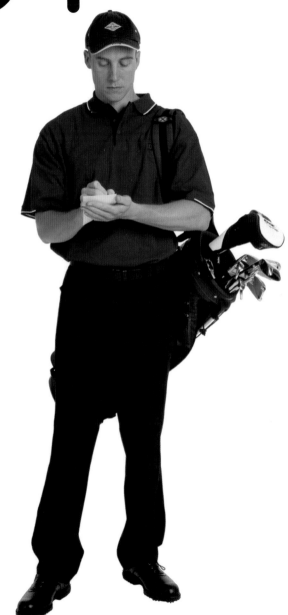

leisure
& sport

search criteria
- **Sport**
- **Man**
- **Golf**
- **Clubs**
- **Bag**
- **Scorecard**
- **Harry**

3095

size 145 x 337 mm
 5.7 x 13.25 inches
 1,710 x 3,975 pixels
resolution 300 ppi
mode RGB

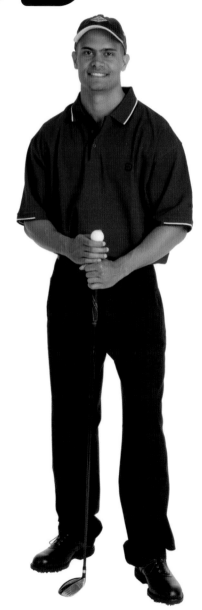

leisure
& sport

search criteria
- Sport
- Man
- Golf
- Ball
- Club
- Standing
- Ryan

3096

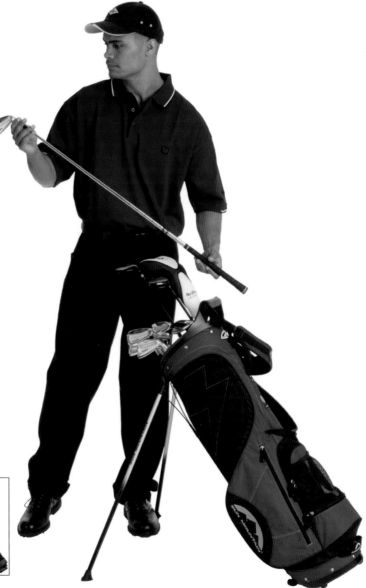

size 225 x 325 mm
8.86 x 12.79 inches
2,657 x 3,838 pixels
resolution 300 ppi
mode RGB

leisure & sport

search criteria
- Sport
- Man
- Golf
- Clubs
- Bag
- Selecting
- Ryan

3097

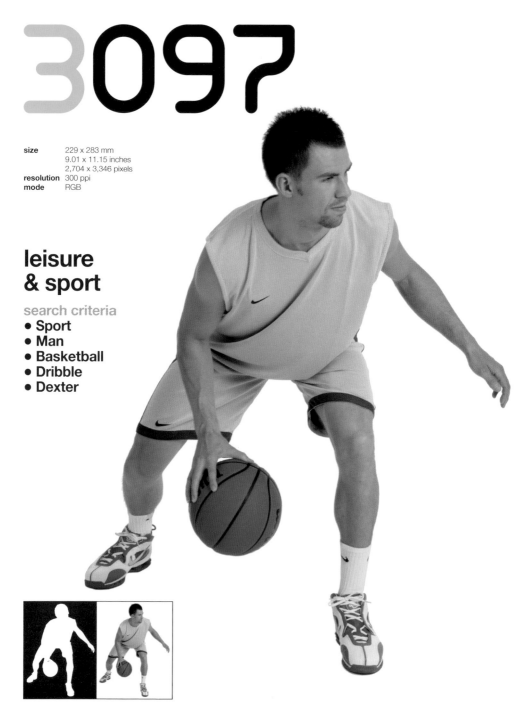

size 229 x 283 mm
9.01 x 11.15 inches
2,704 x 3,346 pixels
resolution 300 ppi
mode RGB

leisure & sport

search criteria
- Sport
- Man
- Basketball
- Dribble
- Dexter

3098

size 175 x 317 mm
6.9 x 12.49 inches
2,070 x 3,748 pixels
resolution 300 ppi
mode RGB

leisure & sport

search criteria
- **Sport**
- **Man**
- **Basketball**
- **Shoot**
- **Dexter**

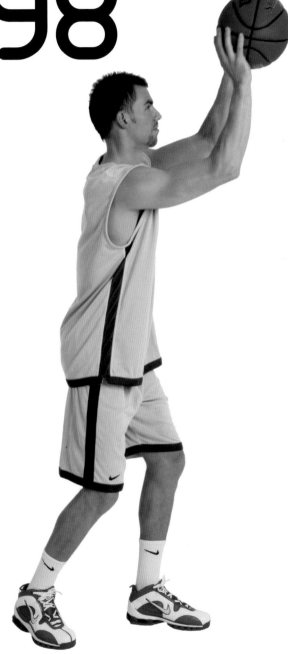

3099

size 126 x 318 mm
4.98 x 12.51 inches
1,494 x 3,753 pixels
resolution 300 ppi
mode RGB

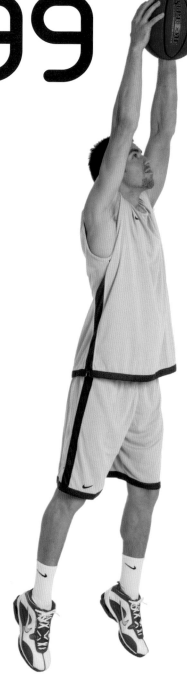

leisure
& sport

search criteria
- **Sport**
- **Man**
- **Basketball**
- **Dunk**
- **Dexter**

3100

size 169 x 273 mm
6.66 x 10.73 inches
1,998 x 3,219 pixels
resolution 300 ppi
mode RGB

leisure
& sport

search criteria
- Sport
- Man
- Basketball
- Dribble
- Ryan

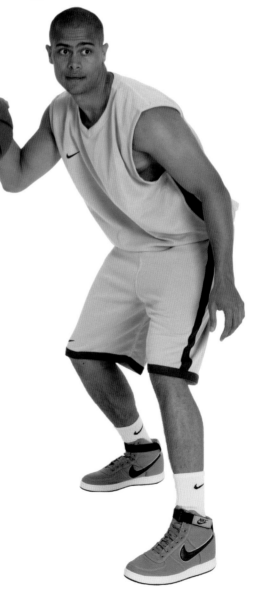

3101

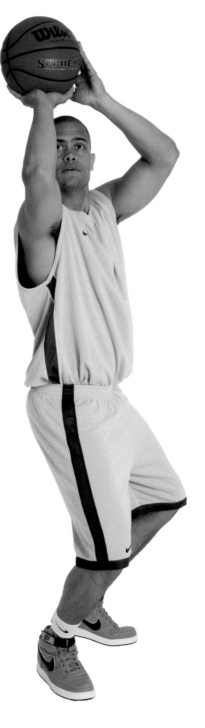

size 140 x 326 mm
 5.5 x 12.83 inches
 1,650 x 3,849 pixels
resolution 300 ppi
mode RGB

leisure
& sport

search criteria
- **Sport**
- **Man**
- **Basketball**
- **Shoot**
- **Ryan**

3102

size 158 x 302 mm
6.22 x 11.89 inches
1,866 x 3,568 pixels
resolution 300 ppi
mode RGB

leisure
& sport

search criteria
- Sport
- Man
- Basketball
- Shoot
- Ryan

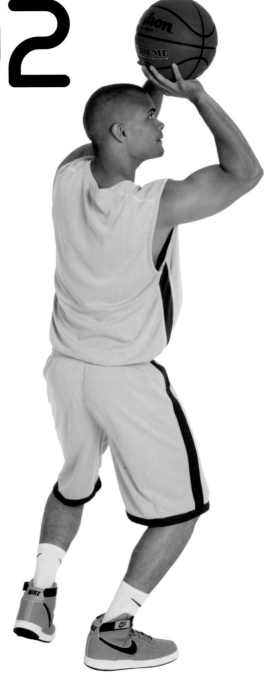

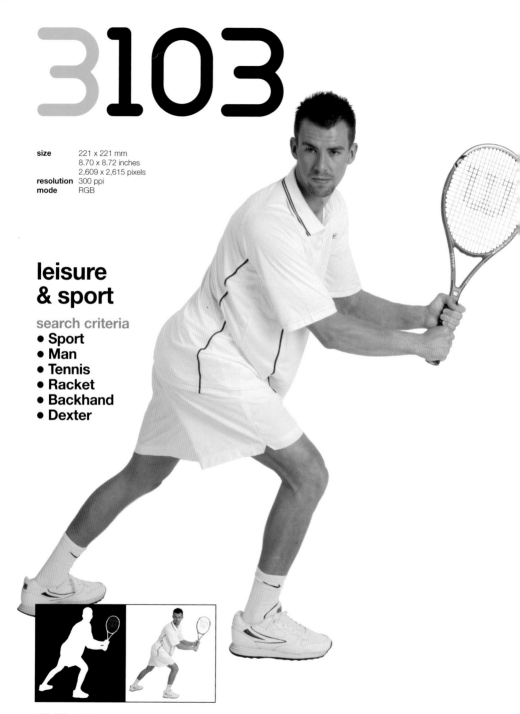

3103

size 221 x 221 mm
8.70 x 8.72 inches
2,609 x 2,615 pixels
resolution 300 ppi
mode RGB

leisure
& sport

search criteria
- Sport
- Man
- Tennis
- Racket
- Backhand
- Dexter

3104

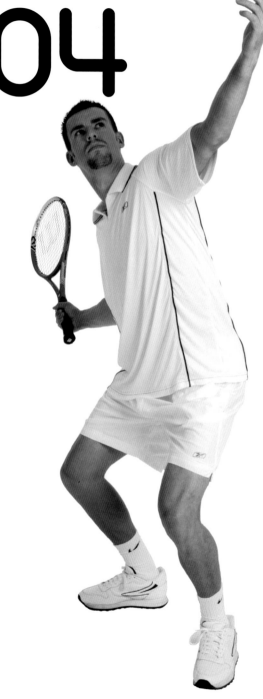

size 152 x 332 mm
6 x 13.07 inches
1,800 x 3,922 pixels
resolution 300 ppi
mode RGB

leisure
& sport

search criteria
- **Sport**
- **Man**
- **Tennis**
- **Racket**
- **Serve**
- **Dexter**

3105

size 144 x 321 mm
5.66 x 12.65 inches
1,698 x 3,796 pixels
resolution 300 ppi
mode RGB

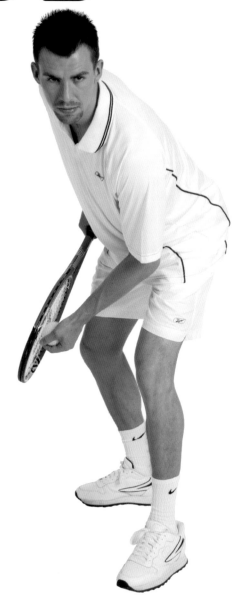

leisure & sport

search criteria
- **Sport**
- **Man**
- **Tennis**
- **Racket**
- **Serve**
- **Dexter**

3106

size 187 x 322 mm
7.38 x 12.67 inches
2,214 x 3,802 pixels
resolution 300 ppi
mode RGB

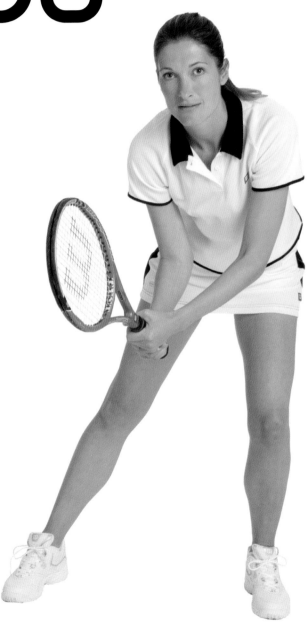

leisure
& sport

search criteria
- **Sport**
- **Woman**
- **Tennis**
- **Racket**
- **Receiving**
- **Ready**
- **Mary**

3107

size 124 x 327 mm
4.9 x 12.87 inches
1,470 x 3,832 pixels
resolution 300 ppi
mode RGB

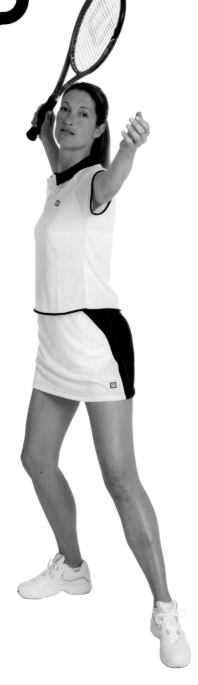

leisure
& sport

search criteria
- Sport
- Woman
- Tennis
- Racket
- Serve
- Mary

3108

size 156 x 333 mm
6.16 x 13.11 inches
1,848 x 3,934 pixels
resolution 300 ppi
mode RGB

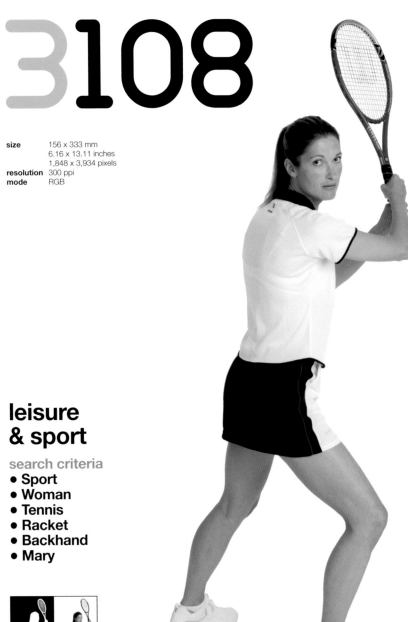

leisure & sport

search criteria
- Sport
- Woman
- Tennis
- Racket
- Backhand
- Mary

3109

size 205 x 321 mm
8.08 x 12.63 inches
2,424 x 3,789 pixels
resolution 300 ppi
mode RGB

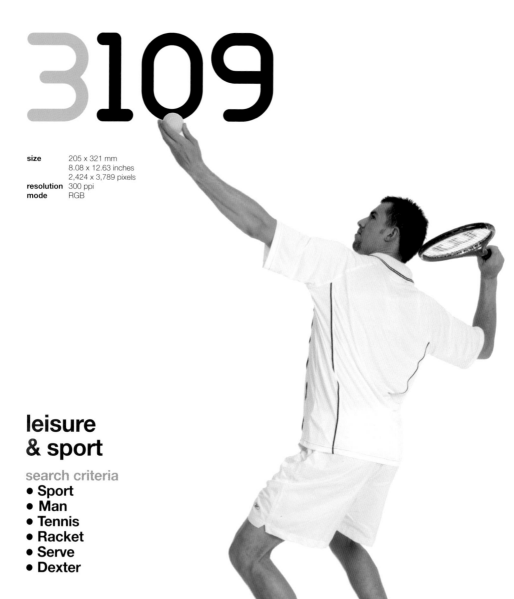

leisure
& sport

search criteria
- **Sport**
- **Man**
- **Tennis**
- **Racket**
- **Serve**
- **Dexter**

3110

size 156 x 331 mm
6.14 x 13.01 inches
1,842 x 3,904 pixels
resolution 300 ppi
mode RGB

leisure
& sport

search criteria
- **Sport**
- **Man**
- **Swimming**
- **Wetsuit**
- **Goggles**
- **Harry**

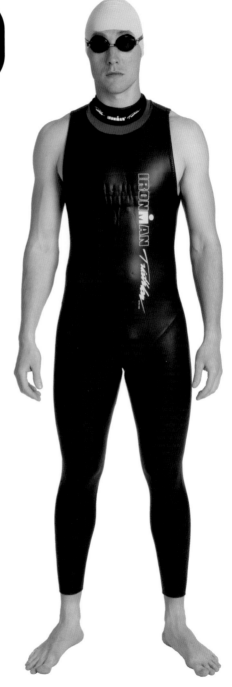

3111

size 229 x 275 mm
9.01 x 10.81 inches
2,704 x 3,244 pixels
resolution 300 ppi
mode RGB

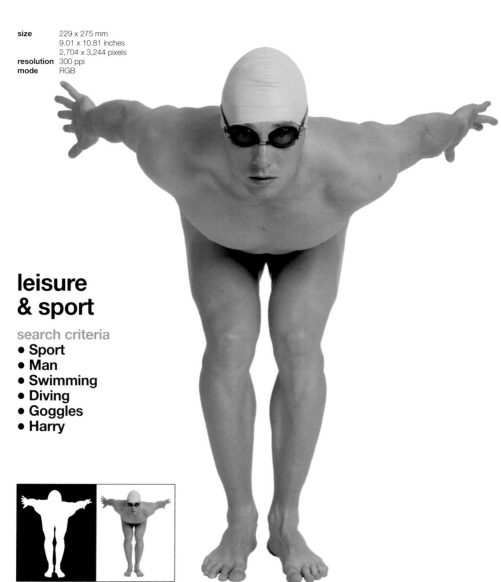

leisure & sport

search criteria
- **Sport**
- **Man**
- **Swimming**
- **Diving**
- **Goggles**
- **Harry**

3112

size 240 x 224 mm
9.45 x 8.82 inches
2,836 x 2,645 pixels
resolution 300 ppi
mode RGB

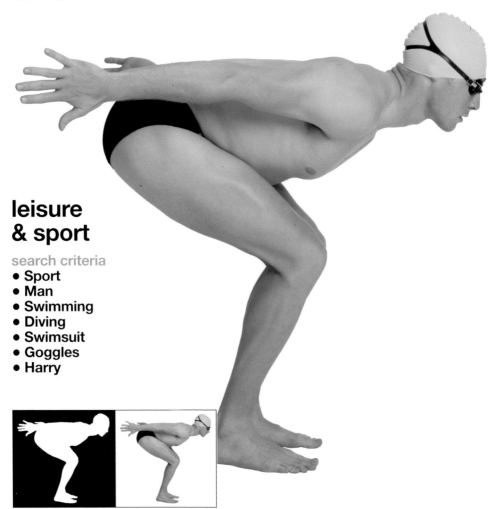

leisure & sport

search criteria
- **Sport**
- **Man**
- **Swimming**
- **Diving**
- **Swimsuit**
- **Goggles**
- **Harry**

3113

size 167 x 299 mm
6.56 x 11.77 inches
1,968 x 3,532 pixels
resolution 300 ppi
mode RGB

leisure
& sport

search criteria
- **Sport**
- **Man**
- **Swimming**
- **Diving**
- **Goggles**
- **Harry**

3114

size 152 x 320 mm
 6 x 12.61 inches
 1,800 x 3,784 pixels
resolution 300 ppi
mode RGB

leisure
& sport

search criteria
- Sport
- Woman
- Swimming
- Diving
- Goggles
- Swimsuit
- Mary

3115

size 174 x 321 mm
6.84 x 12.63 inches
2,052 x 3,790 pixels
resolution 300 ppi
mode RGB

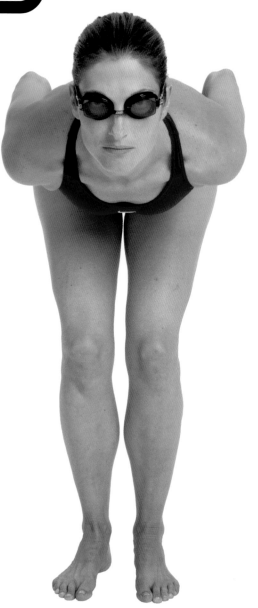

leisure
& sport

search criteria
- **Sport**
- **Woman**
- **Swimming**
- **Diving**
- **Goggles**
- **Swimsuit**
- **Mary**

3116

size 252 x 222 mm
9.91 x 8.74 inches
2,974 x 2,621 pixels
resolution 300 ppi
mode RGB

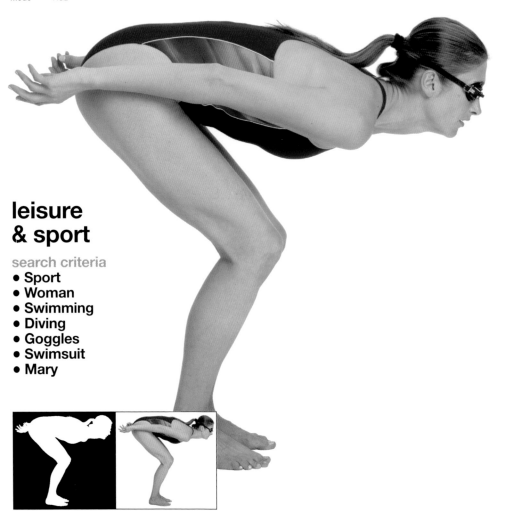

leisure
& sport

search criteria
- Sport
- Woman
- Swimming
- Diving
- Goggles
- Swimsuit
- Mary

3117

size	207 x 220 mm
	8.16 x 8.67 inches
	2,448 x 2,602 pixels
resolution	300 ppi
mode	RGB

leisure
& sport

search criteria
- Sport
- Man
- Cricket
- Wicketkeeper
- Pads
- Gloves
- Ryan

3118

size 185 x 312 mm
7.3 x 12.27 inches
2,190 x 3,682 pixels
resolution 300 ppi
mode RGB

leisure & sport

search criteria
- Sport
- Man
- Cricket
- Batsman
- Bat
- Pads
- Helmet
- Ryan

3119

size 151 x 326 mm
8.96 x 12.83 inches
1,788 x 3,850 pixels
resolution 300 ppi
mode RGB

leisure
& sport

search criteria
- **Sport**
- **Man**
- **Cricket**
- **Batsman**
- **Bat**
- **Helmet**
- **Pads**
- **Dexter**

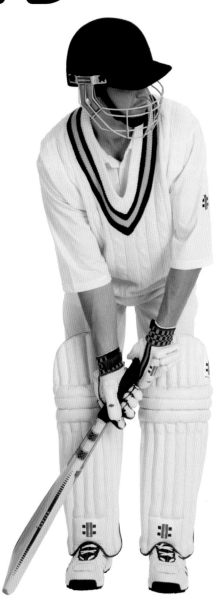

3120

size 177 x 339 mm
9.98 x 13.35 inches
2,094 x 4,005 pixels
resolution 300 ppi
mode RGB

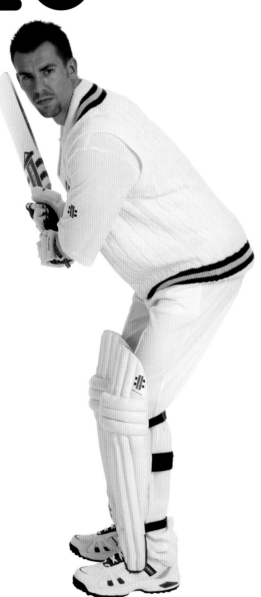

leisure & sport

search criteria
- **Sport**
- **Man**
- **Cricket**
- **Batsman**
- **Bat**
- **Pads**
- **Dexter**

3121

size 164 x 335 mm
6.44 x 13.17 inches
1,932 x 3,951 pixels
resolution 300 ppi
mode RGB

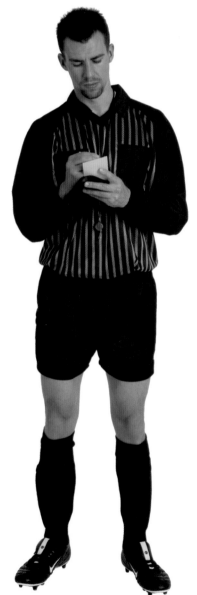

leisure
& sport

search criteria
- Sport
- Man
- Soccer
- Referee
- Yellow card
- Booking
- Foul
- Dexter

3122

size 153 x 339 mm
6.04 x 13.33 inches
1,812 x 3,999 pixels
resolution 300 ppi
mode RGB

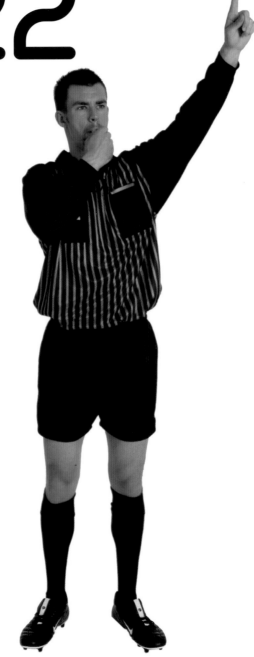

leisure
& sport

search criteria
- Sport
- Man
- Soccer
- Referee
- Whistle
- Foul
- Dexter

3123

size 132 x 339 mm
5.2 x 13.35 inches
1,560 x 4,005 pixels
resolution 300 ppi
mode RGB

leisure
& sport

search criteria
- Sport
- Man
- Soccer
- Referee
- Red card
- Sent off
- Foul
- Dexter

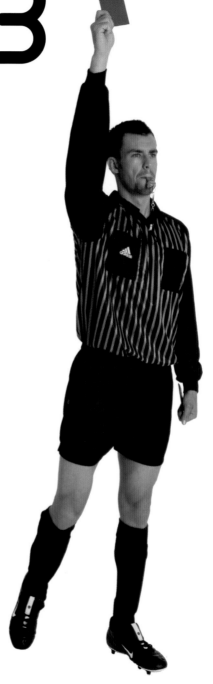

3124

size 156 x 334 mm
6.14 x 13.13 inches
1,842 x 3,939 pixels
resolution 300 ppi
mode RGB

leisure & sport

search criteria
- Sport
- Man
- Soccer
- Referee
- Red card
- Sent off
- Foul
- Ryan

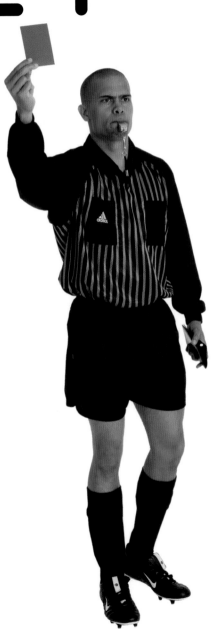

3125

size 153 x 334 mm
6.02 x 13.15 inches
1,805 x 3,946 pixels
resolution 300 ppi
mode RGB

leisure
& sport

search criteria
- Sport
- Man
- Soccer
- Football
- Boots
- Dexter

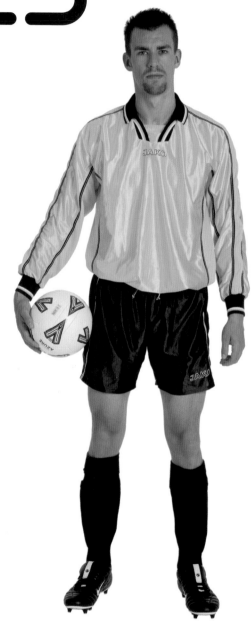

3126

size 214 x 260 mm
8.42 x 10.25 inches
2,525 x 3,076 pixels
resolution 300 ppi
mode RGB

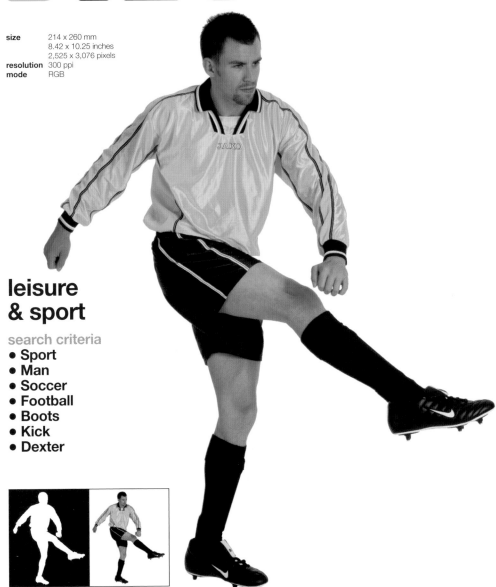

leisure
& sport

search criteria
- **Sport**
- **Man**
- **Soccer**
- **Football**
- **Boots**
- **Kick**
- **Dexter**

3127

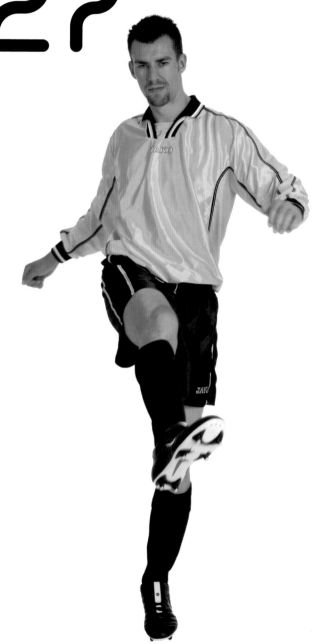

size 129 x 251 mm
5.08 x 9.87 inches
1,524 x 2,962 pixels
resolution 300 ppi
mode RGB

leisure
& sport

search criteria
- Sport
- Man
- Soccer
- Football
- Boots
- Kick
- Dexter

3128

size 162 x 339 mm
6.36 x 13.35 inches
1,908 x 4,004 pixels
resolution 300 ppi
mode RGB

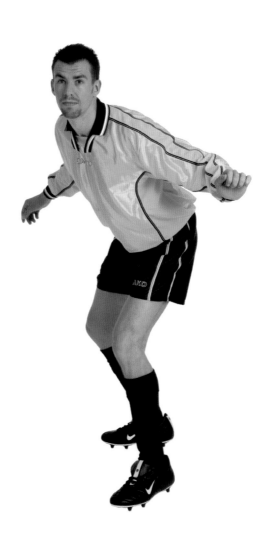

leisure & sport

search criteria
- Sport
- Man
- Soccer
- Football
- Boots
- Header
- Dexter

3129

size 173 x 332 mm
6.8 x 13.07 inches
2,040 x 3,922 pixels
resolution 300 ppi
mode RGB

leisure & sport

search criteria
- Sport
- Man
- Soccer
- Football
- Boots
- Ryan

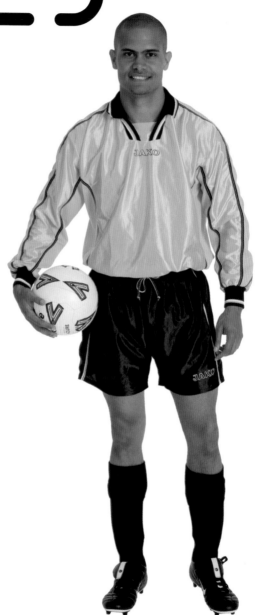

3130

size 125 x 325 mm
4.92 x 12.81 inches
1,476 x 3,844 pixels
resolution 300 ppi
mode RGB

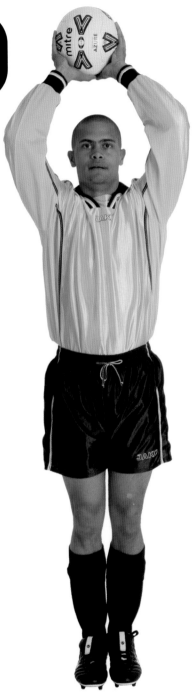

leisure & sport

search criteria
- Sport
- Man
- Soccer
- Football
- Boots
- Throw-in
- Ryan

3131

size 213 x 239 mm
8.38 x 9.39 inches
2,514 x 2,818 pixels
resolution 300 ppi
mode RGB

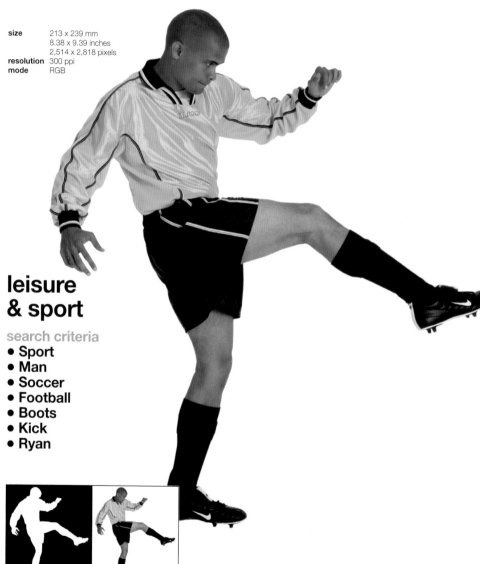

leisure & sport

search criteria
- Sport
- Man
- Soccer
- Football
- Boots
- Kick
- Ryan

3132

size 163 x 261 mm
6.42 x 10.29 inches
1,926 x 3,088 pixels
resolution 300 ppi
mode RGB

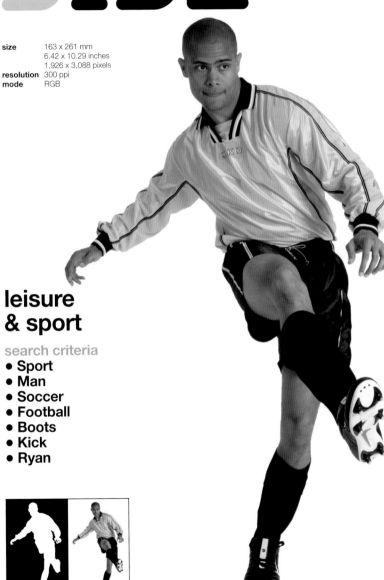

leisure
& sport

search criteria
- Sport
- Man
- Soccer
- Football
- Boots
- Kick
- Ryan

3133

size 160 x 328 mm
6.3 x 12.91 inches
1,890 x 3,874 pixels
resolution 300 ppi
mode RGB

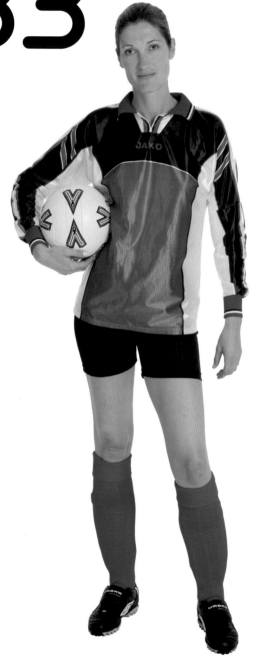

leisure
& sport

search criteria
- Sport
- Woman
- Soccer
- Football
- Boots
- Mary

3134

size 181 x 326 mm
7.14 x 12.85 inches
2,142 x 3,856 pixels
resolution 300 ppi
mode RGB

leisure
& sport

search criteria
- Sport
- Woman
- Soccer
- Football
- Boots
- Kick
- Mary

3135

size 160 x 312 mm
6.3 x 12.29 inches
1,890 x 3,688 pixels
resolution 300 ppi
mode RGB

leisure & sport

search criteria
- Sport
- Man
- Field hockey
- Stick
- Ball
- Harry

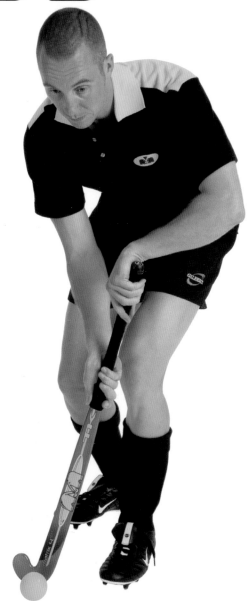

3136

size 208 x 258 mm
8.18 x 10.17 inches
2,454 x 3,052 pixels
resolution 300 ppi
mode RGB

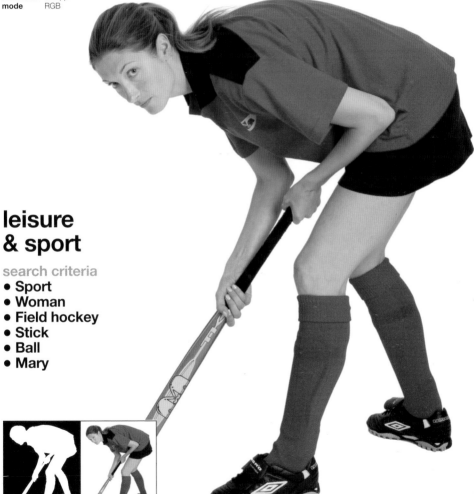

leisure
& sport

search criteria
- Sport
- Woman
- Field hockey
- Stick
- Ball
- Mary

3137

size 146 x 333 mm
5.74 x 13.11 inches
1,722 x 3,933 pixels
resolution 300 ppi
mode RGB

leisure & sport

search criteria
- Sport
- Man
- Rugby
- Ball
- Boots
- Ryan

3138

size 168 x 339 mm
6.62 x 13.33 inches
1,986 x 3,999 pixels
resolution 300 ppi
mode RGB

leisure
& sport

search criteria
- **Sport**
- **Man**
- **Rugby**
- **Ball**
- **Boots**
- **Helmet**
- **Harry**

3139

size 187 x 299 mm
7.38 x 11.77 inches
2,214 x 3,532 pixels
resolution 300 ppi
mode RGB

leisure
& sport

search criteria
- Sport
- Man
- Rugby
- Ball
- Boots
- Mouthpiece
- Helmet
- Harry

3140

size 229 x 264 mm
9.01 x 10.39 inches
2,704 x 3,118 pixels
resolution 300 ppi
mode RGB

leisure & sport

search criteria
- Sport
- Man
- Rugby
- Ball
- Boots
- Mouthpiece
- Helmet
- Push
- Harry

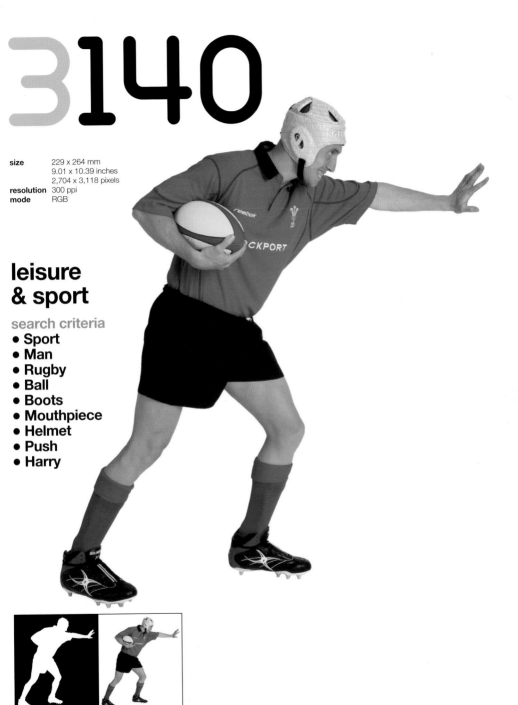

3141

size 141 x 278 mm
5.54 x 10.93 inches
1,662 x 3,280 pixels
resolution 300 ppi
mode RGB

leisure
& sport

search criteria
- Sport
- Man
- Rugby
- Ball
- Boots
- Helmet
- Running
- Ryan

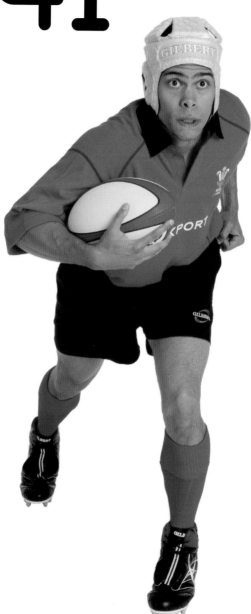

3142

size 218 x 271 mm
8.58 x 10.65 inches
2,574 x 3,196 pixels
resolution 300 ppi
mode RGB

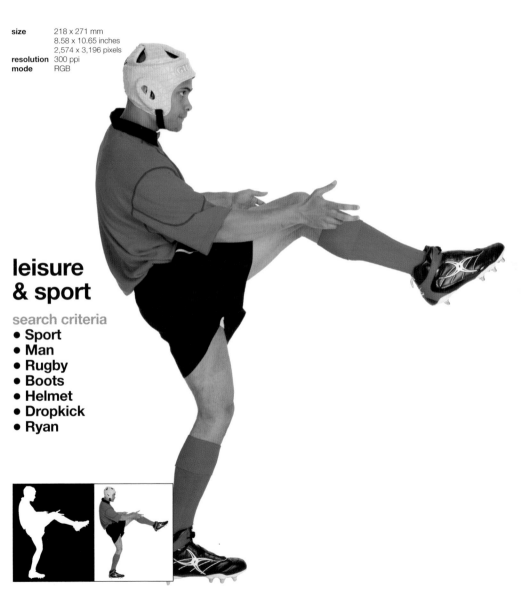

leisure & sport

search criteria
- Sport
- Man
- Rugby
- Boots
- Helmet
- Dropkick
- Ryan

3143

size 222 x 228 mm
8.74 x 8.97 inches
2,621 x 2,692 pixels
resolution 300 ppi
mode RGB

leisure & sport

search criteria
- Sport
- Man
- Athletics
- Sprint
- Running
- Start
- Blocks
- Ryan

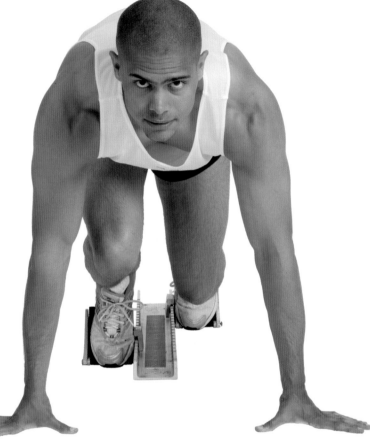

3144

size 160 x 280 mm
6.3 x 11.03 inches
1,890 x 3,310 pixels
resolution 300 ppi
mode RGB

leisure & sport

search criteria
- Sport
- Man
- Athletics
- Sprint
- Running
- Ryan

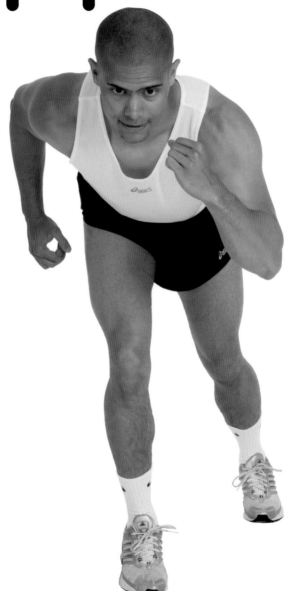

3145

size 154 x 326 mm
 6.06 x 12.83 inches
 1,818 x 3,850 pixels
resolution 300 ppi
mode RGB

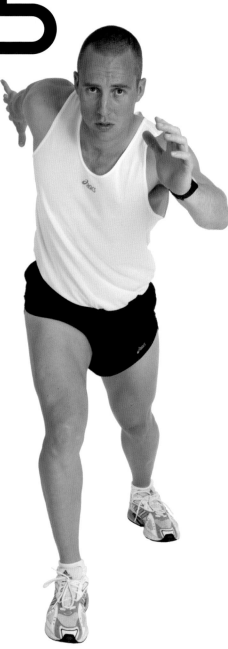

leisure
& sport

search criteria
- **Sport**
- **Man**
- **Athletics**
- **Sprint**
- **Running**
- **Harry**

3146

size 213 x 282 mm
8.38 x 11.11 inches
2,514 x 3,334 pixels
resolution 300 ppi
mode RGB

leisure
& sport

search criteria
- **Sport**
- **Man**
- **Athletics**
- **Sprint**
- **Running**
- **Winning**
- **Ryan**

3147

size 315 x 216 mm
12.41 x 8.52 inches
3,724 x 2,556 pixels
resolution 300 ppi
mode RGB

leisure
& sport

search criteria
- Sport
- Woman
- Athletics
- Sprint
- Running
- Start
- Blocks
- Mary

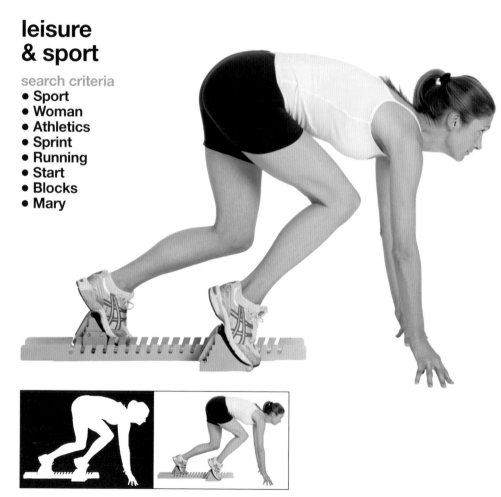

3148

size 237 x 277 mm
 9.33 x 10.89 inches
 2,800 x 3,268 pixels
resolution 300 ppi
mode RGB

leisure
& sport

search criteria
- **Sport**
- **Woman**
- **Athletics**
- **Sprint**
- **Running**
- **Winning**
- **Mary**

3149

size 179 x 290 mm
7.06 x 11.43 inches
2,118 x 3,430 pixels
resolution 300 ppi
mode RGB

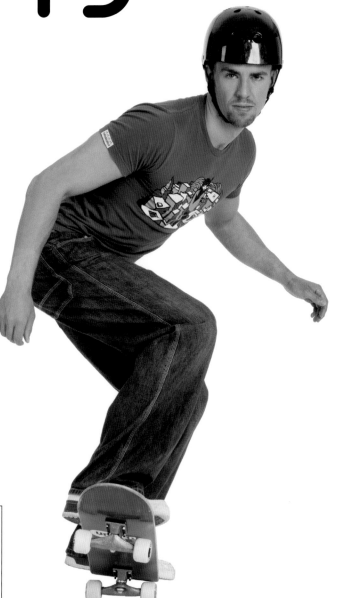

leisure
& sport

search criteria
- **Sport**
- **Man**
- **Skateboard**
- **Helmet**
- **Dexter**

3150

size 208 x 322 mm
8.18 x 12.67 inches
2,454 x 3,802 pixels
resolution 300 ppi
mode RGB

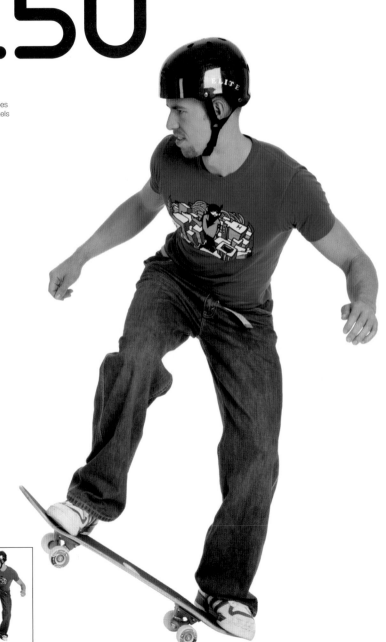

leisure
& sport

search criteria
- **Sport**
- **Man**
- **Skateboard**
- **Helmet**
- **Dexter**

3151

size 148 x 323 mm
5.82 x 12.73 inches
1,746 x 3,820 pixels
resolution 300 ppi
mode RGB

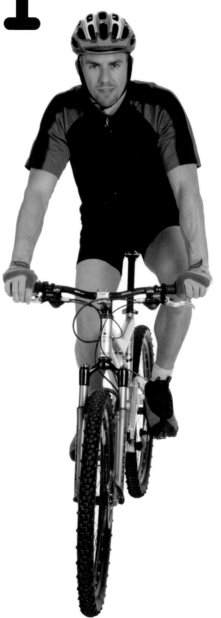

leisure
& sport

search criteria
- **Sport**
- **Man**
- **Cycling**
- **Helmet**
- **Bike**
- **Dexter**

3152

size 229 x 283 mm
9.01 x 11.13 inches
2,704 x 3,340 pixels
resolution 300 ppi
mode RGB

leisure & sport

search criteria
- **Sport**
- **Man**
- **Cycling**
- **Helmet**
- **Bike**
- **Dexter**

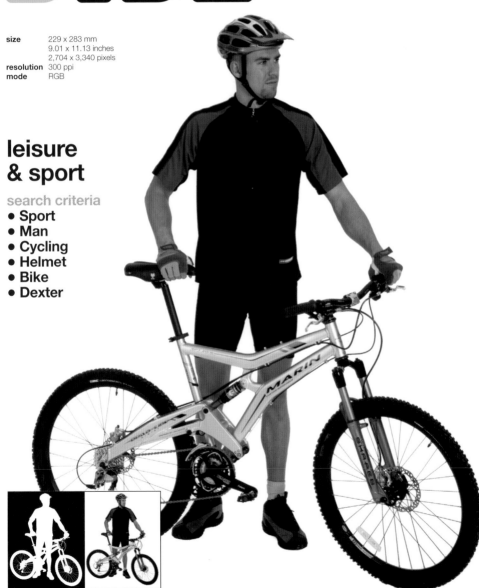

3153

size 134 x 297 mm
5.28 x 11.69 inches
1,584 x 3,508 pixels
resolution 300 ppi
mode RGB

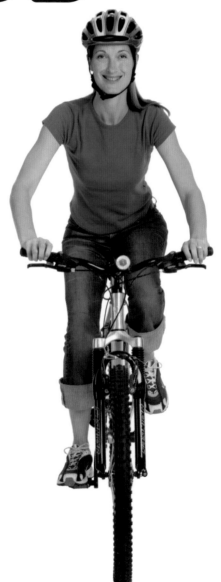

leisure
& sport

search criteria
- **Sport**
- **Woman**
- **Cycling**
- **Helmet**
- **Bike**
- **Riding**
- **Mary**

3154

size 229 x 253 mm
9.01 x 9.97 inches
2,704 x 2,992 pixels
resolution 300 ppi
mode RGB

leisure
& sport

search criteria
- Sport
- Woman
- Cycling
- Helmet
- Bike
- Mary

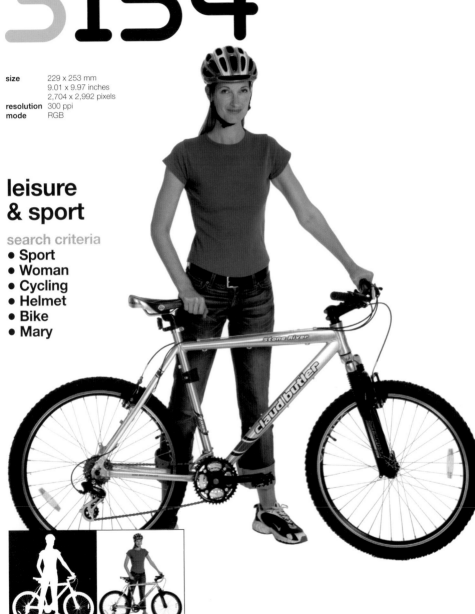

3155

size 203 x 253 mm
8 x 9.97 inches
2,399 x 2,992 pixels
resolution 300 ppi
mode RGB

leisure
& sport

search criteria
- Sport
- Woman
- Cycling
- Helmet
- Bike
- Riding
- Mary

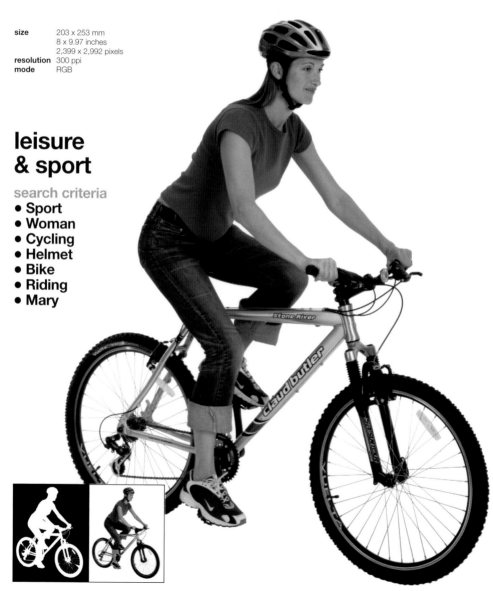

3156

size 279 x 210 mm
11 x 8.28 inches
3,300 x 2,484 pixels
resolution 300 ppi
mode RGB

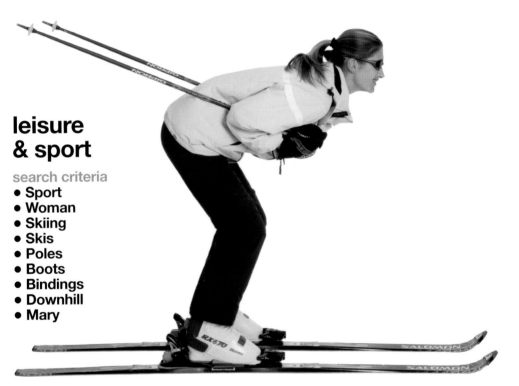

leisure
& sport

search criteria
- **Sport**
- **Woman**
- **Skiing**
- **Skis**
- **Poles**
- **Boots**
- **Bindings**
- **Downhill**
- **Mary**

3157

size 193 x 324 mm
7.6 x 12.75 inches
2,280 x 3,826 pixels
resolution 300 ppi
mode RGB

leisure
& sport

search criteria
- Sport
- Woman
- Skiing
- Skis
- Boots
- Poles
- Sunglasses
- Mary

3158

size 183 x 321 mm
7.2 x 12.65 inches
2,160 x 3,796 pixels
resolution 300 ppi
mode RGB

leisure & sport

search criteria
- Sport
- Woman
- Skiing
- Skis
- Boots
- Poles
- Mary

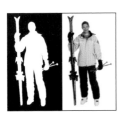

3161

size 170 x 337 mm
6.7 x 13.27 inches
2,010 x 3,981 pixels
resolution 300 ppi
mode RGB

leisure & sport

search criteria
- **Sport**
- **Man**
- **Skiing**
- **Skis**
- **Poles**
- **Boots**
- **Bindings**
- **Dexter**

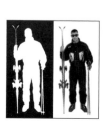

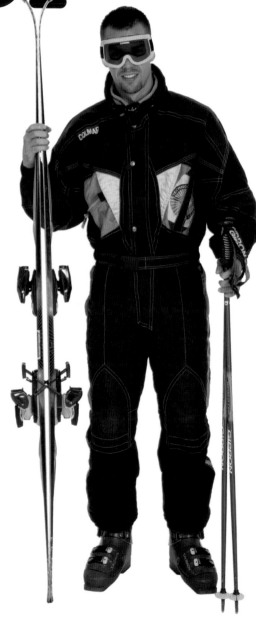

3162

size 219 x 251 mm
8.62 x 9.87 inches
2,585 x 2,962 pixels
resolution 300 ppi
mode RGB

leisure & sport

search criteria
- Sport
- Woman
- Bowling
- Ball
- 10-pin
- Mary

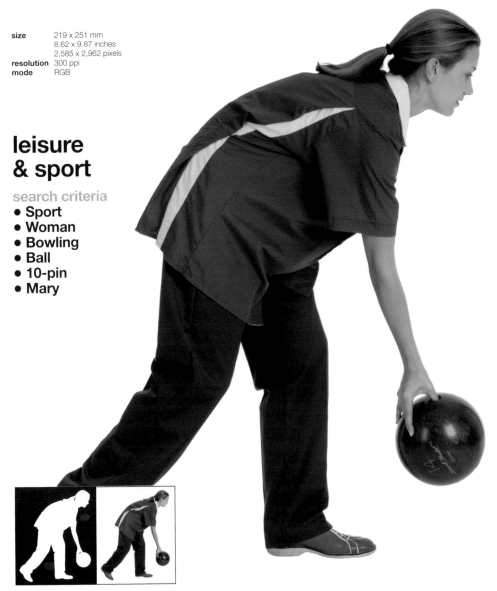

3163

size 223 x 231 mm
8.76 x 9.10 inches
2,628 x 2,729 pixels
resolution 300 ppi
mode RGB

leisure & sport

search criteria
- **Sport**
- **Man**
- **Bowling**
- **Ball**
- **10-pin**
- **Dexter**

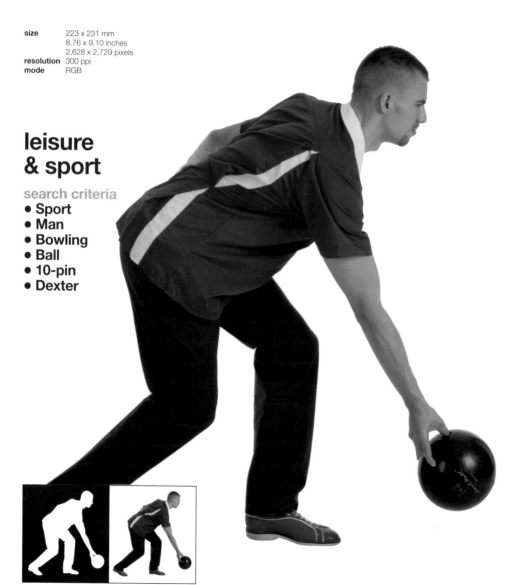

3164

size 289 x 184 mm
11.39 x 7.24 inches
3,418 x 2,171 pixels
resolution 300 ppi
mode RGB

leisure & sport

search criteria
- Sport
- Man
- Bowling
- Ball
- Dexter

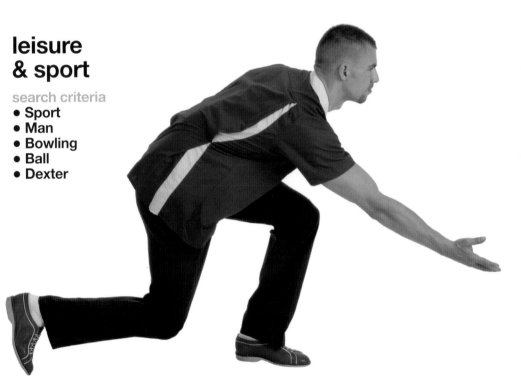

3165

size 161 x 326 mm
6.34 x 12.85 inches
1,902 x 3,856 pixels
resolution 300 ppi
mode RGB

leisure
& sport

search criteria
- Sport
- Man
- Baseball
- Batter
- Ball
- Helmet
- Dexter

3166

size 201 x 331 mm
7.90 x 13.03 inches
2,370 x 3,909 pixels
resolution 300 ppi
mode RGB

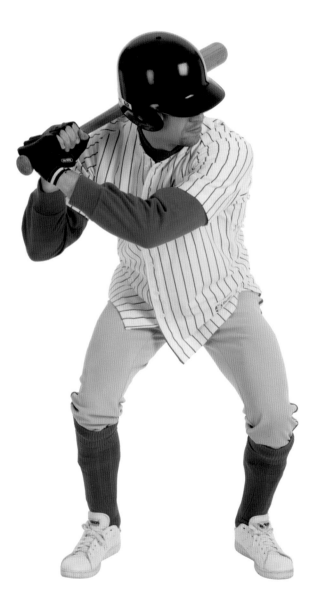

leisure
& sport

search criteria
- **Sport**
- **Man**
- **Baseball**
- **Batter**
- **Batting**
- **Helmet**
- **Dexter**

3167

size 196 x 333 mm
7.72 x 13.11 inches
2,316 x 3,933 pixels
resolution 300 ppi
mode RGB

leisure & sport

search criteria
- Sport
- Man
- Baseball
- Batter
- Batting
- Helmet
- Dexter

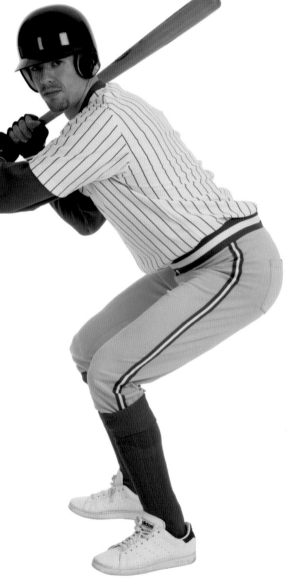

3168

size 140 x 294 mm
5.52 x 11.59 inches
1,656 x 3,478 pixels
resolution 300 ppi
mode RGB

leisure & sport

search criteria
- **Sport**
- **Man**
- **Baseball**
- **Pitcher**
- **Ball**
- **Dexter**

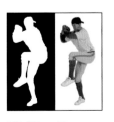

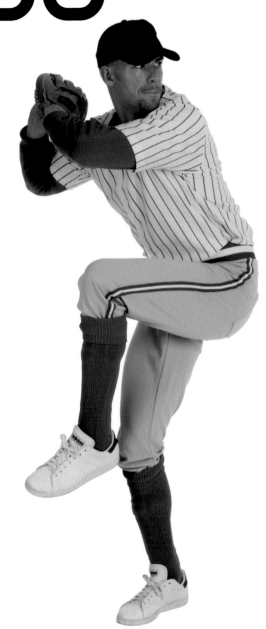

3169

size 192 x 314 mm
7.54 x 12.37 inches
2,262 x 3,712 pixels
resolution 300 ppi
mode RGB

leisure
& sport

search criteria
- **Sport**
- **Man**
- **Football**
- **Helmet**
- **Dexter**

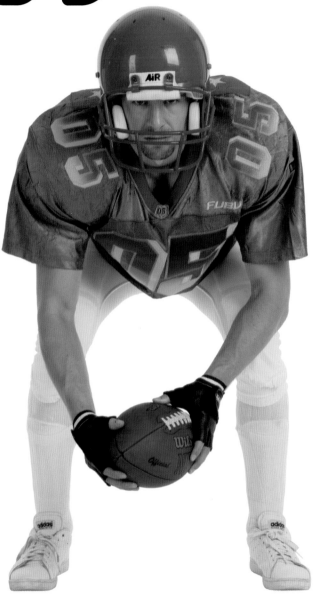

3170

size 186 x 307 mm
7.32 x 12.07 inches
2,196 x 3,622 pixels
resolution 300 ppi
mode RGB

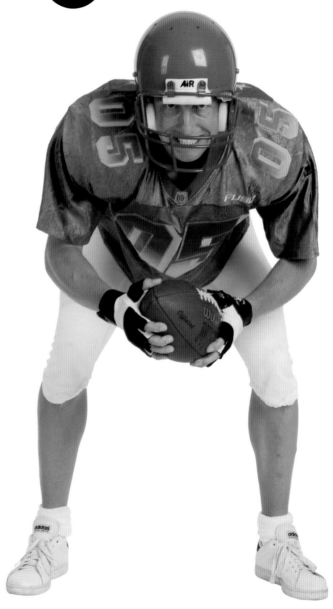

leisure
& sport

search criteria
- **Sport**
- **Man**
- **Football**
- **Helmet**
- **Harry**

3171

size 194 x 298 mm
7.64 x 11.71 inches
2,292 x 3,514 pixels
resolution 300 ppi
mode RGB

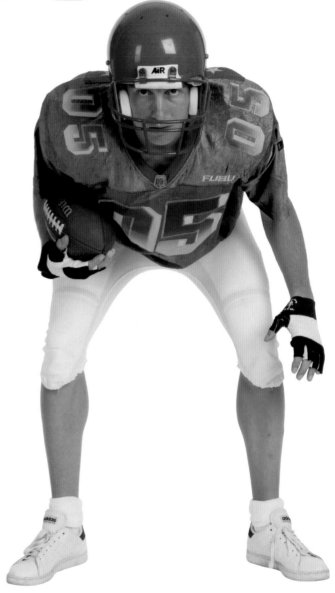

leisure
& sport

search criteria
- **Sport**
- **Man**
- **Football**
- **Helmet**
- **Harry**

3172

size 219 x 288 mm
8.62 x 11.33 inches
2,586 x 3,400 pixels
resolution 300 ppi
mode RGB

leisure & sport

search criteria
- Sport
- Man
- Football
- Helmet
- Dexter

4173

size 206 x 336 mm
 8.12 x 13.23 inches
 2,436 x 3,969 pixels
resolution 300 ppi
mode RGB

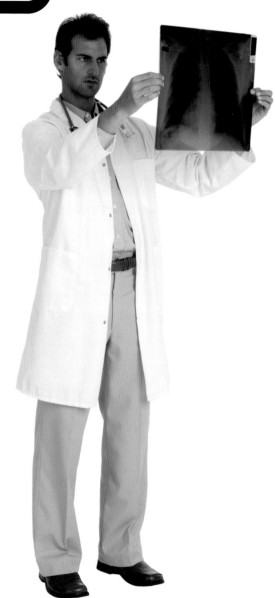

health & medical

search criteria
- **Doctor**
- **X-ray**
- **White coat**
- **Stethoscope**
- **Lung**
- **Jonathan**

4174

size 163 x 303 mm
6.42 x 11.93 inches
1,926 x 3,580 pixels
resolution 300 ppi
mode RGB

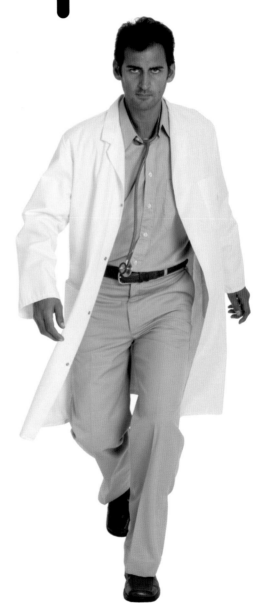

health & medical

search criteria
- **Doctor**
- **Running**
- **Emergency**
- **Stethoscope**
- **White coat**
- **Jonathan**

4175

size 229 x 344 mm
9.01 x 13.55 inches
2,704 x 4064 pixels
resolution 300 ppi
mode RGB

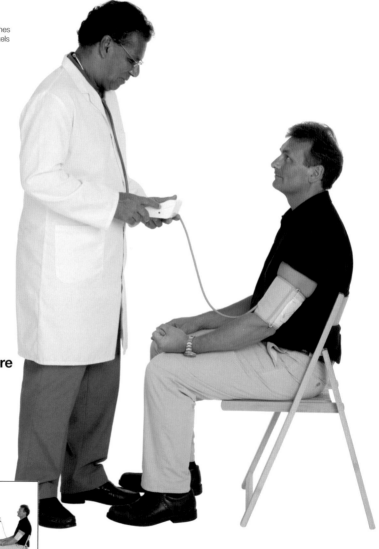

health &
medical

search criteria

- Doctor
- Patient
- Blood pressure
- Test
- Hospital
- Checkup
- Vikas
- Nigel

4176

size 229 x 279 mm
9.01 x 10.99 inches
2,704 x 3,298 pixels
resolution 300 ppi
mode RGB

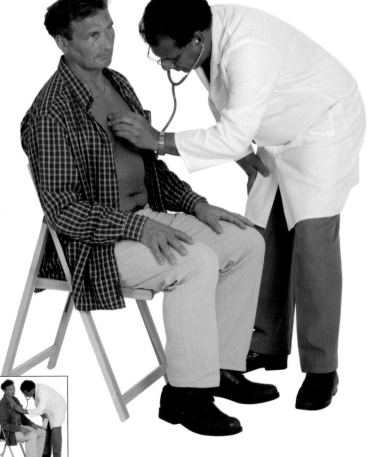

health & medical

search criteria
- **Doctor**
- **Patient**
- **Heartbeat**
- **Test**
- **Hospital**
- **Checkup**
- **Vikas**
- **Nigel**

4177

size 224 x 318 mm
8.84 x 12.51 inches
2,651 x 3,753 pixels
resolution 300 ppi
mode RGB

health & medical

search criteria
- Doctor
- Patient
- Injection
- Syringe
- Immunize
- Surgery
- Vikas
- Nigel

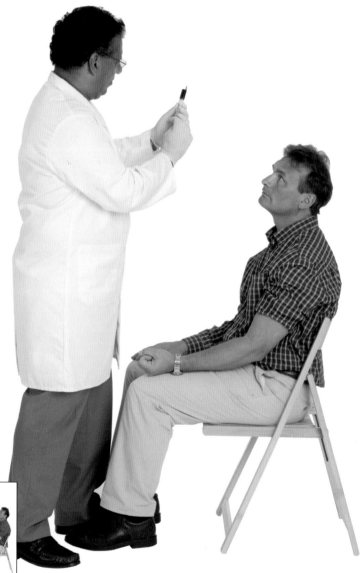

4178

size 145 x 339 mm
5.72 x 13.35 inches
1,716 x 4,005 pixels
resolution 300 ppi
mode RGB

health & medical

search criteria
- **Nurse**
- **Surgery**
- **Syringe**
- **Uniform**
- **Checkup**
- **Mary**

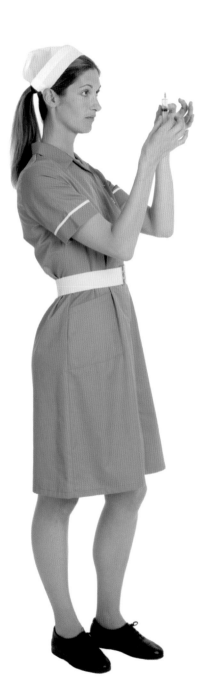

4179

size 150 x 339 mm
5.9 x 13.35 inches
1,770 x 4,005 pixels
resolution 300 ppi
mode RGB

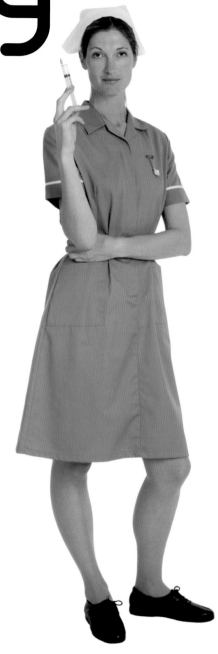

health & medical

search criteria
- **Nurse**
- **Surgery**
- **Syringe**
- **Checkup**
- **Uniform**
- **Waiting**
- **Mary**

4180

size 153 x 344 mm
6.02 x 13.55 inches
1,806 x 4,064 pixels
resolution 300 ppi
mode RGB

health & medical

search criteria
- **Nurse**
- **Doctor**
- **Surgery**
- **Syringe**
- **Checkup**
- **Beth**

4181

size 168 x 338 mm
6.62 x 13.31 inches
1,986 x 3,993 pixels
resolution 300 ppi
mode RGB

health & medical

search criteria
- **Nurse**
- **Doctor**
- **Surgery**
- **Rubber gloves**
- **Clean**
- **Preparation**
- **Beth**

5182

size 229 x 287 mm
9.01 x 11.29 inches
2,704 x 3,387 pixels
resolution 300 ppi
mode RGB

business

search criteria

- Boss
- Desk
- Phone
- Computer
- Tickets
- Travel
- Chair
- Magazines
- Peter

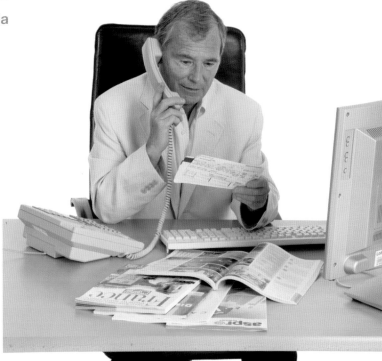

5183

size 229 x 314 mm
12.37 x 9.01 inches
3,712 x 2,704 pixels
resolution 300 ppi
mode RGB

business

search criteria
- Computer
- Laptop
- Desk
- Happy
- Ben
- Janet

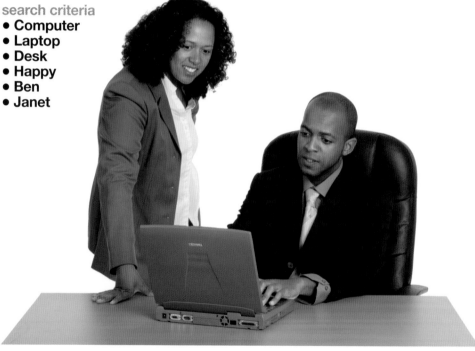

5184

size 311 x 222 mm
12.25 x 8.76 inches
3,676 x 2,627 pixels
resolution 300 ppi
mode RGB

business

search criteria
- Computer
- Laptop
- Desk
- Glasses
- Concern
- Ben
- Janet

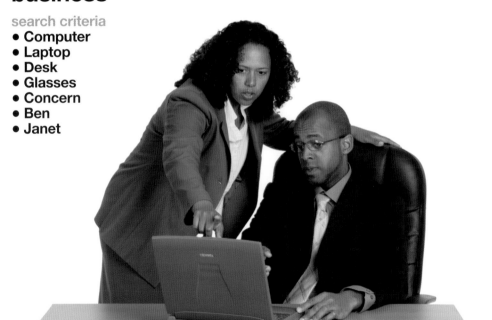

5185

size 328 x 223 mm
12.91 x 8.78 inches
3,873 x 2,633 pixels
resolution 300 ppi
mode RGB

business

search criteria
- Computer
- Laptop
- Desk
- Glasses
- Ben
- Janet

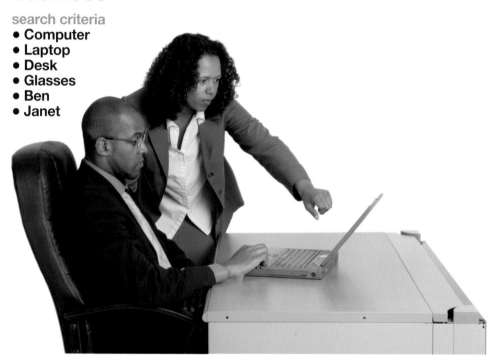

5186

size 297 x 222 mm
11.67 x 8.76 inches
3,502 x 2,627 pixels
resolution 300 ppi
mode RGB

business

search criteria

- Computer
- Laptop
- Desk
- Ben
- Janet
- Back

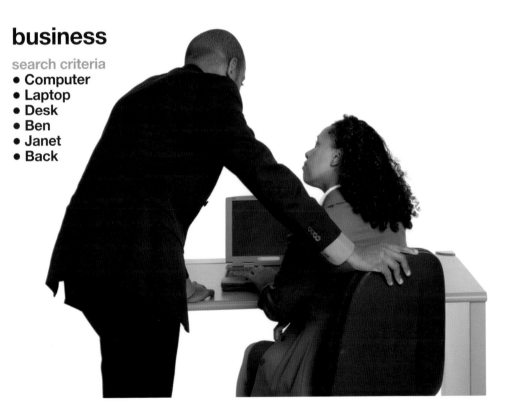

5187

size 324 x 184 mm
12.75 x 7.26 inches
3,826 x 2,177 pixels
resolution 300 ppi
mode RGB

business

search criteria
- Computer
- Monitor
- Unhappy
- Desk
- Janet

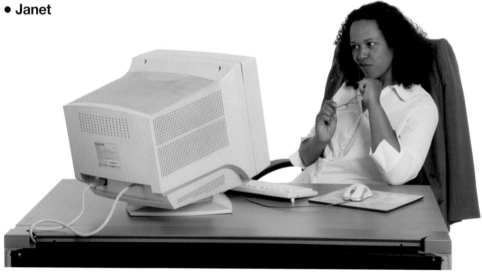

5188

size 308 x 190 mm
 12.13 x 7.48 inches
 3,604 x 2,243 pixels
resolution 300 ppi
mode RGB

business

search criteria
- Call center
- Phone
- Computer
- Happy
- Desk
- Janet

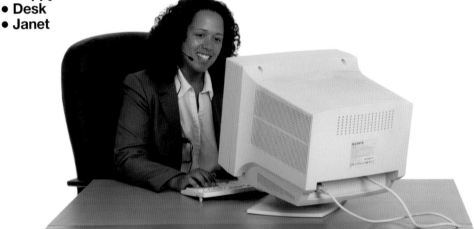

5189

size 229 x 230 mm
9.01 x 9.05 inches
2,704 x 2,716 pixels
resolution 300 ppi
mode RGB

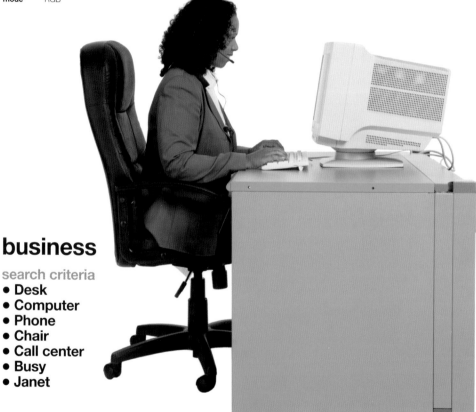

business

search criteria
- **Desk**
- **Computer**
- **Phone**
- **Chair**
- **Call center**
- **Busy**
- **Janet**

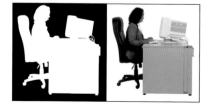

5190

size 339 x 224 mm
 13.33 x 8.84 inches
 3,999 x 2,651 pixels
resolution 300 ppi
mode RGB

business

search criteria

- Desk
- Computer
- Phone
- Call center
- Busy
- Janet

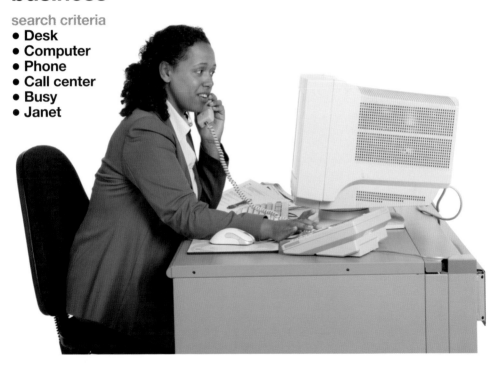

5191

size 335 x 187 mm
13.19 x 7.36 inches
3,957 x 2,207 pixels
resolution 300 ppi
mode RGB

business

search criteria
- **Desk**
- **Computer**
- **Phone**
- **Chair**
- **Busy**
- **Suit**
- **Ben**

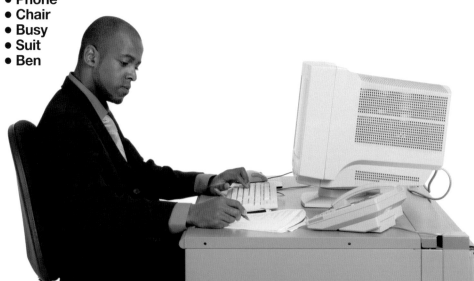

5192

size 329 x 180 mm
12.97 x 7.1 inches
3,891 x 2,129 pixels
resolution 300 ppi
mode RGB

business

search criteria

- Computer
- Desk
- Phone
- Mouse
- Busy
- Shirt
- Ben

5193

size 312 x 202 mm
12.29 x 7.96 inches
3,688 x 2,387 pixels
resolution 300 ppi
mode RGB

business

search criteria
- Boss
- Desk
- Computer
- Laptop
- Pointing
- Peter
- Steve

5194

size 294 x 208 mm
11.57 x 8.18 inches
3,472 x 2,453 pixels
resolution 300 ppi
mode RGB

business

search criteria

- Boss
- Desk
- Computer
- Laptop
- Pointing
- Peter
- Steve

5195

size 287 x 188 mm
 11.29 x 7.4 inches
 3,388 x 2,219 pixels
resolution 300 ppi
mode RGB

business

search criteria
- Boss
- Desk
- Computer
- Laptop
- Talking
- Sue
- Steve

5196

size 328 x 211 mm
 12.93 x 8.3 inches
 3,879 x 2,489 pixels
resolution 300 ppi
mode RGB

business

search criteria

- Boss
- Desk
- Computer
- Laptop
- Talking
- Sue
- Steve
- Back

5197

size 344 x 190 mm
13.55 x 7.48 inches
4,064 x 2,243 pixels
resolution 300 ppi
mode RGB

business

search criteria
- Table
- Interview
- Discuss
- Meet
- Notes
- Peter
- William

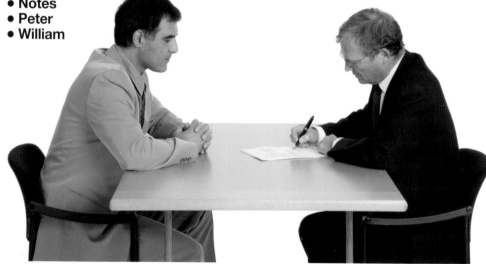

5198

size 344 x 192 mm
13.55 x 7.56 inches
4,064 x 2,267 pixels
resolution 300 ppi
mode RGB

business

search criteria

- Handshake
- Interview
- Discuss
- Table
- Meet
- Peter
- William

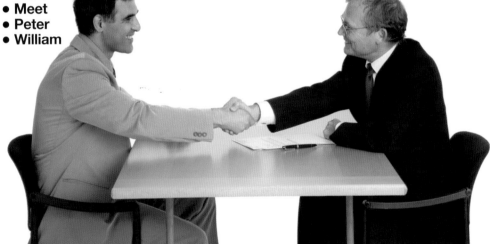

5199

size 305 x 229 mm
12.01 x 9.01 inches
3,603 x 2,704 pixels
resolution 300 ppi
mode RGB

business

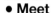
search criteria
- Meet
- Interview
- Handshake
- Notes
- Table
- Standing
- William
- Sue

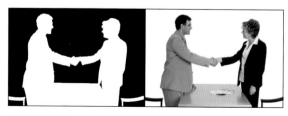

5200

size 332 x 229 mm
13.07 x 9.01 inches
3,921 x 2,704 pixels
resolution 300 ppi
mode RGB

business

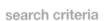

search criteria
- **Handshake**
- **Interview**
- **Standing**
- **Table**
- **Meet**
- **Ben**
- **Janet**

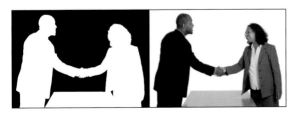

5201

size	333 x 147 mm
	13.13 x 5.8 inches
	3,938 x 1,739 pixels
resolution	300 ppi
mode	RGB

business

search criteria
- Debate
- Table
- Meet
- Discuss
- William
- Andrew

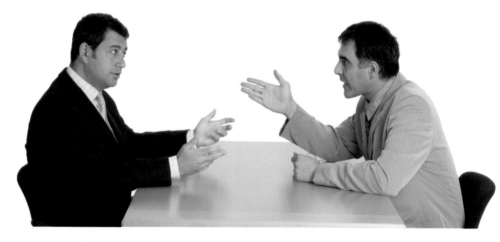

5202

size 334 x 150 mm
13.13 x 5.9 inches
3,940 x 1,769 pixels
resolution 300 ppi
mode RGB

business

search criteria

- Debate
- Discuss
- Table
- Meet
- Andrew
- Sue

5203

size 311 x 219 mm
 12.25 x 8.64 inches
 3,676 x 2,591 pixels
resolution 300 ppi
mode RGB

business

search criteria
- Standing
- Meet
- Table
- Surprise
- Shrug
- Ben
- Janet

5204

size 330 x 142 mm
 12.97 x 5.58 inches
 3,892 x 1,673 pixels
resolution 300 ppi
mode RGB

business

search criteria

- Document
- Examine
- Table
- Discuss
- Concentrate
- Read
- Andrew
- Peter

5205

size 332 x 146 mm
13.07 x 5.76 inches
3,922 x 1,727 pixels
resolution 300 ppi
mode RGB

business

search criteria
- **Document**
- **Ponder**
- **Smile**
- **Table**
- **Read**
- **Andrew**
- **Peter**

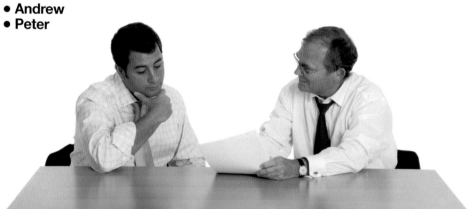

5206

size 344 x 155 mm
13.55 x 6.12 inches
4,064 x 1,835 pixels
resolution 300 ppi
mode RGB

business

search criteria
- Document
- Read
- Smile
- Table
- Andrew
- Sue

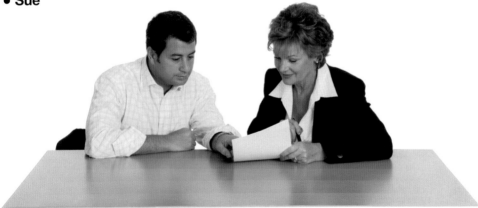

5207

size 322 x 195 mm
12.69 x 7.68 inches
3,808 x 2,303 pixels
resolution 300 ppi
mode RGB

business

search criteria

- Satisfied
- Pleased
- Computer
- Desk
- Leaning
- Chair
- Finished
- Kelly

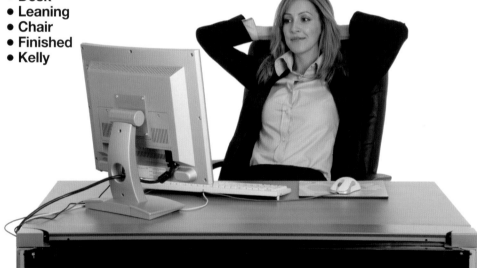

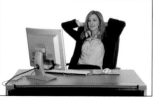

5208

size 313 x 189 mm
12.33 x 7.46 inches
3,700 x 2,237 pixels
resolution 300 ppi
mode RGB

business

search criteria

- Talking
- Phone
- Computer
- Desk
- Concentrate
- Call center
- Kelly

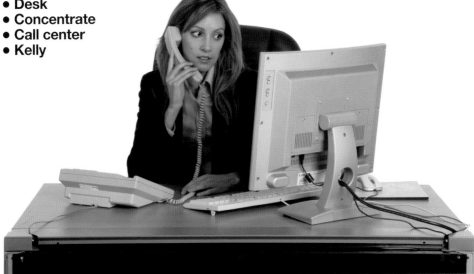

5209

size 301 x 204 mm
11.85 x 8.02 inches
3,556 x 2,405 pixels
resolution 300 ppi
mode RGB

business

search criteria

- Smile
- Talking
- Phone
- Desk
- Call center
- Computer
- Kelly

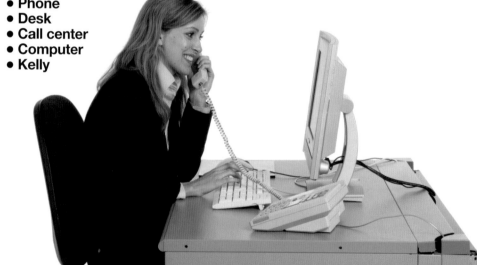

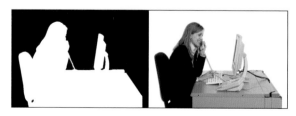

5210

size 312 x 207 mm
12.29 x 8.16 inches
3,688 x 2,447 pixels
resolution 300 ppi
mode RGB

business

search criteria

- Talking
- Typing
- Call center
- Computer
- Phone
- Kelly

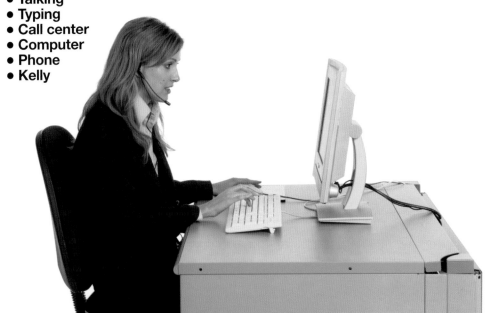

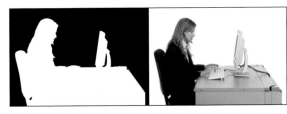

5211

size	324 x 192 mm
	12.75 x 7.58 inches
	3,826 x 2,273 pixels
resolution	300 ppi
mode	RGB

business

search criteria
- Finished
- Desk
- Relaxing
- Peter

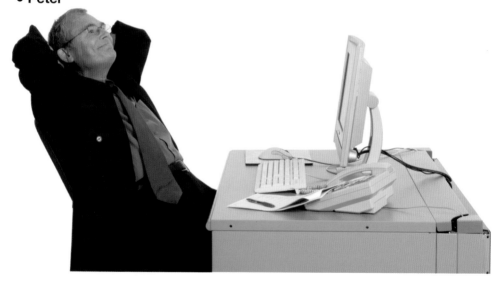

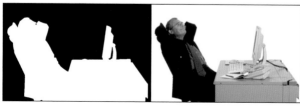

5212

size	321 x 201 mm
	12.63 x 7.9 inches
	3,790 x 2,369 pixels
resolution	300 ppi
mode	RGB

business

search criteria

- Typing
- Reading
- Desk
- Concentrating
- Computer
- Phone
- Peter

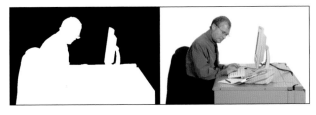

5213

size 317 x 193 mm
12.47 x 7.60 inches
3,742 x 2,279 pixels
resolution 300 ppi
mode RGB

business

search criteria
- Finished
- Relaxing
- Computer
- Desk
- Leaning
- Happy
- Sue

5214

size 326 x 184 mm
12.83 x 7.24 inches
3,850 x 2,171 pixels
resolution 300 ppi
mode RGB

business

search criteria
- Boss
- Secretary
- PA
- Desk
- Notes
- Dictate
- Peter
- Sue

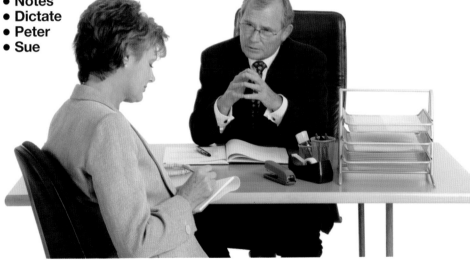

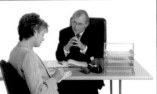

5215

size 322 x 217 mm
12.69 x 8.56 inches
3,808 x 2,567 pixels
resolution 300 ppi
mode RGB

business

search criteria
- **Desk**
- **Diary**
- **Phone**
- **Leaning**
- **Reading**
- **Pen**
- **Sue**
- **Peter**

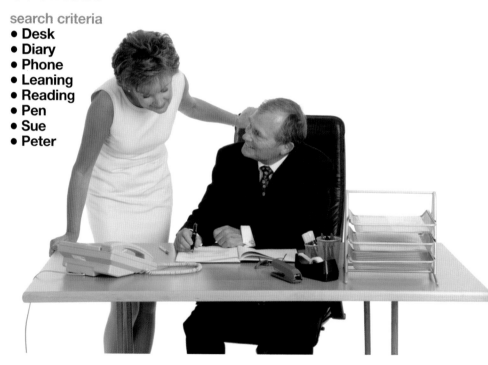

5216

size 191 x 315 mm
7.52 x 12.39 inches
2,256 x 3,718 pixels
resolution 300 ppi
mode RGB

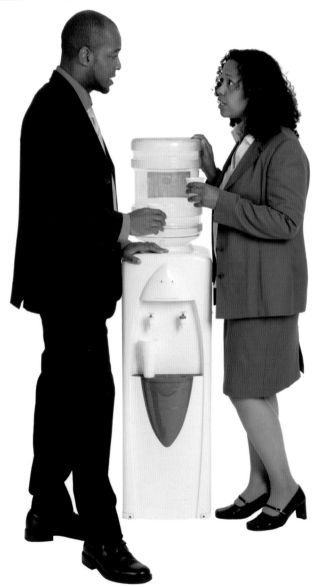

business

search criteria
- **Watercooler**
- **Surprise**
- **Gossip**
- **Chat**
- **Water**
- **Drink**
- **Ben**
- **Janet**

5217

size 223 x 301 mm
8.78 x 11.85 inches
2,633 x 3,556 pixels
resolution 300 ppi
mode RGB

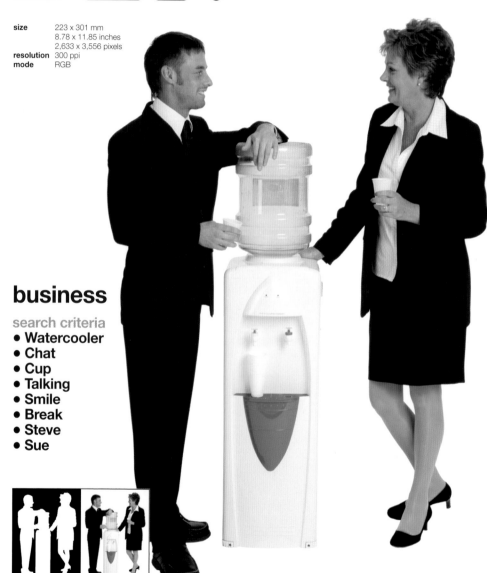

business

search criteria
- **Watercooler**
- **Chat**
- **Cup**
- **Talking**
- **Smile**
- **Break**
- **Steve**
- **Sue**

5218

size 219 x 290 mm
8.64 x 11.43 inches
2,592 x 3,430 pixels
resolution 300 ppi
mode RGB

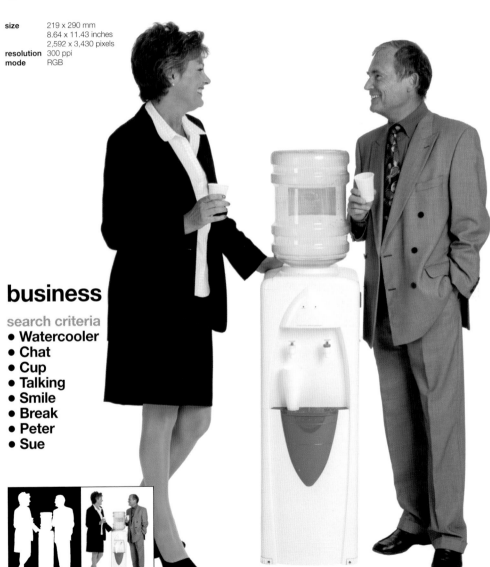

business

search criteria
- **Watercooler**
- **Chat**
- **Cup**
- **Talking**
- **Smile**
- **Break**
- **Peter**
- **Sue**

5219

size 204 x 304 mm
8.04 x 11.95 inches
2,411 x 3,586 pixels
resolution 300 ppi
mode RGB

business

search criteria
- Chatting
- Flirting
- Watercooler
- Drink
- Cup
- Water
- Smile
- Steve
- Kelly

5220

size 204 x 323 mm
8.02 x 12.71 inches
2,406 x 3,814 pixels
resolution 300 ppi
mode RGB

business

search criteria
- **Podium**
- **Speech**
- **Presentation**
- **Address**
- **Microphone**
- **Suit**
- **Side**
- **Ben**

5221

size 195 x 331 mm
7.68 x 13.03 inches
2,304 x 3,910 pixels
resolution 300 ppi
mode RGB

business

search criteria
- **Podium**
- **Speech**
- **Presentation**
- **Somber**
- **Serious**
- **Ben**

5222

size 209 x 323 mm
8.24 x 12.73 inches
2,472 x 3,820 pixels
resolution 300 ppi
mode RGB

business

search criteria
- **Podium**
- **Speech**
- **Presentation**
- **Smile**
- **Question**
- **Janet**

5223

size 175 x 311 mm
6.88 x 12.23 inches
2,064 x 3,670 pixels
resolution 300 ppi
mode RGB

business

search criteria
- Speech
- Pointing
- Finger
- Podium
- Argument
- Peter

5224

size 176 x 322 mm
 6.92 x 12.68 inches
 2,076 x 3,803 pixels
resolution 300 ppi
mode RGB

business

search criteria
- **Speech**
- **Waving**
- **Smile**
- **Podium**
- **Acknowledge**
- **Peter**

5225

size 195 x 323 mm
7.66 x 12.73 inches
2,298 x 3,820 pixels
resolution 300 ppi
mode RGB

business

search criteria
- **Podium**
- **Pointing**
- **Speech**
- **Question**
- **Sue**

5226

size 207 x 332 mm
8.16 x 13.07 inches
2,448 x 3,921 pixels
resolution 300 ppi
mode RGB

business

search criteria
- Smile
- Grip
- Podium
- Speech
- Presentation
- Nervous
- Kelly

5222

size 193 x 330 mm
7.6 x 12.99 inches
2,280 x 3,898 pixels
resolution 300 ppi
mode RGB

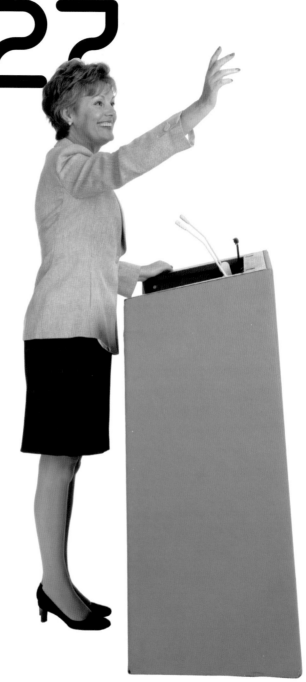

business

search criteria
- **Podium**
- **Presentation**
- **Waving**
- **Speech**
- **Smile**
- **Sue**
- **Side**

5228

size 177 x 304 mm
6.96 x 11.97 inches
2,088 x 3,592 pixels
resolution 300 ppi
mode RGB

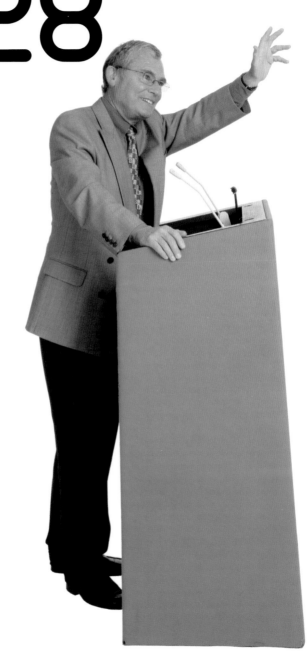

business

search criteria
- **Waving**
- **Speech**
- **Smile**
- **Podium**
- **Presentation**
- **Peter**
- **Side**

5229

size 165 x 331 mm
 6.48 x 13.03 inches
 1,944 x 3,909 pixels
resolution 300 ppi
mode RGB

business

search criteria
- **Smile**
- **Greet**
- **Handshake**
- **Meet**
- **Ben**

5230

size 150 x 314 mm
 5.92 x 12.35 inches
 1,776 x 3,706 pixels
resolution 300 ppi
mode RGB

business

search criteria
- **Smile**
- **Greet**
- **Meet**
- **Handshake**
- **Janet**

5231

size 164 x 339 mm
 6.46 x 13.35 inches
 1,938 x 4,005 pixels
resolution 300 ppi
mode RGB

business

search criteria

- **Smile**
- **Greet**
- **Handshake**
- **Meet**
- **Sue**

5232

size 167 x 332 mm
6.58 x 13.05 inches
1,974 x 3,916 pixels
resolution 300 ppi
mode RGB

business

search criteria

- Smile
- Greet
- Handshake
- Meet
- Suit
- Peter

5233

size 213 x 315 mm
8.38 x 12.41 inches
2,514 x 3,724 pixels
resolution 300 ppi
mode RGB

business

search criteria
- **Handshake**
- **Greet**
- **Meet**
- **Smile**
- **Agree**
- **Ben**
- **Janet**

5234

size 222 x 317 mm
8.76 x 12.49 inches
2,627 x 3,748 pixels
resolution 300 ppi
mode RGB

business

search criteria
- Smile
- Handshake
- Suit
- Briefcase
- Deal
- Steve
- Peter

5235

size 221 x 310 mm
8.7 x 12.19 inches
2,610 x 3,658 pixels
resolution 300 ppi
mode RGB

business

search criteria
- Handshake
- Agree
- Deal
- Smile
- Briefcase
- Peter
- Sue

5236

size 229 x 297 mm
9.01 x 11.69 inches
2,704 x 3,508 pixels
resolution 300 ppi
mode RGB

business

search criteria
- **Handshake**
- **Smile**
- **Meet**
- **Agree**
- **Briefcase**
- **Kelly**
- **Sue**

5237

size 229 x 296 mm
9.01 x 11.65 inches
2,704 x 3,496 pixels
resolution 300 ppi
mode RGB

business

search criteria
- File
- Cabinet
- Filing
- Records
- Search
- Drawer
- Janet

5238

size 224 x 258 mm
8.82 x 10.16 inches
2,646 x 3,048 pixels
resolution 300 ppi
mode RGB

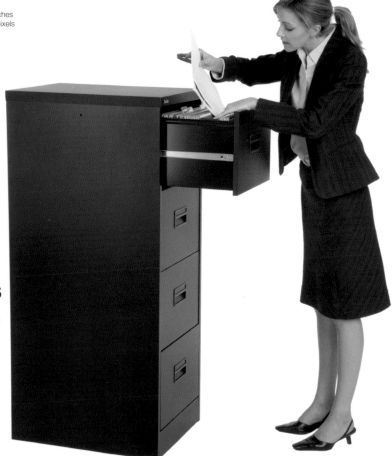

business

search criteria
- File
- Cabinet
- Replace
- Records
- Search
- Drawer
- Kelly

5239

size 199 x 318 mm
 7.84 x 12.53 inches
 2,352 x 3,760 pixels
resolution 300 ppi
mode RGB

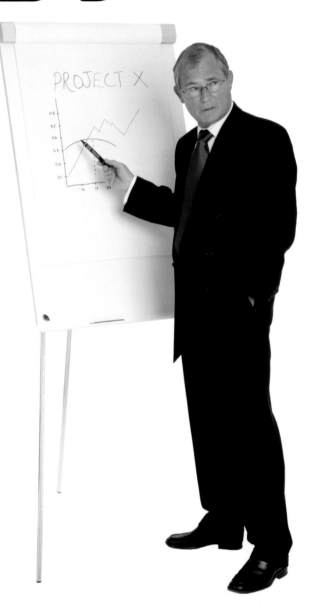

business

search criteria

- **Presentation**
- **Graph**
- **Chart**
- **Pen**
- **Flip chart**
- **Marker**
- **Peter**

5240

size 187 x 315 mm
7.36 x 12.39 inches
2,208 x 3,718 pixels
resolution 300 ppi
mode RGB

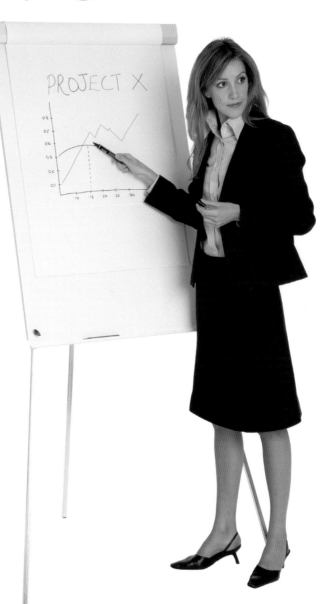

business

search criteria
- **Presentation**
- **Graph**
- **Chart**
- **Pen**
- **Flip chart**
- **Marker**
- **Kelly**

5241

size 197 x 310 mm
7.76 x 12.19 inches
2,328 x 3,658 pixels
resolution 300 ppi
mode RGB

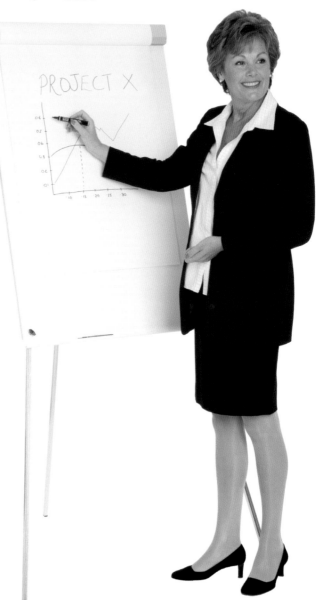

business

search criteria
- Presentation
- Graph
- Chart
- Pen
- Flip chart
- Marker
- Sue

5242

size 140 x 339 mm
5.5 x 13.33 inches
1,605 x 3,999 pixels
resolution 300 ppi
mode RGB

business

search criteria
- **Woman**
- **Suit**
- **Briefcase**
- **Smile**
- **Janet**

5243

size 156 x 340 mm
6.14 x 13.37 inches
1,842 x 4,011 pixels
resolution 300 ppi
mode RGB

business

search criteria
- Woman
- Suit
- Palm/PDA
- Notes
- Briefcase
- Kelly

5244

size 142 x 335 mm
5.58 x 13.19 inches
1,674 x 3,957 pixels
resolution 300 ppi
mode RGB

business

search criteria
- Woman
- Suit
- Palm/PDA
- Notes
- Briefcase
- Sue

5245

size 138 x 339 mm
5.42 x 13.33 inches
1,626 x 3,999 pixels
resolution 300 ppi
mode RGB

business

search criteria
- **Woman**
- **Briefcase**
- **Smile**
- **Suit**
- **Greet**
- **Sue**

5246

size 205 x 324 mm
8.08 x 12.77 inches
2,424 x 3,832 pixels
resolution 300 ppi
mode RGB

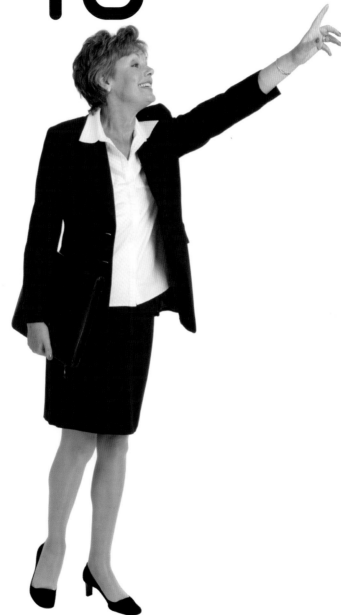

business

search criteria
- **Woman**
- **Suit**
- **Hail**
- **Taxi**
- **Cab**
- **Call**
- **Briefcase**
- **Sue**

5247

size 145 x 340 mm
5.72 x 13.37 inches
1,716 x 4,011 pixels
resolution 300 ppi
mode RGB

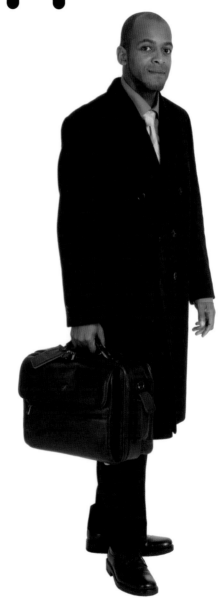

business

search criteria

- **Businessman**
- **Coat**
- **Briefcase**
- **Suit**
- **Smile**
- **Ben**

5248

size 177 x 333 mm
6.98 x 13.11 inches
2,094 x 3,934 pixels
resolution 300 ppi
mode RGB

business

search criteria
- Businessman
- Coat
- Briefcase
- Suit
- Hail
- Taxi
- Cab
- Ben

5249

size 165 x 335 mm
6.5 x 13.19 inches
1,950 x 3,958 pixels
resolution 300 ppi
mode RGB

business

search criteria
- **Businessman**
- **Coat**
- **Briefcase**
- **Suit**
- **Peter**

5250

size 149 x 266 mm
5.88 x 10.45 inches
1,764 x 3,136 pixels
resolution 300 ppi
mode RGB

business

search criteria
- **Businessman**
- **Coat**
- **Briefcase**
- **Suit**
- **Shout**
- **Hail**
- **Taxi**
- **Cab**
- **Peter**

5251

size 171 x 344 mm
6.72 x 13.55 inches
2,016 x 4,064 pixels
resolution 300 ppi
mode RGB

business

search criteria
- **Businessman**
- **Walking**
- **Serious**
- **Suit**
- **Briefcase**
- **Rush**
- **Ben**

5252

size 153 x 332 mm
6.02 x 13.37 inches
1,806 x 3,921 pixels
resolution 300 ppi
mode RGB

business

search criteria
- **Businessman**
- **Standing**
- **Suit**
- **Briefcase**
- **Relaxed**
- **Smile**
- **Ben**

5253

size 158 x 340 mm
6.24 x 13.37 inches
1,872 x 4,011 pixels
resolution 300 ppi
mode RGB

business

search criteria
- **Suit**
- **Newspaper**
- **Financial Times**
- **Briefcase**
- **Businessman**
- **Smile**
- **Andrew**

5254

size 185 x 338 mm
7.3 x 13.29 inches
2,190 x 3,987 pixels
resolution 300 ppi
mode RGB

business

search criteria
- Businessman
- Read
- Newspaper
- Financial Times
- Briefcase
- Waiting
- Andrew

5255

size 152 x 333 mm
6 x 13.09 inches
1,800 x 3,928 pixels
resolution 300 ppi
mode RGB

business

search criteria
- **Businessman**
- **Read**
- **Newspaper**
- **Financial Times**
- **Suit**
- **Briefcase**
- **Peter**

5256

size 158 x 337 mm
 6.22 x 13.25 inches
 1,866 x 3,975 pixels
resolution 300 ppi
mode RGB

business

search criteria

- Businessman
- Coat
- Newspaper
- Financial Times
- Briefcase
- Smile
- Peter

5257

size 224 x 259 mm
 8.84 x 10.19 inches
 2,651 x 3,058 pixels
resolution 300 ppi
mode RGB

business

search criteria

- **Group**
- **Celebration**
- **Handshake**
- **Congratulate**
- **Peter**
- **William**
- **Andrew**
- **Sue**

5258

size 220 x 298 mm
8.66 x 11.71 inches
2,597 x 3,514 pixels
resolution 300 ppi
mode RGB

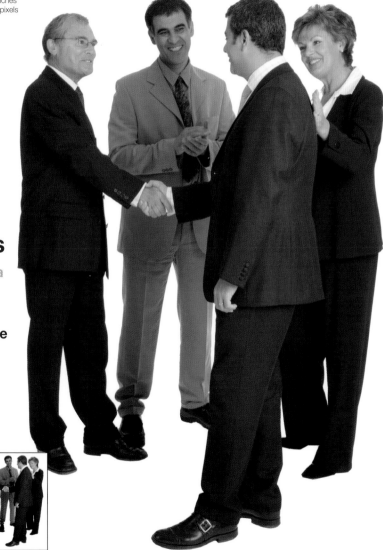

business

search criteria
- Group
- Celebration
- Handshake
- Congratulate
- Smile
- Peter
- William
- Andrew
- Sue

5259

size
212 x 300 mm
8.34 x 11.81 inches
2,502 x 3,544 pixels
resolution 300 ppi
mode RGB

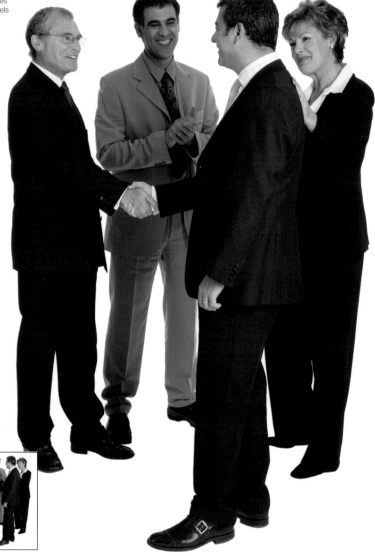

business

search criteria
- Group
- Celebration
- Handshake
- Congratulate
- Peter
- William
- Andrew
- Sue

5260

size 207 x 303 mm
8.14 x 11.91 inches
2,441 x 3,573 pixels
resolution 300 ppi
mode RGB

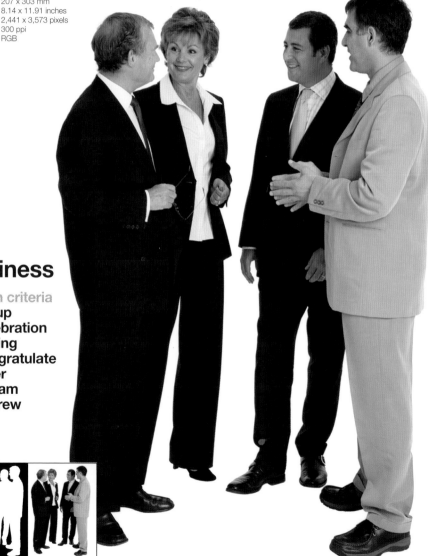

business

search criteria
- Group
- Celebration
- Talking
- Congratulate
- Peter
- William
- Andrew
- Sue

5261

size 210 x 312 mm
 8.28 x 12.29 inches
 2,484 x 3,688 pixels
resolution 300 ppi
mode RGB

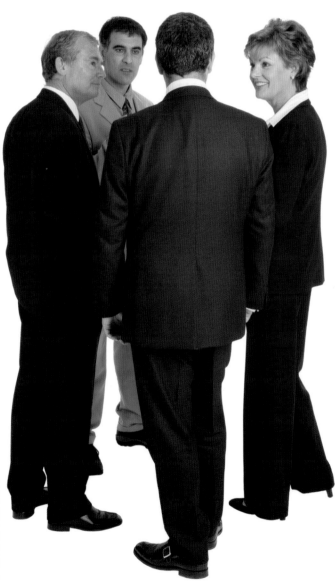

business

search criteria

- Group
- Huddle
- Close
- Talking
- Smile
- Peter
- William
- Andrew
- Sue

5262

size	206 x 268 mm
	8.12 x 10.54 inches
	2,436 x 3,162 pixels
resolution	300 ppi
mode	RGB

business

search criteria

- **Group**
- **Celebration**
- **Fists**
- **Success**
- **Peter**
- **William**
- **Andrew**
- **Sue**

5263

size 211 x 273 mm
8.3 x 10.73 inches
2,490 x 3,220 pixels
resolution 300 ppi
mode RGB

business

search criteria
- **Businessmen**
- **Suit**
- **Discuss**
- **Argument**
- **Pointing**
- **Tell**
- **Andrew**
- **William**

5264

size 204 x 267 mm
8.04 x 10.49 inches
2,411 x 3,,148 pixels
resolution 300 ppi
mode RGB

business

search criteria
- **Businessmen**
- **Suit**
- **Discuss**
- **Argument**
- **Pointing**
- **Angry**
- **Tell**
- **Peter**
- **Andrew**

6265

size 188 x 242 mm
7.42 x 9.53 inches
2,226 x 2,860 pixels
resolution 300 ppi
mode RGB

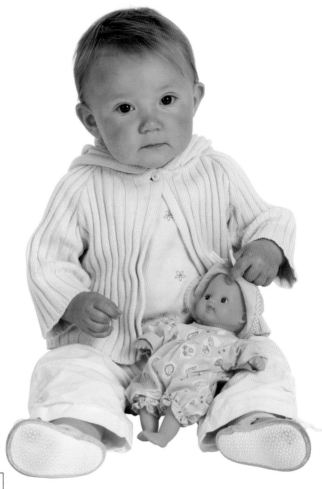

children

search criteria
- **Baby**
- **Pink**
- **Doll**
- **Frown**
- **Toy**
- **Alex**

6266

size 194 x 241 mm
7.64 x 9.47 inches
2,292 x 2,842 pixels
resolution 300 ppi
mode RGB

children

search criteria
- Baby
- Rattle
- Pink
- Toy
- Alex

6267

size 219 x 197 mm
8.63 x 7.74 inches
2,588 x 2,322 pixels
resolution 300 ppi
mode RGB

children

search criteria

- Baby
- Bricks
- Blocks
- Building
- Toy
- Fiona

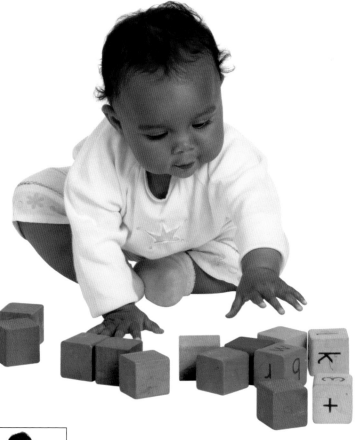

6268

size 222 x 235 mm
8.74 x 9.25 inches
2,621 x 2,776 pixels
resolution 300 ppi
mode RGB

children

search criteria
- Baby
- Bricks
- Blocks
- Building
- Toy
- Fiona

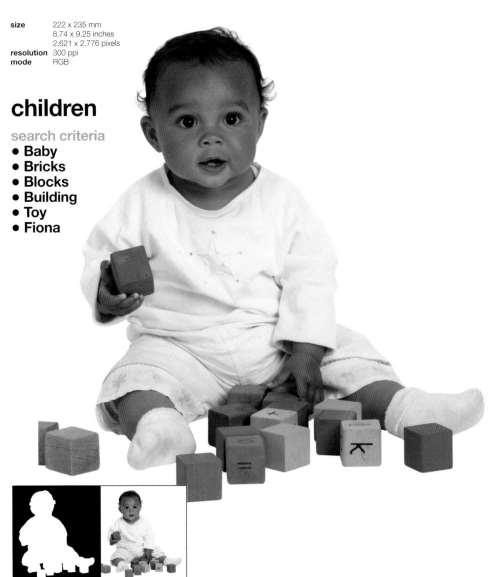

6269

size 176 x 253 mm
 6.94 x 9.95 inches
 2,082 x 2,986 pixels
resolution 300 ppi
mode RGB

children

search criteria

- **Baby**
- **Bricks**
- **Blocks**
- **Building**
- **Toy**
- **Tower**
- **Fiona**

6270

size 227 x 203 mm
8.96 x 7.98 inches
2,687 x 2,394 pixels
resolution 300 ppi
mode RGB

children

search criteria
- **Toddler**
- **Bricks**
- **Blocks**
- **Building**
- **Toy**
- **Tower**
- **Amy**

6271

size 200 x 297 mm
7.88 x 11.67 inches
2,364 x 3,502 pixels
resolution 300 ppi
mode RGB

children

search criteria
- **Toddler**
- **Toy**
- **Camera**
- **Child**
- **Picture**
- **Amy**

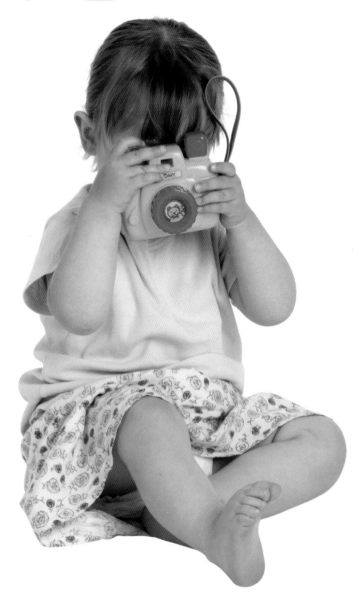

6272

size 174 x 217 mm
6.84 x 8.56 inches
2,052 x 2,567 pixels
resolution 300 ppi
mode RGB

children

search criteria
- **Toddler**
- **Soft toy**
- **Rabbit**
- **Hug**
- **Smile**
- **Amy**

6273

size 187 x 327 mm
7.36 x 12.89 inches
2,208 x 3,867 pixels
resolution 300 ppi
mode RGB

children

search criteria
- Girl
- Toddler
- Child
- Hug
- Teddy bear
- Toy
- Nervous
- Amy

6274

size 169 x 323 mm
6.64 x 12.71 inches
1,992 x 3,813 pixels
resolution 300 ppi
mode RGB

children

search criteria
- **Kiss**
- **Peck**
- **Children**
- **Smiling**
- **Timmy**
- **Letisha**

6275

size 193 x 263 mm
7.6 x 10.35 inches
2,280 x 3,106 pixels
resolution 300 ppi
mode RGB

children

search criteria
- **Children**
- **Walking**
- **Skipping**
- **Holding hands**
- **Elliot**
- **James**

6276

size 229 x 312 mm
9.01 x 12.27 inches
2,704 x 3,682 pixels
resolution 300 ppi
mode RGB

children

search criteria
- **Girl**
- **Teddy bear**
- **Hug**
- **Cradle**
- **Care**
- **Letisha**

6277

size 219 x 277 mm
8.62 x 10.91 inches
2,586 x 3,274 pixels
resolution 300 ppi
mode RGB

children

search criteria
- Girl
- Reading
- Book
- Study
- Concentrate
- Sitting
- Learning
- Letisha

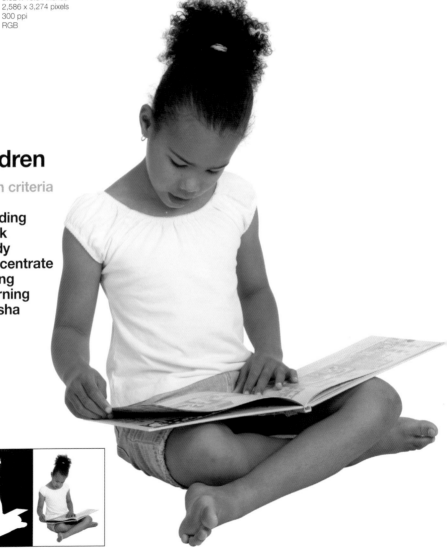

6278

size 318 x 220 mm
12.53 x 8.68 inches
3,760 x 2,603 pixels
resolution 300 ppi
mode RGB

children

search criteria

- **Girl**
- **Lying down**
- **Reading**
- **Study**
- **Book**
- **Learning**
- **Letisha**

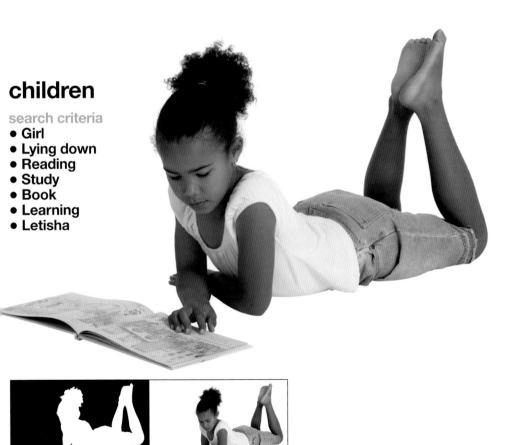

6279

size 229 x 340 mm
9.01 x 13.97 inches
2,704 x 4,010 pixels
resolution 300 ppi
mode RGB

children

search criteria
- Boy
- Reading
- Book
- Dinosaurs
- Study
- Homework
- Sitting
- Stool
- Jake

6280

size 214 x 336 mm
8.43 x 13.23 inches
2,530 x 3,969 pixels
resolution 300 ppi
mode RGB

children

search criteria
- **Girl**
- **Reading**
- **Sitting**
- **Study**
- **Stool**
- **Story**
- **Sally**

6281

size 218 x 327 mm
 8.58 x 12.89 inches
 2,573 x 3,867 pixels
resolution 300 ppi
mode RGB

children

search criteria
- Story
- Book
- Girl
- Reading
- Smiling
- Stool
- Sitting
- Enjoy
- Sally

6282

size 293 x 217 mm
11.55 x 8.54 inches
3,466 x 2,561 pixels
resolution 300 ppi
mode RGB

children

search criteria
- Children
- Bench
- Eating
- Chips
- Sharing
- Toddler
- Amy
- Elliot

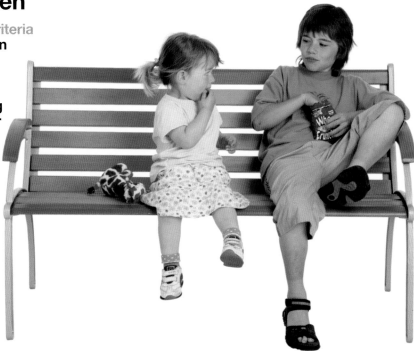

6283

size 161 x 349 mm
6.34 x 13.74 inches
1,902 x 4,121 pixels
resolution 300 ppi
mode RGB

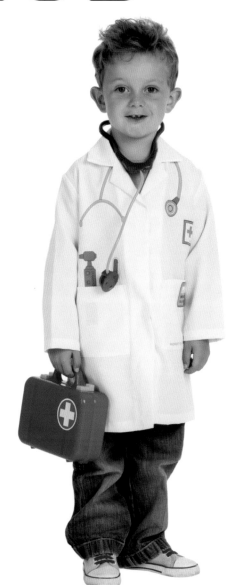

children

search criteria
- Boy
- Play
- Costume
- Doctor
- Toddler
- Game
- Edward

6284

size 290 x 202 mm
11.43 x 7.96 inches
3,430 x 2,388 pixels
resolution 300 ppi
mode RGB

children

search criteria

- Boy
- Teddy bear
- Costume
- Doctor
- Thermometer
- Play
- Game
- Edward

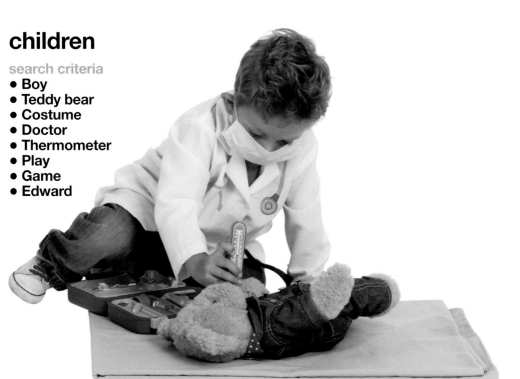

6285

size 209 x 284 mm
8.22 x 11.19 inches
2,465 x 3,358 pixels
resolution 300 ppi
mode RGB

children

search criteria
- **Toddler**
- **Boy**
- **Painting**
- **Abstract**
- **Easel**
- **Brush**
- **Play**
- **Edward**

6286

size 217 x 269 mm
8.54 x 10.59 inches
2,561 x 3,178 pixels
resolution 300 ppi
mode RGB

children

search criteria
- **Toddler**
- **Boy**
- **Painting**
- **Abstract**
- **Easel**
- **Brush**
- **Play**
- **Edward**

6287

size 213 x 293 mm
 8.4 x 11.55 inches
 2,519 x 3,466 pixels
resolution 300 ppi
mode RGB

children

search criteria

- **Boy**
- **Toddler**
- **Blackboard**
- **Chalk**
- **Drawing**
- **Art**
- **Edward**

6288

size 215 x 282 mm
8.48 x 11.09 inches
2,544 x 3,328 pixels
resolution 300 ppi
mode RGB

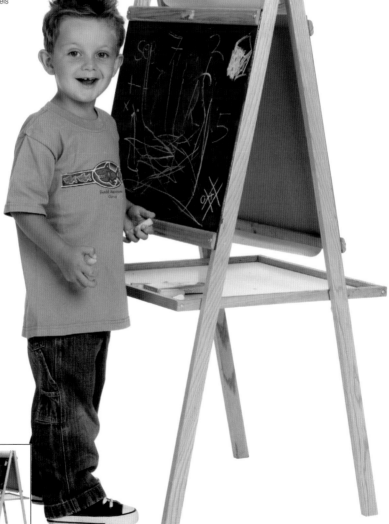

children

search criteria

- **Boy**
- **Toddler**
- **Blackboard**
- **Chalk**
- **Drawing**
- **Art**
- **Smile**
- **Edward**

6289

size 208 x 289 mm
8.2 x 11.39 inches
2,460 x 3,418 pixels
resolution 300 ppi
mode RGB

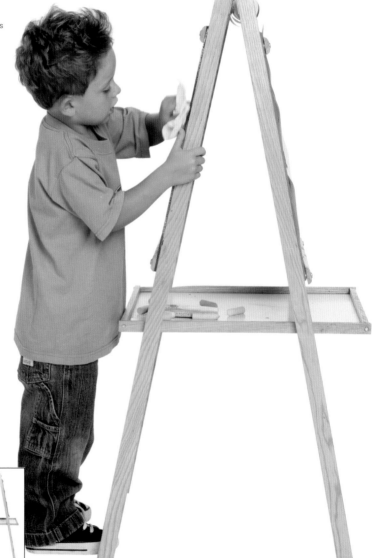

children

search criteria
- Boy
- Toddler
- Blackboard
- Chalk
- Drawing
- Art
- Edward

6290

size 160 x 325 mm
6.3 x 12.79 inches
1,890 x 3,838 pixels
resolution 300 ppi
mode RGB

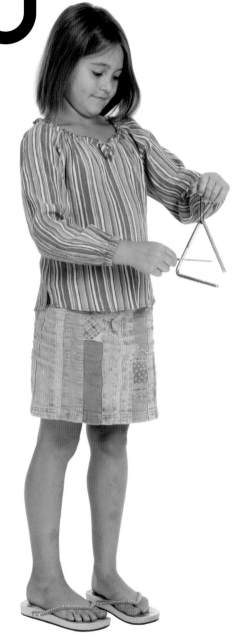

children

search criteria
- Girl
- Child
- Triangle
- Music
- Playing
- Instrument
- Matilda

6291

size 206 x 313 mm
8.12 x 12.31 inches
2,436 x 3,694 pixels
resolution 300 ppi
mode RGB

children

search criteria
- **Children**
- **Boy**
- **Girl**
- **Holding hands**
- **Happy**
- **Puppy love**
- **Smile**
- **Jake**
- **Matilda**

6292

size 224 x 339 mm
8.82 x 13.35 inches
2,645 x 4,004 pixels
resolution 300 ppi
mode RGB

children

search criteria
- Children
- Boy
- Girl
- Holding hands
- Happy
- Puppy love
- Smile
- Back
- Jake
- Matilda

6293

size 136 x 344 mm
5.36 x 13.55 inches
1,608 x 4,064 pixels
resolution 300 ppi
mode RGB

children

search criteria
- **Girl**
- **Ballet**
- **Gymnastics**
- **Dance**
- **Stand**
- **Tip-toes**
- **Leotard**
- **Side**
- **Matilda**

6294

size 175 x 313 mm
6.88 x 12.31 inches
2,064 x 3,694 pixels
resolution 300 ppi
mode RGB

children

search criteria
search criteria
- Girl
- Ballet
- Gymnastics
- Dance
- Stand
- Tip-toes
- Fifth position
- Leotard
- Matilda

6295

size 286 x 199 mm
11.25 x 7.84 inches
3,376 x 2,352 pixels
resolution 300 ppi
mode RGB

children

search criteria
- Girl
- Ballet
- Gymnastics
- Leotard
- Sit
- Smiling
- Matilda

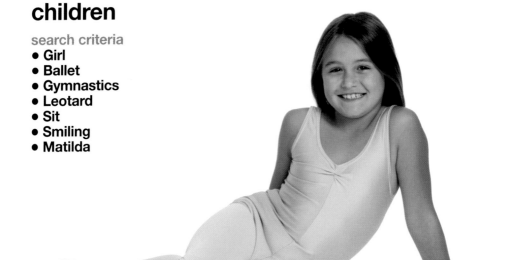

6296

size 223 x 332 mm
8.8 x 13.07 inches
2,639 x 3,922 pixels
resolution 300 ppi
mode RGB

children

search criteria
- Girl
- Ballet
- Second position (arms)
- Fourth position (legs)
- Stand
- Tip-toes
- Leotard
- Emily

6297

size 180 x 334 mm
7.08 x 13.13 inches
2,124 x 3,939 pixels
resolution 300 ppi
mode RGB

children

search criteria
- **Girl**
- **Ballet**
- **Second position (arms)**
- **Fourth position (legs)**
- **Stand**
- **Tip-toes**
- **Smiling**
- **Leotard**
- **Emily**

6298

size 223 x 258 mm
8.8 x 10.17 inches
2,639 x 3,052 pixels
resolution 300 ppi
mode RGB

children

search criteria
- **Girl**
- **Ballet**
- **One leg**
- **Balance**
- **Smiling**
- **Leotard**
- **Emily**

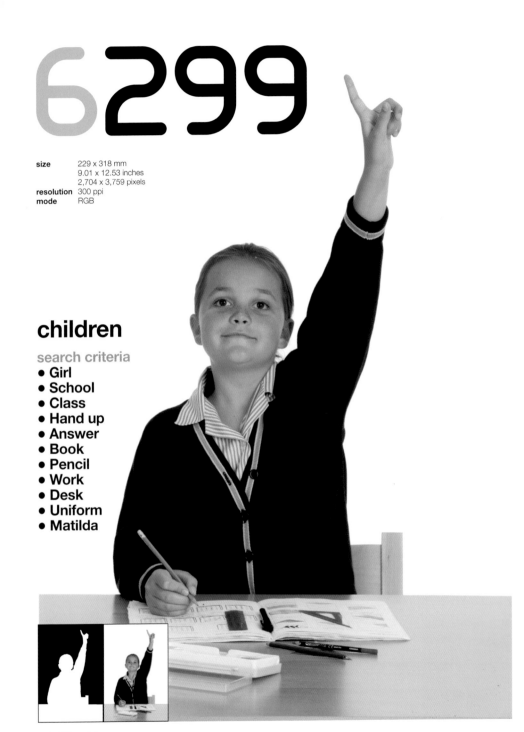

6299

size 229 x 318 mm
9.01 x 12.53 inches
2,704 x 3,759 pixels
resolution 300 ppi
mode RGB

children

search criteria
- Girl
- School
- Class
- Hand up
- Answer
- Book
- Pencil
- Work
- Desk
- Uniform
- Matilda

6300

size 327 x 225 mm
12.87 x 8.87 inches
3,862 x 2,662 pixels
resolution 300 ppi
mode RGB

children

search criteria
- Book
- Girl
- Work
- School
- Desk
- Pen
- Concentrate
- Matilda

6301

size 309 x 229 mm
 12.15 x 9.01 inches
 3,646 x 2,704 pixels
resolution 300 ppi
mode RGB

children

search criteria

- **Book**
- **Girl**
- **Work**
- **School**
- **Desk**
- **Pencil case**
- **Thinking**
- **Study**
- **Matilda**

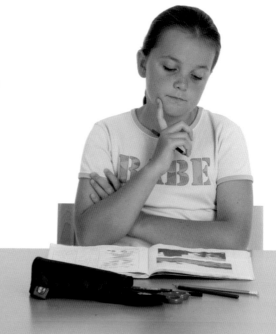

6302

size 328 x 229 mm
 12.91 x 9.01 inches
 3,874 x 2,704 pixels
resolution 300 ppi
mode RGB

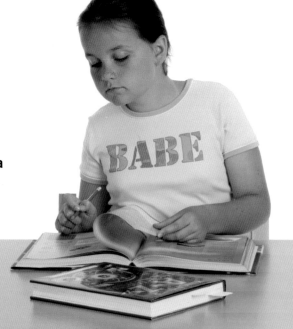

children

search criteria

- Book
- Girl
- Work
- Desk
- Pencil case
- Encyclopedia
- Turn
- Page
- Matilda

7303

size 211 x 282 mm
8.3 x 11.09 inches
2,490 x 3,328 pixels
resolution 300 ppi
mode RGB

fitness & workout

search criteria
- **Yoga**
- **Rest**
- **Gym**
- **Calm**
- **Crossed legs**
- **Sukhasana**
- **Mary**

7304

size 338 x 152 mm
 13.29 x 6 inches
 3,987 x 1,800 pixels
resolution 300 ppi
mode RGB

fitness & workout

search criteria
- **Yoga**
- **Rest**
- **Crouch**
- **Gym**
- **Calm**
- **Bow**
- **Mary**

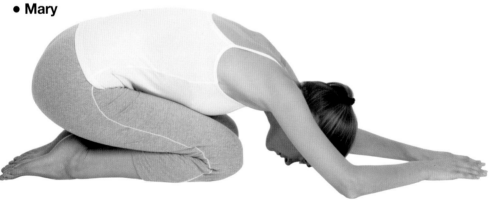

7305

size 128 x 334 mm
5.04 x 13.15 inches
1,512 x 3,945 pixels
resolution 300 ppi
mode RGB

fitness & workout

search criteria
- **Yoga**
- **Standing**
- **Hands together**
- **Pray**
- **Tracksuit**
- **Mary**

7306

size 291 x 188 mm
11.45 x 7.42 inches
3,435 x 2,226 pixels
resolution 300 ppi
mode RGB

fitness & workout

search criteria
- **Gym**
- **Exercise**
- **Sit-up**
- **Trainers**
- **Mary**

7307

size 344 x 105 mm
 13.55 x 4.14 inches
 4,064 x 1,242 pixels
resolution 300 ppi
mode RGB

fitness & workout

search criteria
- **Gym**
- **Exercise**
- **Press-up**
- **Push-up**
- **Mary**

7308

size 210 x 245 mm
8.28 x 9.63 inches
2,484 x 2,890 pixels
resolution 300 ppi
mode RGB

fitness & workout

search criteria
- **Gym**
- **Exercise**
- **Press-up**
- **Push-up**
- **Mary**

7309

size 216 x 267 mm
8.52 x 10.51 inches
2,555 x 3,154 pixels
resolution 300 ppi
mode RGB

fitness & workout

search criteria

- **Gym**
- **Exercise**
- **Ardha sarvangasana**
- **Shoulder stand**
- **Training**
- **Mary**

7310

size 229 x 313 mm
 9.01 x 12.31 inches
 2,704 x 3,694 pixels
resolution 300 ppi
mode RGB

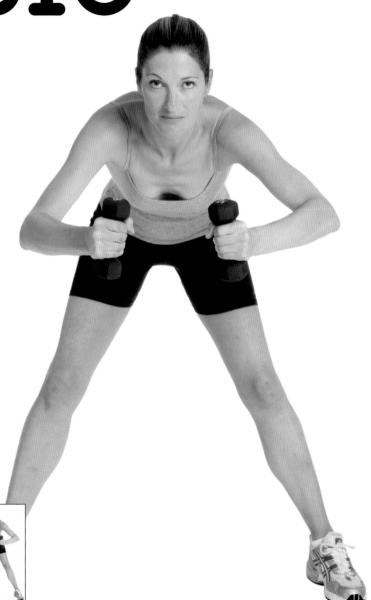

fitness & workout

search criteria

- **Gym**
- **Exercise**
- **Weights**
- **Training**
- **Mary**

7311

size 160 x 338 mm
6.3 x 13.29 inches
1,890 x 3,987 pixels
resolution 300 ppi
mode RGB

fitness & workout

search criteria
- **Gym**
- **Exercise**
- **Towel**
- **Sweat-band**
- **Water**
- **Bottle**
- **Mary**

7312

size 229 x 325 mm
9.01 x 12.81 inches
2,704 x 3,843 pixels
resolution 300 ppi
mode RGB

fitness & workout

search criteria
- **Gym**
- **Man**
- **Chest**
- **Sweat**
- **Dexter**

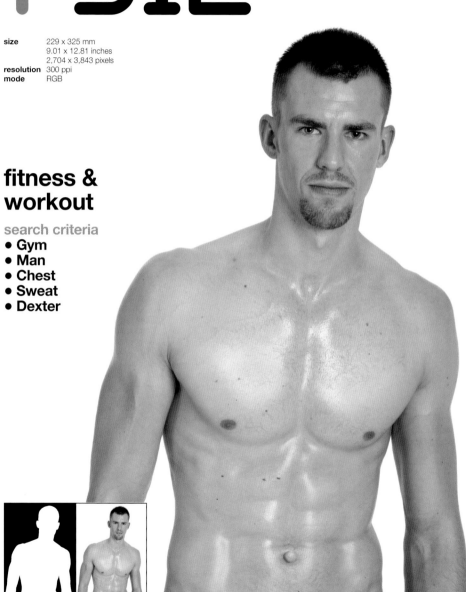

8313

size　154 x 331 mm
　　　　6.06 x 13.03 inches
　　　　1,818 x 3,910 pixels
resolution　300 ppi
mode　RGB

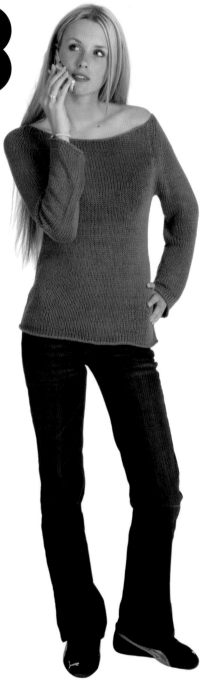

telephone poses

search criteria
- Phone
- Listen
- Hand on hip
- Cell phone
- Bored
- Standing
- Charlotte

8314

size 166 x 326 mm
6.54 x 12.85 inches
1,962 x 3,856 pixels
resolution 300 ppi
mode RGB

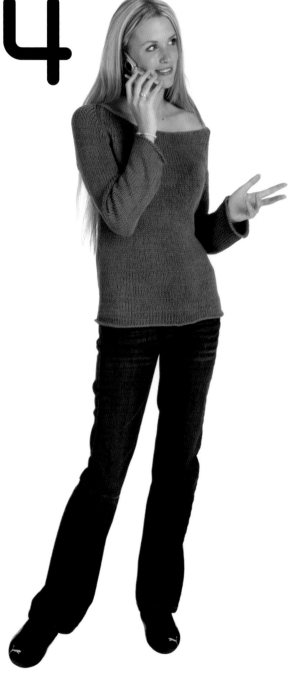

telephone
poses

search criteria
- **Phone**
- **Listen**
- **Explain**
- **Cell phone**
- **Happy**
- **Standing**
- **Charlotte**

8315

size 163 x 331 mm
6.42 x 13.03 inches
1,926 x 3,910 pixels
resolution 300 ppi
mode RGB

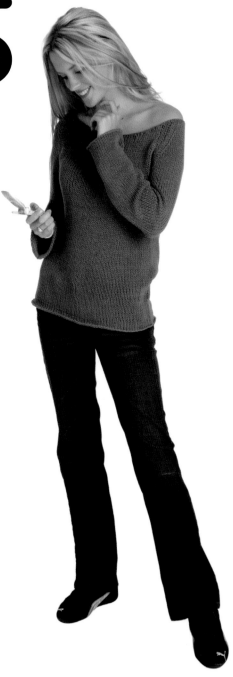

telephone poses

search criteria
- Cell phone
- Text message
- Smile
- Happy
- Read
- Standing
- Charlotte

8316

size 151 x 334 mm
5.94 x 13.13 inches
1,782 x 3,940 pixels
resolution 300 ppi
mode RGB

telephone poses

search criteria

- **Charlotte**
- **Cell phone**
- **Text message**
- **Smile**
- **Happy**
- **Read**
- **Sigh**
- **Standing**

8317

size 173 x 338 mm
6.8 x 13.29 inches
2,040 x 3,987 pixels
resolution 300 ppi
mode RGB

telephone poses

search criteria
- Cell phone
- Smile
- Laugh
- Shrug
- Text message
- Standing
- Abby

8318

size 161 x 329 mm
6.32 x 12.95 inches
1,896 x 3,886 pixels
resolution 300 ppi
mode RGB

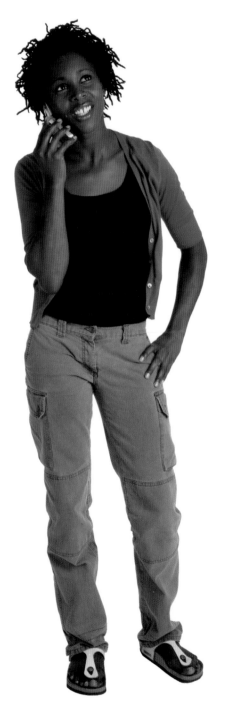

telephone
poses

search criteria
- **Cell phone**
- **Phone**
- **Chat**
- **Listen**
- **Hand on hip**
- **Standing**
- **Abby**

8319

size 169 x 332 mm
 6.64 x 13.05 inches
 1,992 x 3,916 pixels
resolution 300 ppi
mode RGB

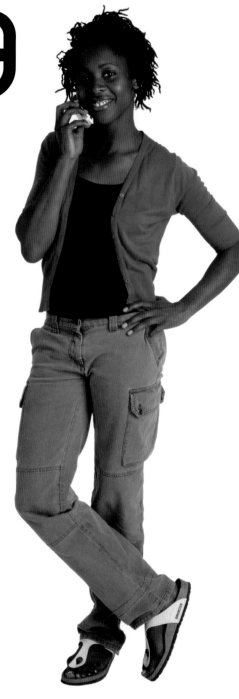

telephone poses

search criteria
- Cell phone
- Listen
- Happy
- Smile
- Hand on hip
- Standing
- Abby

8320

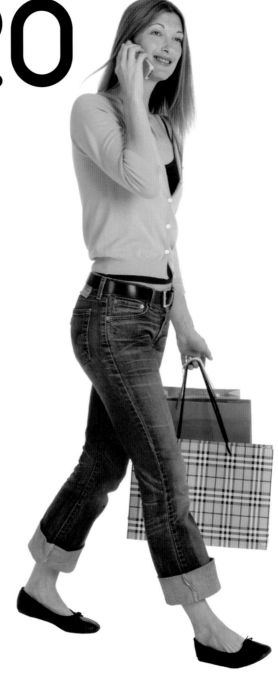

size 151 x 298 mm
5.94 x 11.73 inches
1,782 x 3,520 pixels
resolution 300 ppi
mode RGB

telephone
poses

search criteria
- Shopping
- Cell phone
- Walking
- Bag
- Smile
- Happy
- Mary

8321

size 174 x 339 mm
6.86 x 13.35 inches
2,058 x 4,005 pixels
resolution 300 ppi
mode RGB

telephone poses

search criteria
- Shopping
- Cell phone
- Standing
- Bag
- Listen
- Happy
- Mary

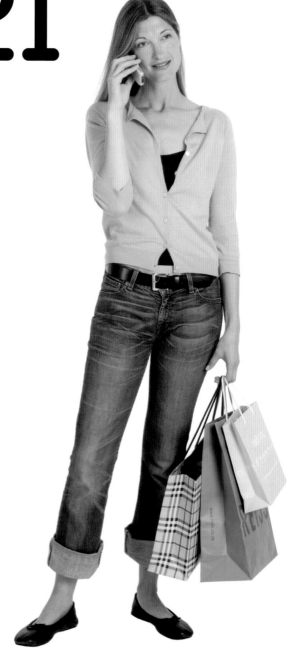

8322

size 169 x 332 mm
6.66 x 13.05 inches
1,998 x 3,916 pixels
resolution 300 ppi
mode RGB

telephone
poses

search criteria
- **Shopping**
- **Bluetooth**
- **Standing**
- **Bag**
- **Listen**
- **Talk**
- **Mary**

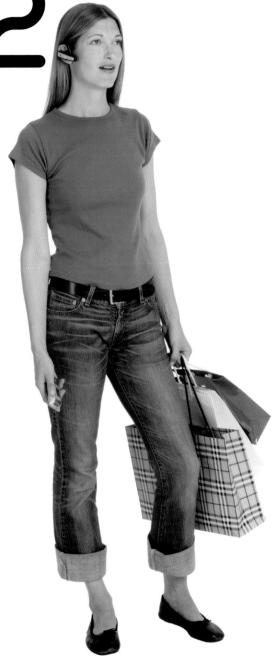

8323

size 132 x 333 mm
5.2 x 13.11 inches
1,560 x 3,934 pixels
resolution 300 ppi
mode RGB

telephone poses

search criteria

- **Suit**
- **Cell phone**
- **Bluetooth**
- **Magazine**
- **Talk**
- **Standing**
- **William**

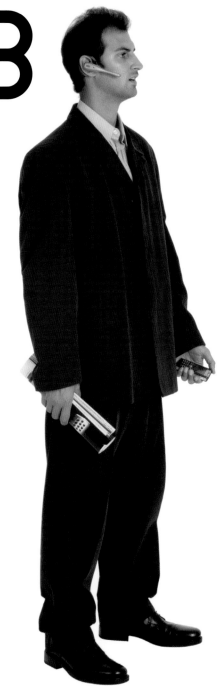

8324

size 150 x 332 mm
5.9 x 13.09 inches
1,770 x 3,927 pixels
resolution 300 ppi
mode RGB

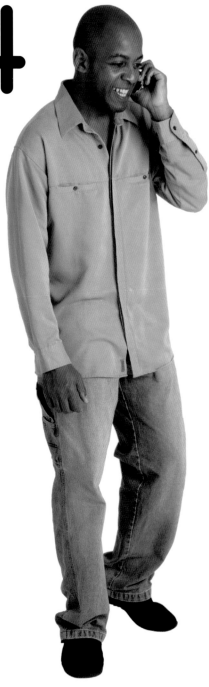

telephone poses

search criteria
- Cell phone
- Shirt
- Smile
- Standing
- Happy
- Ben

8325

size 157 x 332 mm
6.2 x 13.05 inches
1,860 x 3,916 pixels
resolution 300 ppi
mode RGB

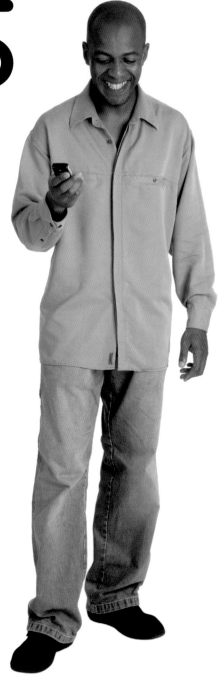

telephone poses

search criteria
- **Text message**
- **Cell phone**
- **Read**
- **Smile**
- **Happy**
- **Standing**
- **Ben**

8326

size 205 x 339 mm
8.08 x 13.35 inches
2,424 x 4,005 pixels
resolution 300 ppi
mode RGB

telephone poses

search criteria
- **Text message**
- **Cell phone**
- **Typing**
- **Standing**
- **Dave**

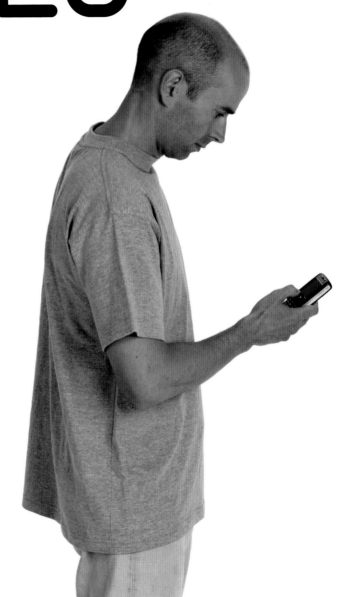

8327

size 330 x 229 mm
 12.99 x 9.01 inches
 3,898 x 2,704 pixels
resolution 300 ppi
mode RGB

telephone poses

search criteria
- **Cordless phone**
- **Ironing**
- **Iron**
- **Smile**
- **Standing**
- **Chat**
- **Lyndsey**

8328

size 321 x 221 mm
12.65 x 8.7 inches
3,795 x 2,609 pixels
resolution 300 ppi
mode RGB

telephone poses

search criteria
- **Cordless phone**
- **Base station**
- **Table**
- **Smile**
- **Laugh**
- **Chat**
- **Sitting**
- **Lyndsey**

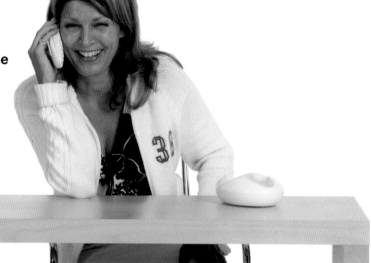

8329

size 146 x 334 mm
5.74 x 13.13 inches
1,721 x 3,940 pixels
resolution 300 ppi
mode RGB

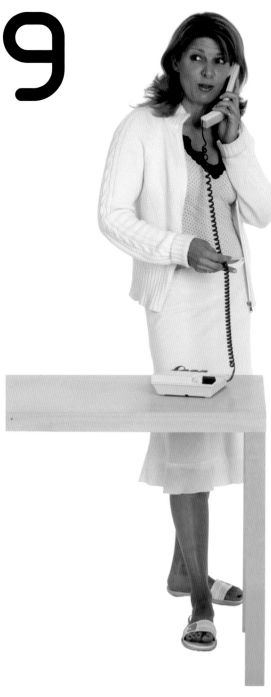

telephone poses

search criteria
- Standing
- Phone
- Cable
- Twiddlng
- Surprise
- Chat
- Table
- Lyndsey

8330

size 169 x 334 mm
6.64 x 13.15 inches
1,991 x 3,946 pixels
resolution 300 ppi
mode RGB

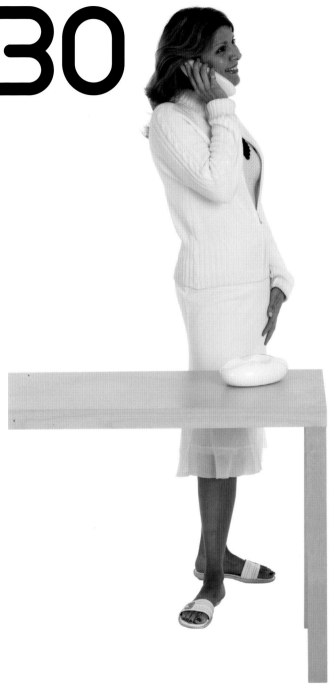

telephone poses

search criteria
- **Standing**
- **Table**
- **Cordless phone**
- **Smile**
- **Chat**
- **Happy**
- **Lyndsey**

8331

size 178 x 333 mm
7.02 x 13.11 inches
2,105 x 3,934 pixels
resolution 300 ppi
mode RGB

telephone poses

search criteria
- **Standing**
- **Phone**
- **Cable**
- **Holding cord**
- **Surprise**
- **Chat**
- **Table**
- **Dave**

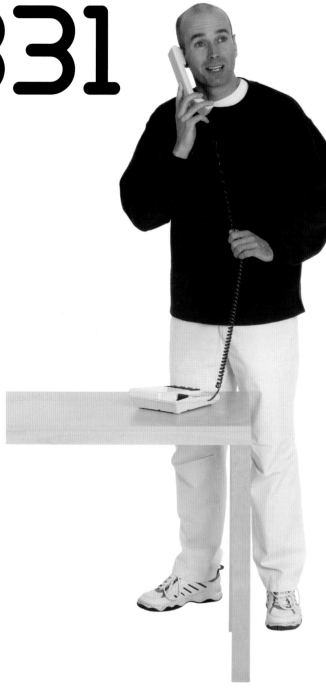

8332

size 292 x 218 mm
11.51 x 8.6 inches
3,453 x 2,579 pixels
resolution 300 ppi
mode RGB

telephone poses

search criteria

- Sitting
- Smile
- Surprise
- Chat
- Table
- Happy
- Cordless phone
- Dave

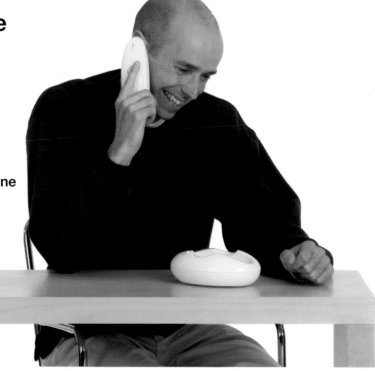

8333

size 294 x 212 mm
 11.57 x 8.36 inches
 3,471 x 2,507 pixels
resolution 300 ppi
mode RGB

telephone poses

search criteria
- **Table**
- **Phone**
- **Surprise**
- **Angry**
- **Confused**
- **Sitting**
- **Dave**

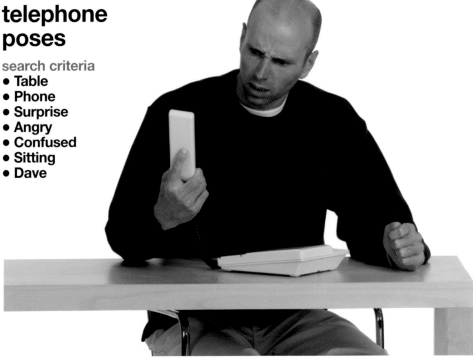

8334

size 229 x 321 mm
9.01 x 12.63 inches
2,704 x 3,789 pixels
resolution 300 ppi
mode RGB

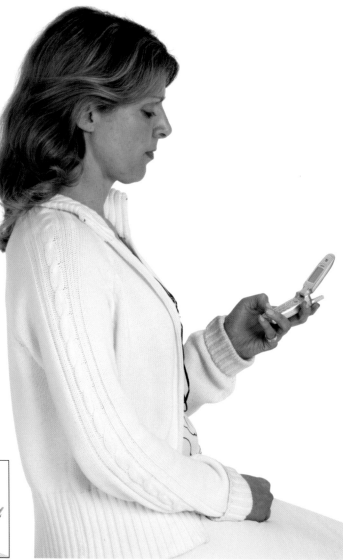

telephone
poses

search criteria
- **Text message**
- **Cell phone**
- **Sitting**
- **Typing**
- **Calm**
- **Lyndsey**

8335

size 175 x 328 mm
6.9 x 12.91 inches
2,070 x 3,874 pixels
resolution 300 ppi
mode RGB

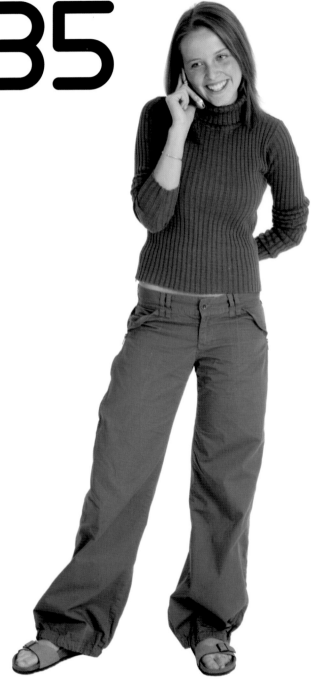

telephone poses

search criteria
- Teen
- Cell phone
- Standing
- Smile
- Kylie

8336

size 159 x 327 mm
6.26 x 12.87 inches
1,878 x 3,862 pixels
resolution 300 ppi
mode RGB

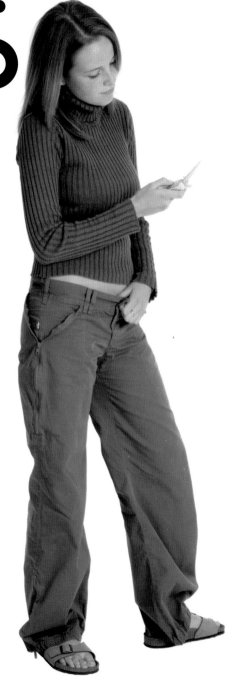

telephone poses

search criteria

- Teen
- Cell phone
- Text message
- Typing
- Standing
- Kylie

8337

size 149 x 331 mm
5.86 x 13.01 inches
1,758 x 3,904 pixels
resolution 300 ppi
mode RGB

telephone
poses

search criteria
- **Teen**
- **Cell phone**
- **Slouch**
- **Standing**
- **Listening**
- **Stuart**

8338

size 148 x 339 mm
5.82 x 13.33 inches
1,746 x 3,999 pixels
resolution 300 ppi
mode RGB

telephone poses

search criteria
- **Teen**
- **Cell phone**
- **Text message**
- **Angry**
- **Standing**
- **Stuart**

8339

size 336 x 116 mm
13.23 x 4.56 inches
3,969 x 1,368 pixels
resolution 300 ppi
mode RGB

telephone
poses

search criteria
- **Cordless phone**
- **Base station**
- **Chat**
- **Lying down**
- **Smile**
- **Kylie**

8340

size 314 x 169 mm
 12.35 x 6.66 inches
 3,705 x 1,998 pixels
resolution 300 ppi
mode RGB

telephone poses

search criteria
- **Cordless phone**
- **Base station**
- **Chat**
- **Lying down**
- **Kylie**

8341

size 263 x 216 mm
10.35 x 8.5 inches
3,106 x 2,550 pixels
resolution 300 ppi
mode RGB

telephone poses

search criteria
- Cell phone
- Listening
- Sitting
- Bench
- Stuart

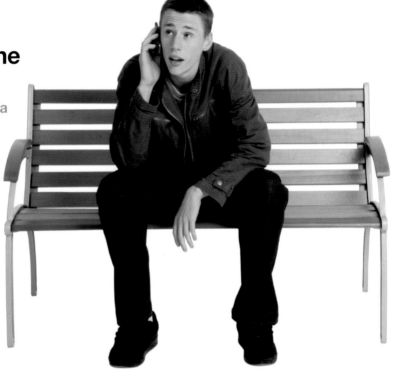

8342

size 235 x 224 mm
9.25 x 8.84 inches
2,776 x 2,651 pixels
resolution 300 ppi
mode RGB

telephone poses

search criteria

- Cell phone
- Leaning
- Listening
- Miserable
- Sitting
- Bench
- Stuart

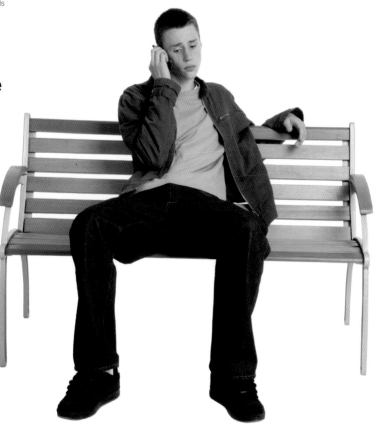

8343

size 258 x 224 mm
10.17 x 8.82 inches
3,052 x 2,645 pixels
resolution 300 ppi
mode RGB

telephone poses

search criteria
- Cell phone
- Bench
- Sitting
- Smile
- Happy
- Kylie

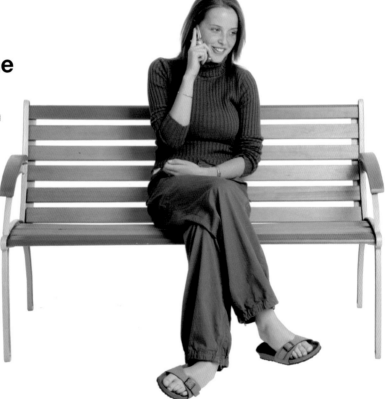

8344

size 263 x 213 mm
10.35 x 8.38 inches
3,106 x 2,514 pixels
resolution 300 ppi
mode RGB

telephone poses

search criteria
- **Text message**
- **Cell phone**
- **Clutch**
- **Read**
- **Bench**
- **Kylie**

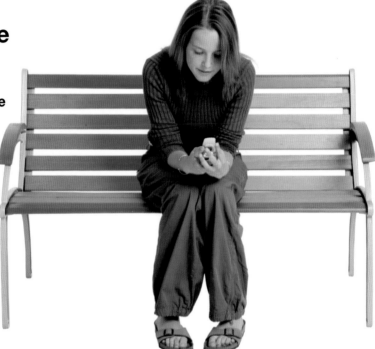

8345

size 256 x 221 mm
10.37 x 8.7 inches
3,022 x 2,610 pixels
resolution 300 ppi
mode RGB

telephone poses

search criteria

- **Text message**
- **Cell phone**
- **Smile**
- **Read**
- **Sitting**
- **Kylie**

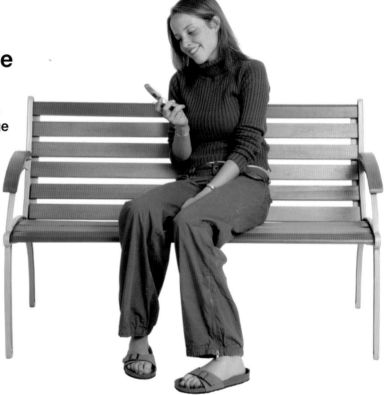

8346

size 263 x 222 mm
10.37 x 8.74 inches
3,112 x 2,621 pixels
resolution 300 ppi
mode RGB

telephone poses

search criteria

- Cell phone
- Diary
- Pen
- Notes
- Bench
- Planning
- Sitting
- Ben

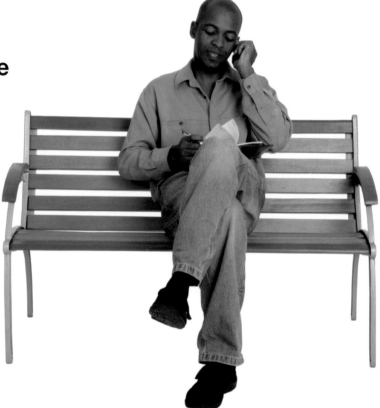

8347

size 210 x 212 mm
8.27 x 8.36 inches
2,482 x 2,508 pixels
resolution 300 ppi
mode RGB

telephone poses

search criteria
- **Sitting**
- **Cordless phone**
- **Interested**
- **Listening**
- **Crossed legs**
- **Kylie**

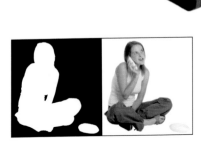

8348

size 203 x 205 mm
7.97 x 8.06 inches
2,392 x 2,418 pixels
resolution 300 ppi
mode RGB

telephone poses

search criteria
- **Sitting**
- **Cordless phone**
- **Smile**
- **Listening**
- **Crossed legs**
- **Kylie**

8349

size 196 x 335 mm
7.7 x 13.17 inches
2,310 x 3,951 pixels
resolution 300 ppi
mode RGB

telephone
poses

search criteria
- **Sitting**
- **Phone**
- **Listening**
- **Smile**
- **Stool**
- **Sally**

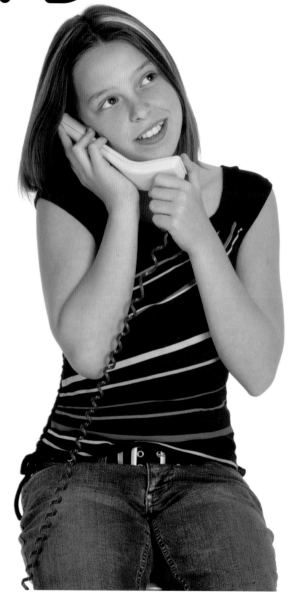

8350

size 199 x 326 mm
7.82 x 12.83 inches
2,345 x 3,849 pixels
resolution 300 ppi
mode RGB

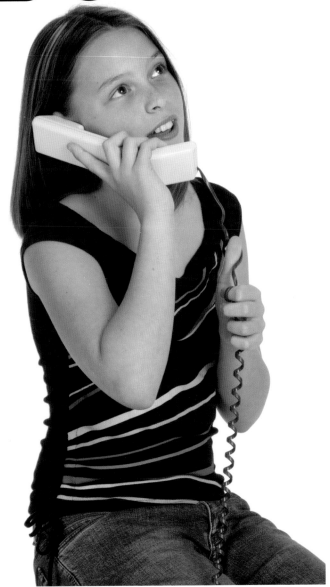

telephone
poses

search criteria
- **Talk**
- **Phone**
- **Cord**
- **Stool**
- **Sitting**
- **Sally**

8351

size 200 x 328 mm
7.86 x 12.93 inches
2,358 x 3,879 pixels
resolution 300 ppi
mode RGB

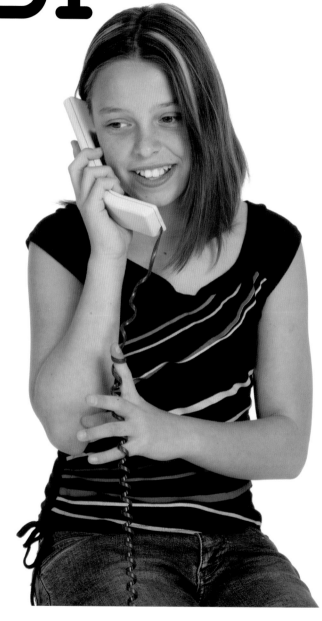

telephone poses

search criteria
- **Phone**
- **Smile**
- **Listening**
- **Cord**
- **Sitting**
- **Sally**

8352

size 199 x 312 mm
7.82 x 12.29 inches
2,346 x 3,687 pixels
resolution 300 ppi
mode RGB

telephone
poses

search criteria
- Phone
- Listening
- Smile
- Cord
- Sitting
- Jake

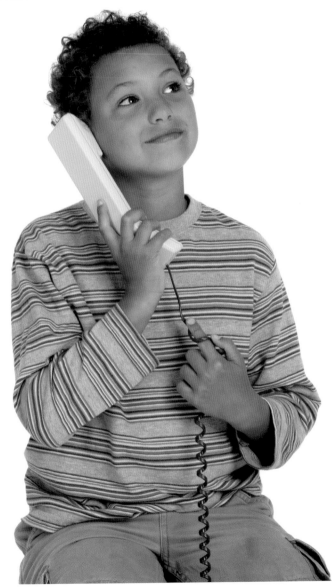

8353

size 216 x 281 mm
8.52 x 11.07 inches
2,555 x 3,321 pixels
resolution 300 ppi
mode RGB

telephone
poses

search criteria
- **Phone**
- **Giggle**
- **Smile**
- **Happy**
- **Sitting**
- **Jake**

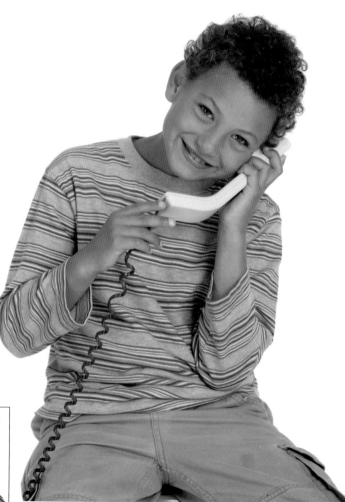

9354

size 298 x 198 mm
11.71 x 7.78 inches
3,514 x 2,334 pixels
resolution 300 ppi
mode RGB

workers

search criteria
- Cleaning
- Washing
- Homemaker
- Scrubbing
- Kneeling
- Bucket
- Brush
- Floor
- Beth

9355

size 218 x 229 mm
8.6 x 9 inches
2,579 x 2,699 pixels
resolution 300 ppi
mode RGB

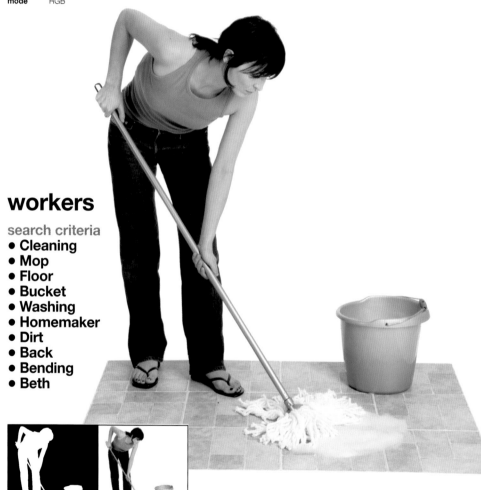

workers

search criteria
- Cleaning
- Mop
- Floor
- Bucket
- Washing
- Homemaker
- Dirt
- Back
- Bending
- Beth

9356

size 219 x 224 mm
8.62 x 8.84 inches
2,586 x 2,651 pixels
resolution 300 ppi
mode RGB

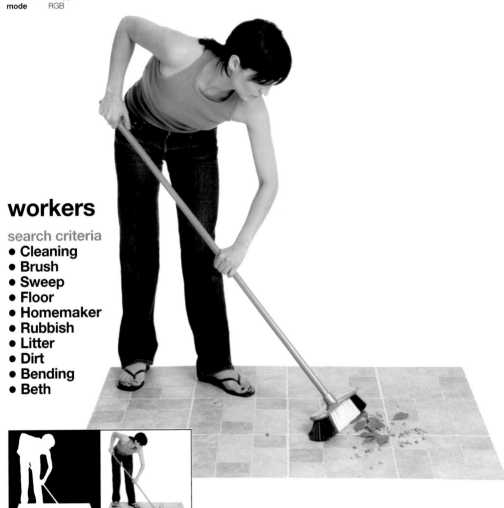

workers

search criteria
- **Cleaning**
- **Brush**
- **Sweep**
- **Floor**
- **Homemaker**
- **Rubbish**
- **Litter**
- **Dirt**
- **Bending**
- **Beth**

9357

size 276 x 194 mm
10.87 x 7.64 inches
3,262 x 2,292 pixels
resolution 300 ppi
mode RGB

workers

search criteria
- **Homemaker**
- **Cleaning**
- **Sweeping**
- **Dustpan**
- **Brush**
- **Floor**
- **Dirt**
- **Beth**

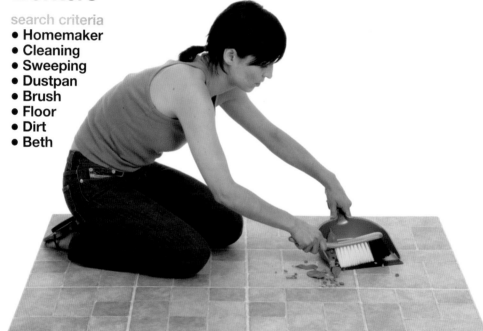

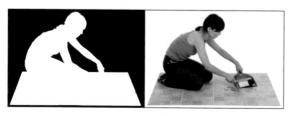

9358

size 220 x 281 mm
8.66 x 11.05 inches
2,598 x 3,316 pixels
resolution 300 ppi
mode RGB

workers

search criteria
- Homemaker
- Cleaning
- Vacuum
- Hoover
- Floor
- Dirt
- Standing
- Beth

9359

size 181 x 318 mm
7.14 x 12.53 inches
2,142 x 3,760 pixels
resolution 300 ppi
mode RGB

workers

search criteria
- Homemaker
- Cleaning
- Mop
- Floor
- Bucket
- Dirt
- Standing
- Beth

9360

size 124 x 326 mm
4.88 x 12.85 inches
1,464 x 3,855 pixels
resolution 300 ppi
mode RGB

workers

search criteria
- Homemaker
- Cleaning
- Dusting
- Duster
- Reaching
- Dirt
- Standing
- Beth

9361

size 114 x 331 mm
 4.48 x 13.03 inches
 1,344 x 3,909 pixels
resolution 300 ppi
mode RGB

workers

search criteria
- **Homemaker**
- **Cleaning**
- **Dusting**
- **Duster**
- **Reaching**
- **Back**
- **Beth**

9362

size 138 x 329 mm
5.44 x 12.95 inches
1,632 x 3,886 pixels
resolution 300 ppi
mode RGB

workers

search criteria
- **Homemaker**
- **Cleaning**
- **Window**
- **Bucket**
- **Squeegee**
- **Wiping**
- **Standing**
- **Beth**

9363

size 149 x 315 mm
5.86 x 12.39 inches
1,759 x 3,718 pixels
resolution 300 ppi
mode RGB

workers

search criteria
- Homemaker
- Cleaning
- Window
- Bucket
- Squeegee
- Wiping
- Standing
- Beth

9364

size 215 x 304 mm
8.48 x 11.97 inches
2,544 x 3,592 pixels
resolution 300 ppi
mode RGB

workers

search criteria

- **Homemaker**
- **Cleaning**
- **Window**
- **Bucket**
- **Squeegee**
- **Wiping**
- **Standing**
- **Back**
- **Beth**

9365

size 182 x 329 mm
7.16 x 12.93 inches
2,148 x 3,880 pixels
resolution 300 ppi
mode RGB

workers

search criteria
- Homemaker
- Cleaning
- Window
- Bucket
- Cloth
- Wiping
- Standing
- Back
- Beth

9366

size 182 x 329 mm
7.16 x 12.93 inches
2,148 x 3,880 pixels
resolution 300 ppi
mode RGB

workers

search criteria
- **Homemaker**
- **Cleaning**
- **Window**
- **Bucket**
- **Squeegee**
- **Cloth**
- **Standing**
- **Beth**

9367

size 229 x 266 mm
9.01 x 10.45 inches
2,704 x 3,136 pixels
resolution 300 ppi
mode RGB

workers

search criteria
- Homemaker
- Cleaning
- Polish
- Duster
- Cloth
- Table
- Wiping
- Beth

9368

size 224 x 283 mm
8.84 x 11.15 inches
2,651 x 3,346 pixels
resolution 300 ppi
mode RGB

workers

search criteria
- Homemaker
- Cook
- Chef
- Apron
- Kitchen
- Cut
- Vegetables
- Table
- Knife
- Beth

9369

size 215 x 288 mm
8.48 x 11.33 inches
2,543 x 3,400 pixels
resolution 300 ppi
mode RGB

workers

search criteria
- Homemaker
- Apron
- Wiping
- Kitchen
- Dishcloth
- Washing
- Cups
- Plates
- Table
- Beth

9370

ssize 215 x 288 mm
 8.48 x 11.33 inches
 2,543 x 3,400 pixels
resolution 300 ppi
mode RGB

workers

search criteria

- **Homemaker**
- **Apron**
- **Wiping**
- **Kitchen**
- **Cloth**
- **Washing**
- **Fruit**
- **Apples**
- **Table**
- **Bowl**
- **Beth**

9371

size 216 x 237 mm
8.5 x 9.33 inches
2,549 x 2,800 pixels
resolution 300 ppi
mode RGB

workers

search criteria
- **Homemaker**
- **Ironing board**
- **Iron**
- **Shirt**
- **Standing**
- **Laundry**
- **Beth**

9372

size 143 x 313 mm
5.64 x 12.31 inches
1,692 x 3,694 pixels
resolution 300 ppi
mode RGB

workers

search criteria
- **Homemaker**
- **Fold**
- **Sheet**
- **Standing**
- **Laundry**
- **Beth**

9373

size 162 x 344 mm
 6.36 x 13.55 inches
 1,908 x 4,064 pixels
resolution 300 ppi
mode RGB

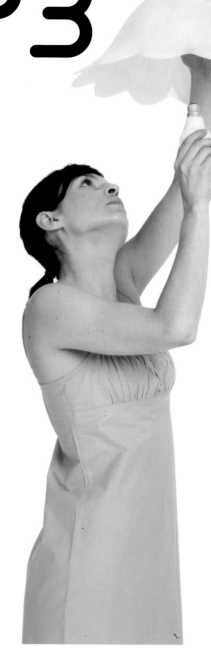

workers

search criteria
- **Homemaker**
- **Lightbulb**
- **Changing**
- **Lamp**
- **Shade**
- **Beth**

9374

size 173 x 341 mm
6.82 x 13.43 inches
2,046 x 4,029 pixels
resolution 300 ppi
mode RGB

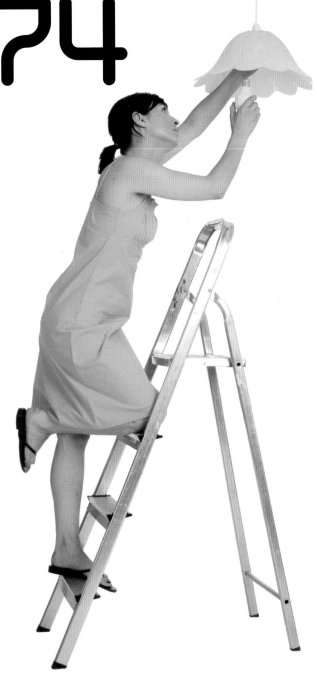

workers

search criteria

- **Homemaker**
- **Lightbulb**
- **Changing**
- **Lamp**
- **Shade**
- **Stepladder**
- **Climb**
- **Beth**

9375

size 184 x 334 mm
7.24 x 13.13 inches
2,172 x 3,940 pixels
resolution 300 ppi
mode RGB

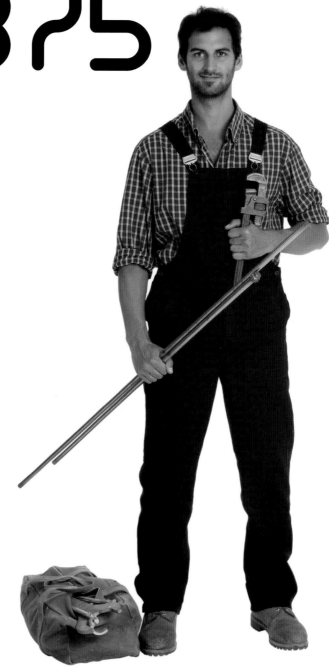

workers

search criteria
- **Plumber**
- **Pipes**
- **Wrench**
- **Tools**
- **Bag**
- **Overalls**
- **Eric**

9376

size 141 x 329 mm
5.56 x 12.93 inches
1,668 x 3,880 pixels
resolution 300 ppi
mode RGB

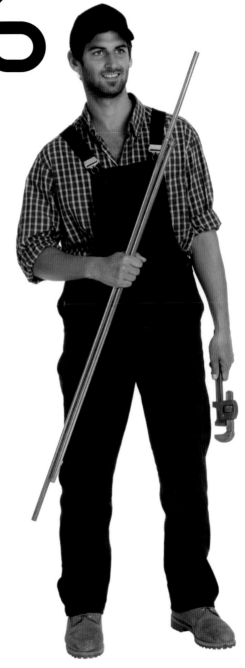

workers

search criteria
- **Plumber**
- **Pipes**
- **Wrench**
- **Tool**
- **Overalls**
- **Eric**

9377

size 141 x 338 mm
5.54 x 13.29 inches
1,662 x 3,987 pixels
resolution 300 ppi
mode RGB

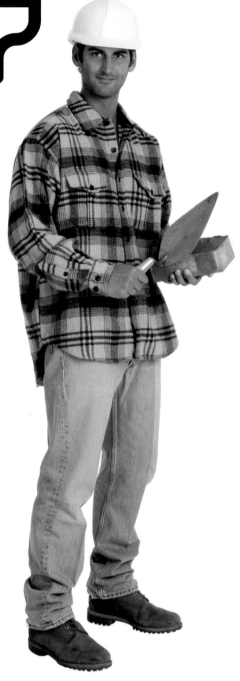

workers

search criteria
- **Builder**
- **Hard hat**
- **Helmet**
- **Trowel**
- **Brick**
- **Mortar**
- **Eric**

9378

size 143 x 334 mm
5.62 x 13.15 inches
1,686 x 3,945 pixels
resolution 300 ppi
mode RGB

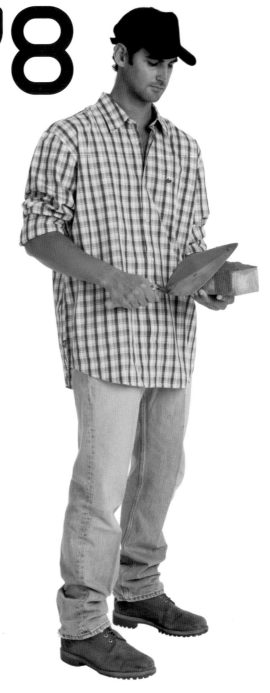

workers

search criteria
- **Builder**
- **Baseball cap**
- **Brick**
- **Trowel**
- **Mortar**
- **Eric**

9379

size 152 x 339 mm
6 x 13.33 inches
1,800 x 3,999 pixels
resolution 300 ppi
mode RGB

workers

search criteria
- **Window cleaner**
- **Squeegee**
- **Overalls**
- **Bucket**
- **Mop**
- **Eric**

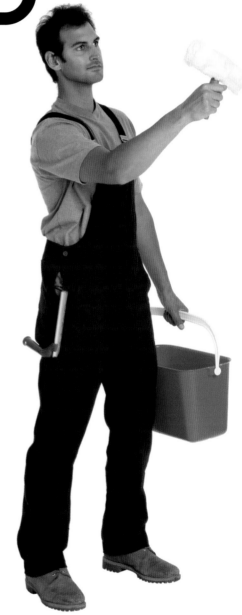

9380

size 229 x 307 mm
 9.01 x 12.09 inches
 2,704 x 3,628 pixels
resolution 300 ppi
mode RGB

workers

search criteria

- Street sweeper
- Brush
- Broom
- Garbage bag
- Trash
- Gloves
- Tabard
- Eric

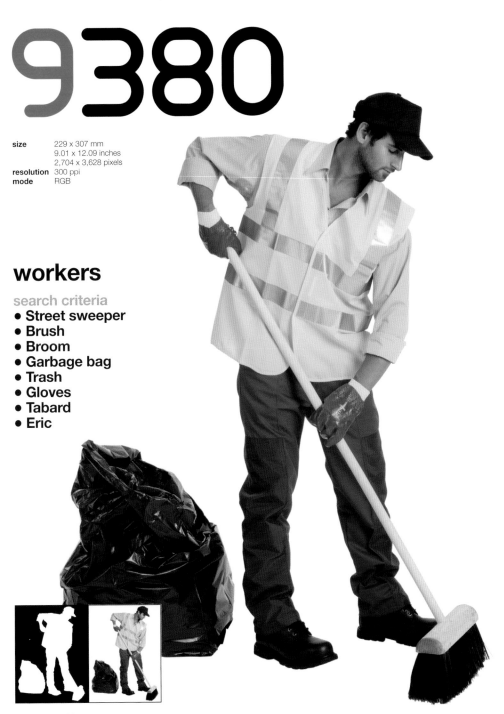

9381

size 157 x 331 mm
6.2 x 13.01 inches
1,860 x 3,904 pixels
resolution 300 ppi
mode RGB

workers

search criteria
- Carpenter
- Circular saw
- Tool belt
- Hammer
- Overalls
- Samuel

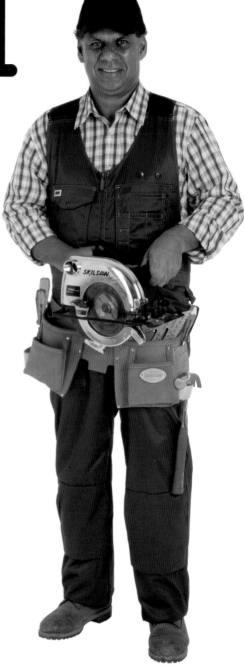

9382

size 171 x 329 mm
6.74 x 12.95 inches
2,022 x 3,886 pixels
resolution 300 ppi
mode RGB

workers

search criteria
- Carpenter
- Circular saw
- Tool belt
- Hammer
- Overalls
- Hard hat
- Wood
- Planks
- Samuel

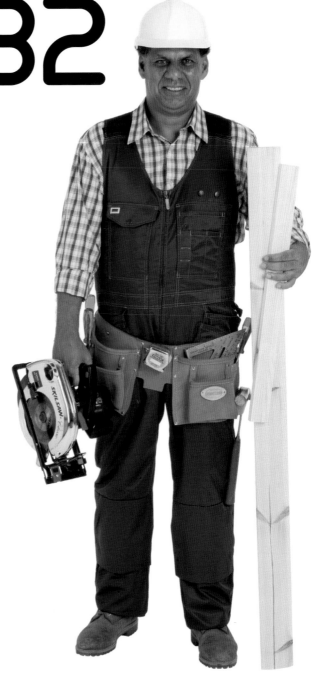

9383

size 143 x 336 mm
5.62 x 13.23 inches
1,686 x 3,969 pixels
resolution 300 ppi
mode RGB

workers

search criteria
- Carpenter
- Joiner
- Saw
- Wood
- Apron
- Smiling
- Samuel

9384

size 157 x 323 mm
 6.2 x 12.73 inches
 1,860 x 3,820 pixels
resolution 300 ppi
mode RGB

workers

search criteria
- Carpenter
- Circular saw
- Hammer
- Overalls
- Hard hat
- Smiling
- Nigel

9385

size 174 x 322 mm
6.84 x 12.67 inches
2,052 x 3,802 pixels
resolution 300 ppi
mode RGB

workers

search criteria
- **Carpenter**
- **Circular saw**
- **Tool belt**
- **Hammer**
- **Overalls**
- **Wood**
- **Nigel**

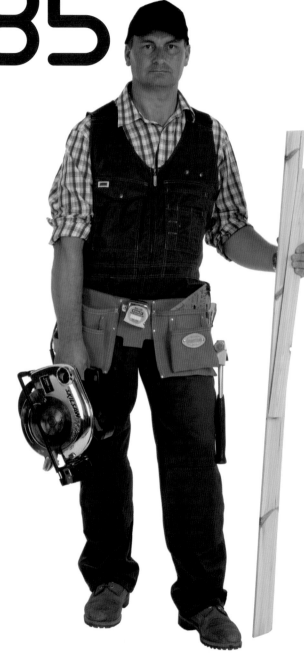

9386

size 177 x 334 mm
 6.96 x 13.13 inches
 2,088 x 3,939 pixels
resolution 300 ppi
mode RGB

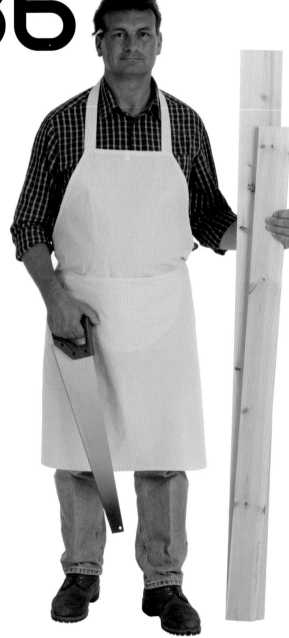

workers

search criteria
- **Carpenter**
- **Joiner**
- **Saw**
- **Wood**
- **Planks**
- **Apron**
- **Smiling**
- **Nigel**

9387

size 229 x 253 mm
9.01 x 9.95 inches
2,704 x 2,986 pixels
resolution 300 ppi
mode RGB

workers

search criteria
- **Gardener**
- **Lawn mower**
- **Pushing**
- **Gloves**
- **Samuel**

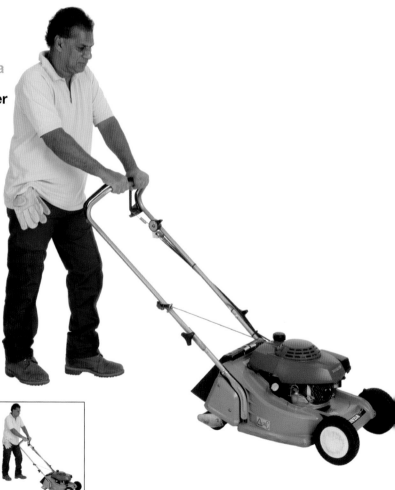

9388

size 120 x 344 mm
1,416 x 4,064 pixels
4.72 x 13.55 inches
resolution 300 ppi
mode RGB

workers

search criteria

- **Gardener**
- **Lawn mower**
- **Pushing**
- **Samuel**

9389

size 148 x 344 mm
5.84 x 13.55 inches
1,752 x 4,064 pixels
resolution 300 ppi
mode RGB

workers

search criteria
- **Painter**
- **Decorator**
- **Overalls**
- **Paint**
- **Brush**
- **Wallpaper**
- **Samuel**

9390

size 144 x 335 mm
5.66 x 13.19 inches
1,698 x 3,957 pixels
resolution 300 ppi
mode RGB

workers

search criteria

- **British fireman**
- **Uniform**
- **Gloves**
- **Safety helmet**
- **Dexter**

9391

size 151 x 327 mm
5.96 x 12.89 inches
1,788 x 3,868 pixels
resolution 300 ppi
mode RGB

workers

search criteria
- **British fireman**
- **Uniform**
- **Gloves**
- **Safety helmet**
- **Ryan**

9392

size 168 x 330 mm
6.62 x 13.01 inches
1,986 x 3,903 pixels
resolution 300 ppi
mode RGB

workers

search criteria

- **British fireman**
- **Uniform**
- **Gloves**
- **Safety helmet**
- **Ryan**

9393

size 146 x 328 mm
 5.74 x 12.91 inches
 1,722 x 3,874 pixels
resolution 300 ppi
mode RGB

workers

search criteria
- **Fireman**
- **Uniform**
- **Gloves**
- **Safety helmet**
- **Ryan**

9394

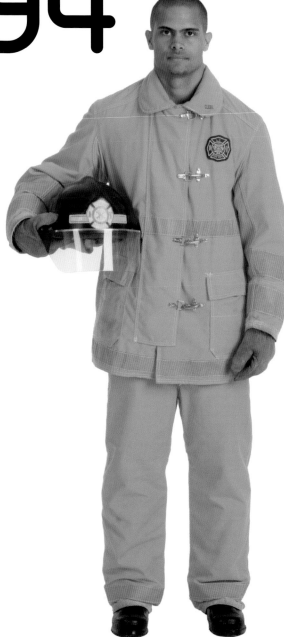

size 166 x 329 mm
6.54 x 12.95 inches
1,962 x 3,886 pixels
resolution 300 ppi
mode RGB

workers

search criteria
- Fireman
- Uniform
- Gloves
- Safety helmet
- Ryan

9395

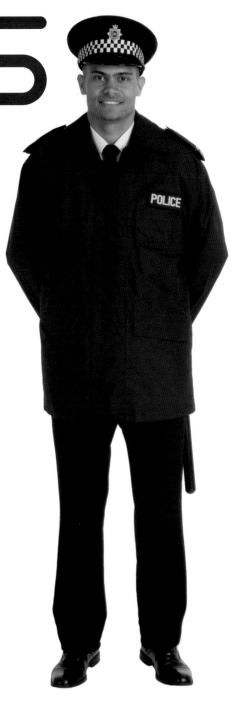

size 142 x 330 mm
5.58 x 13.01 inches
1,674 x 3,903 pixels
resolution 300 ppi
mode RGB

workers

search criteria
- **British police officer**
- **Truncheon**
- **Baton**
- **Uniform**
- **Hat**
- **Coat**
- **Ryan**

9396

size 127 x 331 mm
5 x 13.01 inches
1,500 x 3,904 pixels
resolution 300 ppi
mode RGB

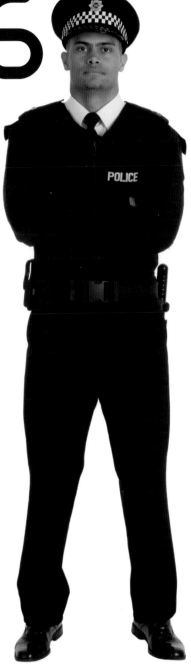

workers

search criteria
- **British police officer**
- **Truncheon**
- **Baton**
- **Uniform**
- **Hat**
- **Belt**
- **Ryan**

9397

size 136 x 331 mm
5.36 x 13.01 inches
1,608 x 3,904 pixels
resolution 300 ppi
mode RGB

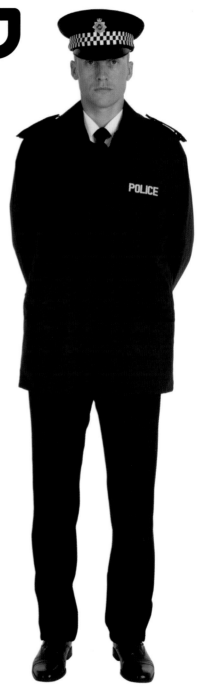

workers

search criteria
- **British police officer**
- **Uniform**
- **Hat**
- **Coat**
- **Harry**

9398

size 145 x 332 mm
5.72 x 13.07 inches
1,716 x 3,922 pixels
resolution 300 ppi
mode RGB

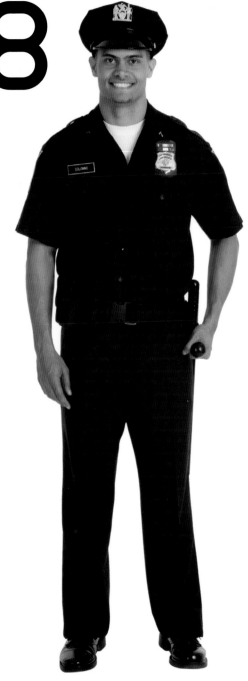

workers

search criteria
- Police officer
- Uniform
- Baton
- Nightstick
- Belt
- Badge
- Hat
- Ryan

9399

size 139 x 332 mm
5.48 x 13.07 inches
1,644 x 3,922 pixels
resolution 300 ppi
mode RGB

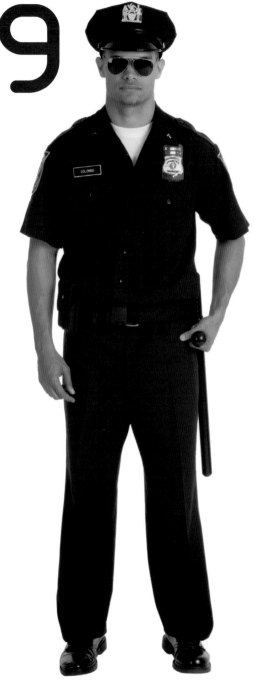

workers

search criteria
- Police officer
- Uniform
- Baton
- Nightstick
- Belt
- Badge
- Hat
- Sunglasses
- Ryan

9400

size 139 x 332 mm
5.48 x 13.07 inches
1,644 x 3,922 pixels
resolution 300 ppi
mode RGB

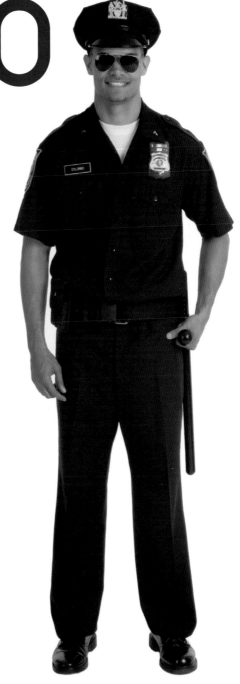

workers

search criteria
- **Police officer**
- **Uniform**
- **Baton**
- **Nightstick**
- **Belt**
- **Badge**
- **Hat**
- **Sunglasses**
- **Ryan**

427 *500 model poses*

9401

size 116 x 340 mm
4.58 x 13.37 inches
1,374 x 4,011 pixels
resolution 300 ppi
mode RGB

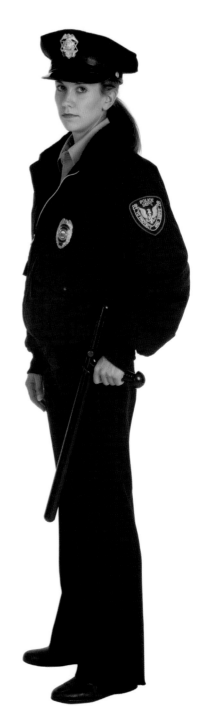

workers

search criteria
- **Police officer**
- **Uniform**
- **Baton**
- **Nightstick**
- **Belt**
- **Badge**
- **Hat**
- **Beth**

9402

size 138 x 332 mm
5.42 x 13.05 inches
1,626 x 3,916 pixels
resolution 300 ppi
mode RGB

workers

search criteria
- Police officer
- Uniform
- Baton
- Nightstick
- Belt
- Badge
- Hat
- Beth

9403

size 152 x 316 mm
6 x 12.45 inches
1,800 x 3,736 pixels
resolution 300 ppi
mode RGB

workers

search criteria
- Driver
- Chauffeur
- Gloves
- Cap
- Uniform
- Ryan

9404

size 141 x 336 mm
5.56 x 13.21 inches
1,668 x 3,963 pixels
resolution 300 ppi
mode RGB

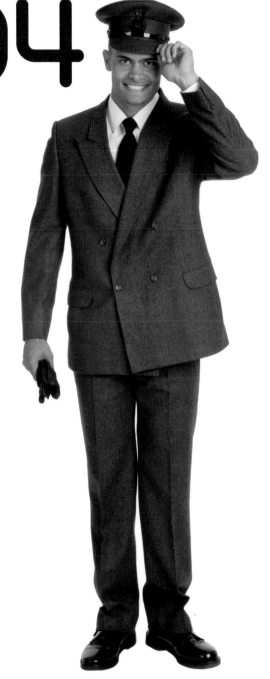

workers

search criteria
- **Driver**
- **Chauffeur**
- **Gloves**
- **Cap**
- **Uniform**
- **Ryan**

9405

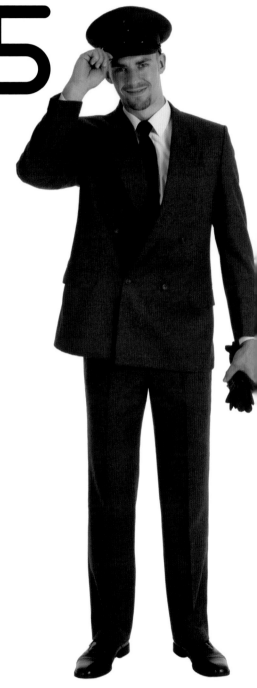

size 142 x 329 mm
5.6 x 12.95 inches
1,680 x 3,886 pixels
resolution 300 ppi
mode RGB

workers

search criteria
- Driver
- Chauffeur
- Gloves
- Cap
- Uniform
- Dexter

9406

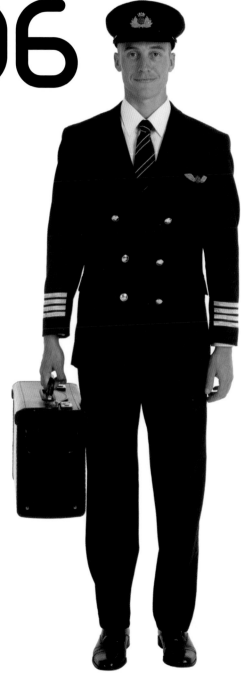

size 138 x 334 mm
5.44 x 13.15 inches
1,632 x 3,946 pixels
resolution 300 ppi
mode RGB

workers

search criteria

- **Captain**
- **Pilot**
- **Aircrew**
- **Uniform**
- **Cap**
- **Briefcase**
- **Harry**

9407

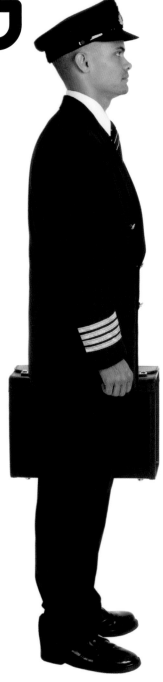

size 128 x 335 mm
5.04 x 13.17 inches
1,512 x 3,952 pixels
resolution 300 ppi
mode RGB

workers

search criteria
- Captain
- Pilot
- Aircrew
- Uniform
- Briefcase
- Cap
- Ryan

9408

size 154 x 336 mm
6.08 x 13.21 inches
1,824 x 3,963 pixels
resolution 300 ppi
mode RGB

workers

search criteria
- Captain
- Pilot
- Aircrew
- Uniform
- Sunglasses
- Briefcase
- Cap
- Ryan

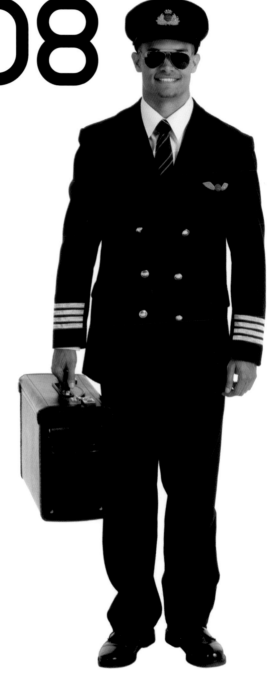

9409

size 118 x 337 mm
4.66 x 13.25 inches
1,398 x 3,975 pixels
resolution 300 ppi
mode RGB

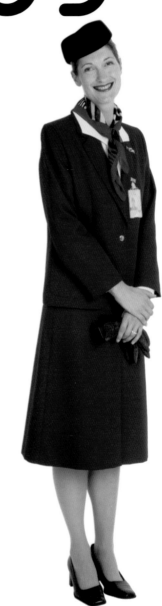

workers

search criteria
- Cabin attendant
- Stewardess
- Crew
- Uniform
- Gloves
- Mary

9410

size 184 x 336 mm
7.26 x 13.21 inches
2,178 x 3,963 pixels
resolution 300 ppi
mode RGB

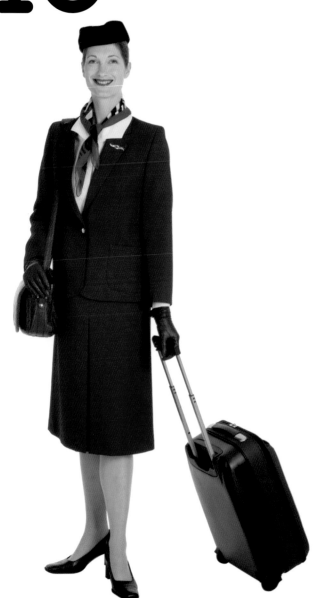

workers

search criteria
- Cabin attendant
- Stewardess
- Crew
- Uniform
- Gloves
- Suitcase
- Handbag
- Mary

9411

size 184 x 336 mm
 5.74 x 13.21 inches
 1,723 x 3,963 pixels
resolution 300 ppi
mode RGB

workers

search criteria
- **Cabin attendant**
- **Stewardess**
- **Crew**
- **Uniform**
- **Gloves**
- **Handbag**
- **Mary**

9412

size 160 x 327 mm
6.28 x 12.89 inches
1,884 x 3,868 pixels
resolution 300 ppi
mode RGB

workers

search criteria
- Mailman
- Postman
- Uniform
- Delivery
- Bag
- Letters
- Cap
- Ryan

9413

size	180 x 322 mm
	7.08 x 12.67 inches
	2,124 x 3,802 pixels
resolution	300 ppi
mode	RGB

workers

search criteria
- Mailman
- Postman
- Uniform
- Delivery
- Bag
- Letters
- Cap
- Ryan

9414

size 156 x 332 mm
6.16 x 13.09 inches
1,848 x 3,927 pixels
resolution 300 ppi
mode RGB

workers

search criteria
- Mailman
- Postman
- Uniform
- Delivery
- Bag
- Letters
- Cap
- Harry

9415

size 166 x 323 mm
6.52 x 12.71 inches
1,956 x 3,814 pixels
resolution 300 ppi
mode RGB

workers

search criteria
- **British postman**
- **Delivery**
- **Bag**
- **Letters**
- **Coat**
- **Cap**
- **Ryan**

9416

size 163 x 344 mm
6.42 x 13.55 inches
1,926 x 4,064 pixels
resolution 300 ppi
mode RGB

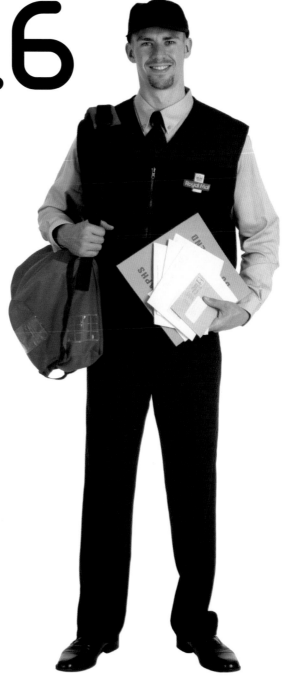

workers

search criteria
- British postman
- Delivery
- Bag
- Letters
- Cap
- Dexter

9417

size 136 x 334 mm
 5.36 x 13.15 inches
 1,608 x 3,946 pixels
resolution 300 ppi
mode RGB

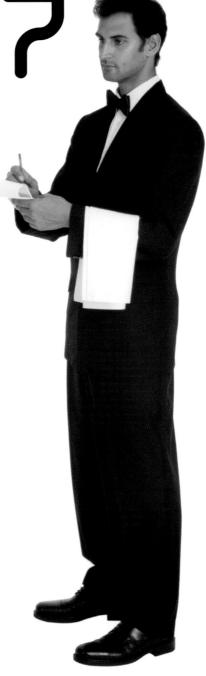

workers

search criteria
- Waiter
- Order
- Notepad
- Cloth
- Bow tie
- Suit
- Eric

9418

size 169 x 327 mm
6.64 x 12.87 inches
1,992 x 3,862 pixels
resolution 300 ppi
mode RGB

workers

search criteria
- Waiter
- Tray
- Wine
- Glass
- Cloth
- Bow tie
- Suit
- Eric

9419

size 200 x 327 mm
7.86 x 12.87 inches
2,357 x 3,861 pixels
resolution 300 ppi
mode RGB

workers

search criteria
- **Waitress**
- **Glass**
- **Cloth**
- **Polish**
- **Silver service**
- **Table**
- **Cutlery**
- **Plate**
- **Mary**

9420

size 220 x 317 mm
8.67 x 12.47 inches
2,602 x 3,741 pixels
resolution 300 ppi
mode RGB

workers

search criteria
- Waitress
- Silver service
- Cloth
- Glass
- Cutlery
- Plate
- Table
- Mary

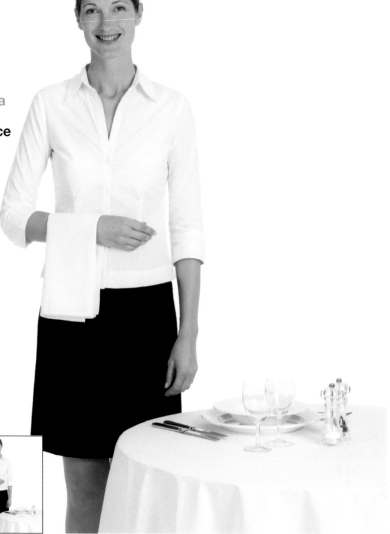

9421

size 145 x 340 mm
5.7 x 13.37 inches
1,710 x 4,011 pixels
resolution 300 ppi
mode RGB

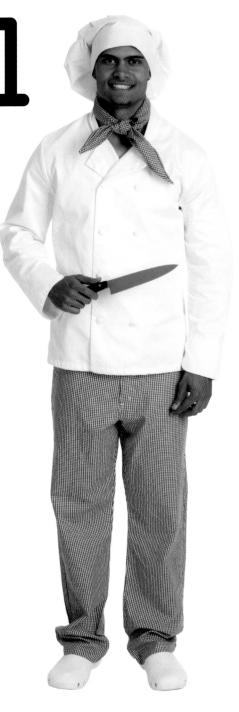

workers

search criteria
- Chef
- Cook
- Knife
- Hat
- Cravat
- Whites
- Ryan

9422

size 160 x 337 mm
6.3 x 13.27 inches
1,890 x 3,981 pixels
resolution 300 ppi
mode RGB

workers

search criteria

- Chef
- Cook
- Knife
- Meat cleaver
- Hat
- Cravat
- Whites
- Ryan

9423

size 146 x 331 mm
5.74 x 13.01 inches
1,722 x 3,904 pixels
resolution 300 ppi
mode RGB

workers

search criteria
- Chef
- Cook
- Hat
- Cravat
- Whites
- Arms folded
- Harry

9424

size 141 x 339 mm
5.56 x 13.35 inches
1,668 x 4,005 pixels
resolution 300 ppi
mode RGB

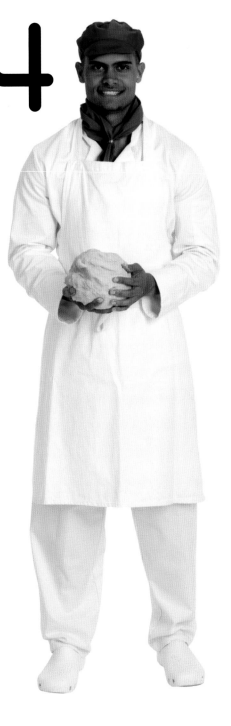

workers

search criteria
- Chef
- Cook
- Hat
- Cravat
- Whites
- Dough ball
- Pizza
- Bread
- Ryan

9425

size 208 x 331 mm
8.18 x 13.05 inches
2,454 x 3,915 pixels
resolution 300 ppi
mode RGB

workers

search criteria
- Chef
- Cook
- Hat
- Cravat
- Whites
- Dough ball
- Pizza
- Bread
- Ryan

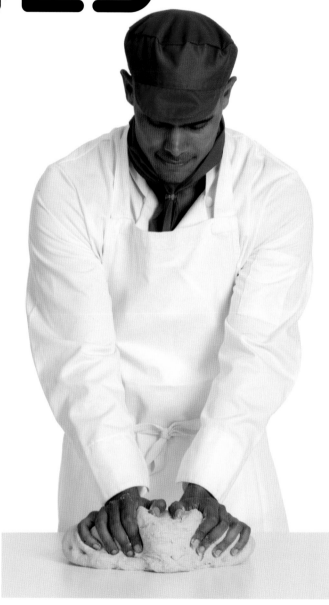

9426

size 229 x 332 mm
9.01 x 13.09 inches
2,704 x 3,927 pixels
resolution 300 ppi
mode RGB

workers

search criteria
- **Chef**
- **Cook**
- **Hat**
- **Cravat**
- **Whites**
- **Dough ball**
- **Pizza**
- **Bread**
- **Harry**

9427

size 151 x 318 mm
5.94 x 12.51 inches
1,782 x 3,754 pixels
resolution 300 ppi
mode RGB

workers

search criteria
- Mechanic
- Overalls
- Cell phone
- Smiling
- Tools
- Wrench
- Ratchet
- Eric

9428

size 163 x 321 mm
6.42 x 12.65 inches
1,926 x 3,796 pixels
resolution 300 ppi
mode RGB

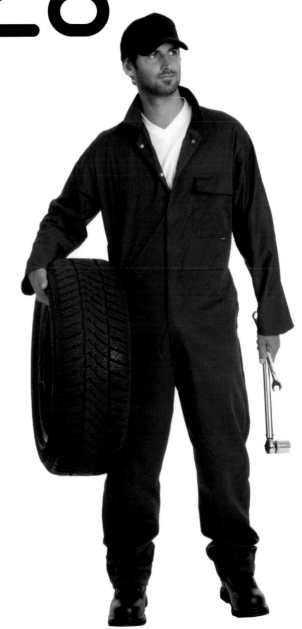

workers

search criteria
- Mechanic
- Overalls
- Cap
- Tire
- Tools
- Wrench
- Ratchet
- Eric

9429

size 229 x 319 mm
 9.01 x 12.57 inches
 2,704 x 3,772 pixels
resolution 300 ppi
mode RGB

workers

search criteria

- Mechanic
- Overalls
- Cap
- Tire
- Tools
- Ratchet
- Jack
- Samuel

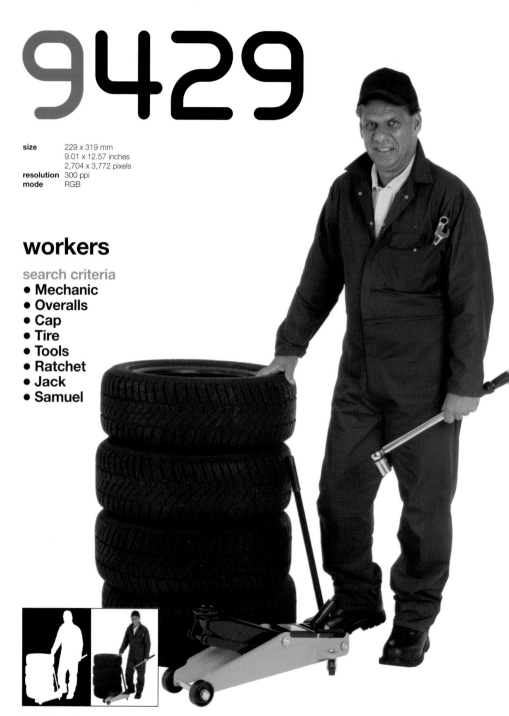

10430

size 134 x 310 mm
5.26 x 12.19 inches
1,578 x 3,658 pixels
resolution 300 ppi
mode RGB

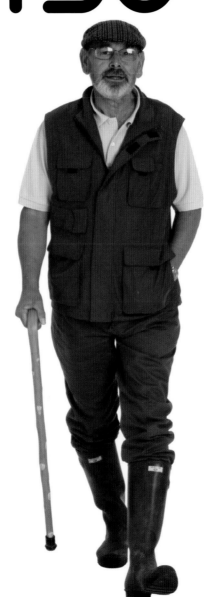

senior citizens

search criteria

- **Old man**
- **Walking**
- **Walking stick**
- **Body warmer**
- **Rubber boots**
- **Flat cap**
- **Bert**

10431

size 165 x 327 mm
6.5 x 12.89 inches
1,90 x 3,868 pixels
resolution 300 ppi
mode RGB

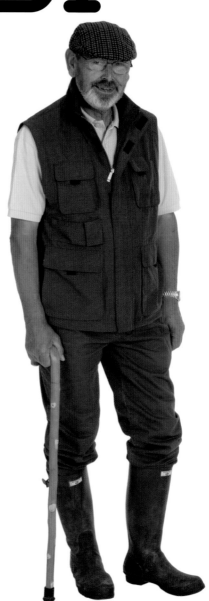

senior citizens

search criteria
- Old man
- Standing
- Walking stick
- Body warmer
- Rubber boots
- Flat cap
- Bert

10432

size 148 x 315 mm
5.82 x 12.39 inches
1,746 x 3,718 pixels
resolution 300 ppi
mode RGB

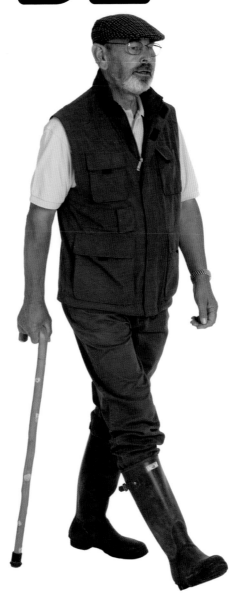

senior citizens

search criteria
- Old man
- Walking
- Walking stick
- Body warmer
- Rubber boots
- Flat cap
- Bert

10433

size 180 x 338 mm
7.1 x 13.29 inches
2,129 x 3,987 pixels
resolution 300 ppi
mode RGB

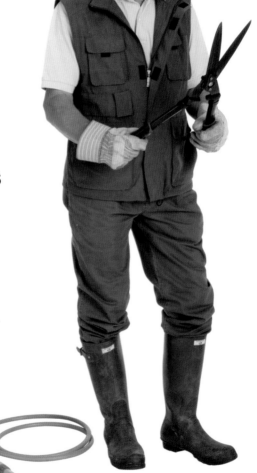

senior citizens

search criteria
- Old man
- Gardening
- Garden shears
- Body warmer
- Rubber boots
- Flat cap
- Hose
- Bert

10434

size 191 x 329 mm
7.52 x 12.93 inches
2,255 x 3,880 pixels
resolution 300 ppi
mode RGB

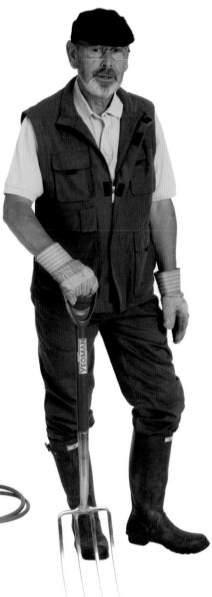

senior citizens

search criteria
- Old man
- Gardening
- Garden fork
- Body warmer
- Rubber boots
- Flat cap
- Hose
- Bert

10435

size 231 x 224 mm
9.09 x 8.82 inches
2,728 x 2,645 pixels
resolution 300 ppi
mode RGB

senior citizens

search criteria
- **Old man**
- **Sitting**
- **Chair**
- **Reading**
- **Glasses**
- **Side**
- **Bert**

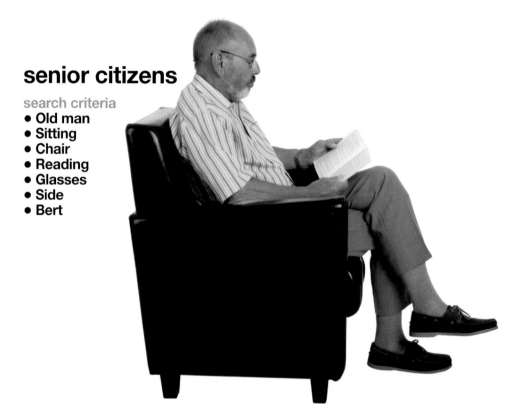

10436

size 202 x 263 mm
7.94 x 10.37 inches
2,382 x 3,112 pixels
resolution 300 ppi
mode RGB

senior citizens

search criteria
- **Old man**
- **Sitting**
- **Chair**
- **Reading**
- **Glasses**
- **Pipe**
- **Bert**

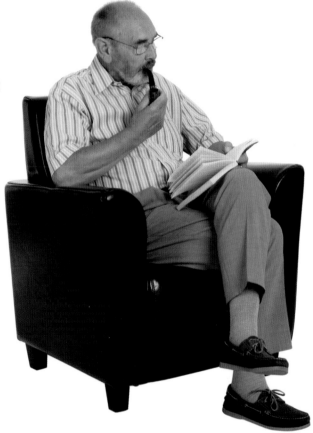

10437

size 298 x 220 mm
11.71 x 8.66 inches
3,514 x 2,597 pixels
resolution 300 ppi
mode RGB

senior citizens

search criteria
- Old man
- Old woman
- Playing
- Table
- Cards
- Game
- Bert
- Sue

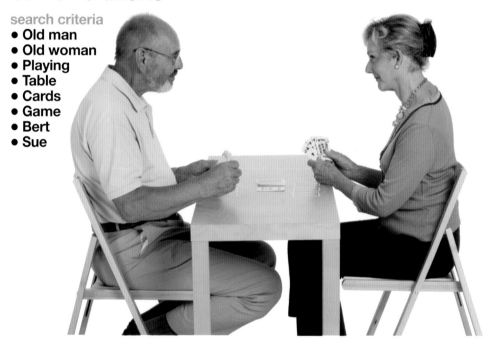

10438

size 296 x 223 mm
11.65 x 8.8 inches
3,496 x 2,639 pixels
resolution 300 ppi
mode RGB

senior citizens

search criteria
- Old man
- Old woman
- Playing
- Table
- Chess
- Game
- Bert
- Sue

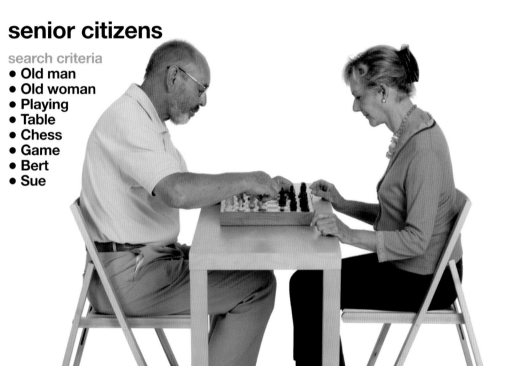

10439

size 222 x 283 mm
8.74 x 11.13 inches
2,621 x 3,340 pixels
resolution 300 ppi
mode RGB

senior citizens

search criteria
- **Old man**
- **Old woman**
- **Wheelchair**
- **Walking**
- **Pushing**
- **Bert**
- **Sue**

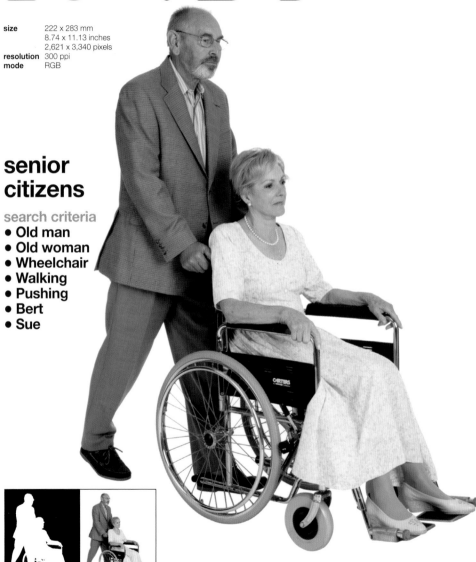

10440

size 220 x 274 mm
 8.68 x 10.77 inches
 2,603 x 3,232 pixels
resolution 300 ppi
mode RGB

senior citizens

search criteria
- **Old man**
- **Old woman**
- **Wheelchair**
- **Walking**
- **Pushing**
- **Smiling**
- **Bert**
- **Sue**

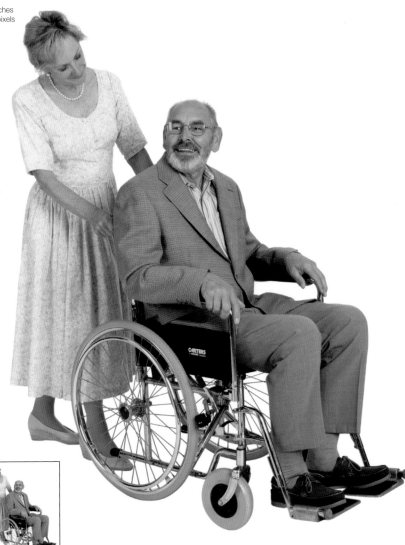

10441

size 167 x 335 mm
6.56 x 13.19 inches
1,968 x 3,957 pixels
resolution 300 ppi
mode RGB

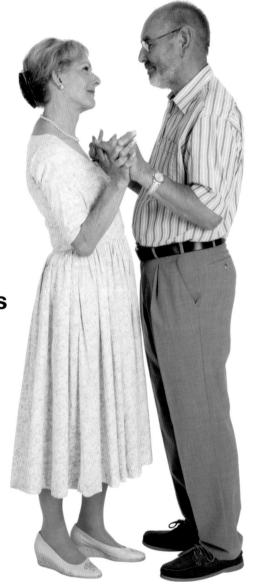

senior citizens

search criteria
- **Old man**
- **Old woman**
- **Standing**
- **Holding hands**
- **Romance**
- **Bert**
- **Sue**

10442

size 156 x 324 mm
6.16 x 12.75 inches
1,848 x 3,826 pixels
resolution 300 ppi
mode RGB

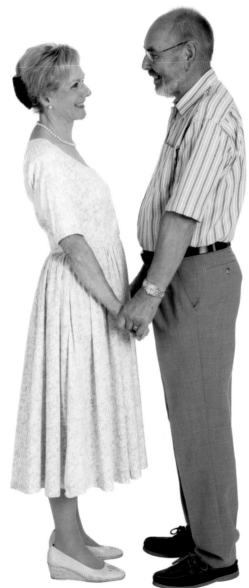

senior citizens

search criteria

- Old man
- Old woman
- Standing
- Holding hands
- Romance
- Bert
- Sue

10443

size 211 x 287 mm
8.32 x 11.29 inches
2,496 x 3,388 pixels
resolution 300 ppi
mode RGB

senior citizens

search criteria
- Old man
- Old woman
- Walking
- Romance
- Smiling
- Holding hands
- Bert
- Sue

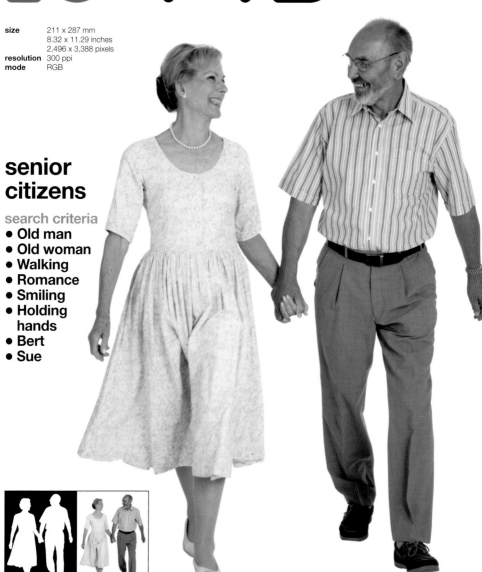

10444

size 183 x 286 mm
7.22 x 11.27 inches
2,166 x 3,382 pixels
resolution 300 ppi
mode RGB

senior citizens

search criteria
- Old man
- Old woman
- Walking
- Romance
- Smiling
- Holding hands
- Bert
- Sue

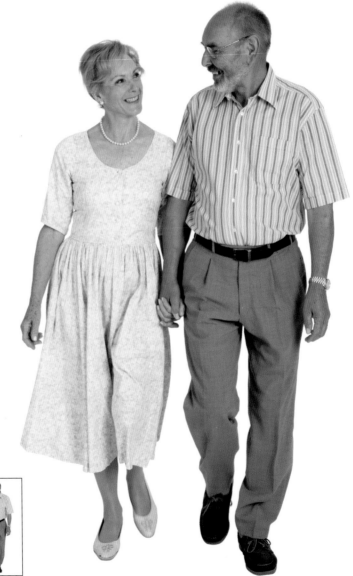

10445

size 189 x 293 mm
7.44 x 11.53 inches
2,232 x 3,460 pixels
resolution 300 ppi
mode RGB

senior citizens

search criteria
- **Old man**
- **Old woman**
- **Walking**
- **Romance**
- **Smiling**
- **Holding hands**
- **Back**
- **Bert**
- **Sue**

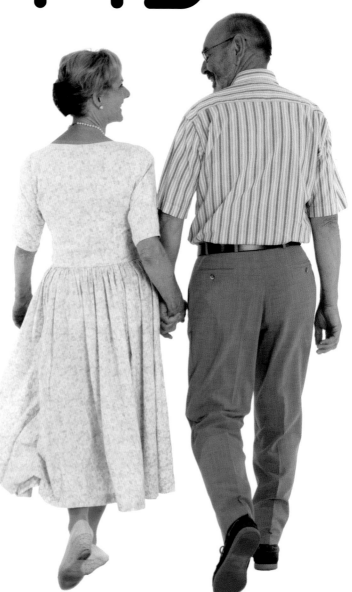

10446

size 156 x 329 mm
6.16 x 12.93 inches
1,848 x 3,880 pixels
resolution 300 ppi
mode RGB

senior citizens

search criteria
- Old man
- Walking
- Walking stick
- Tired
- Bert

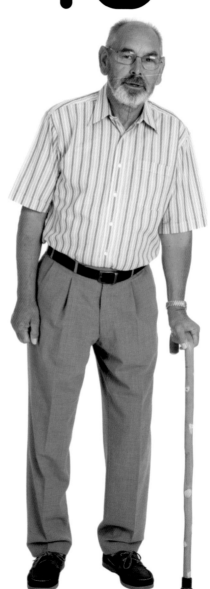

10447

size 223 x 322 mm
8.77 x 12.67 inches
2,632 x 3,801 pixels
resolution 300 ppi
mode RGB

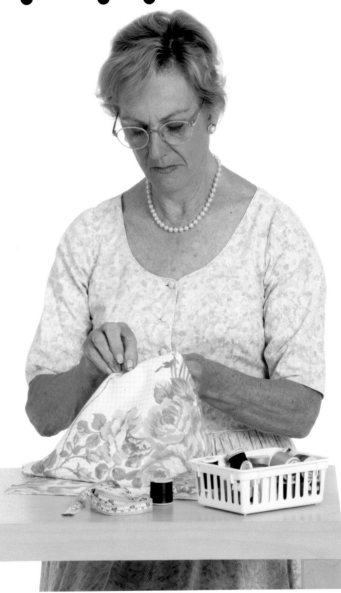

senior citizens

search criteria
- Old woman
- Sewing
- Needle
- Thread
- Sue

10448

size 215 x 322 mm
8.48 x 12.69 inches
2,543 x 3,807 pixels
resolution 300 ppi
mode RGB

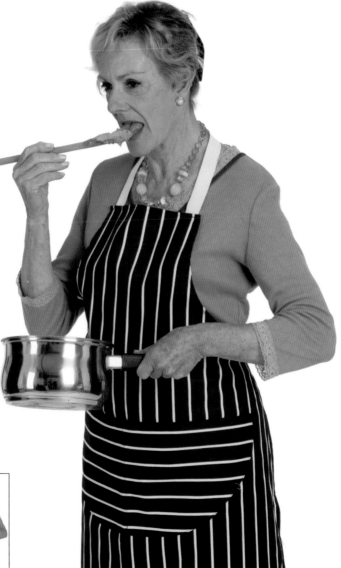

senior citizens

search criteria
- Homemaker
- Old woman
- Cooking
- Pan
- Spoon
- Tasting
- Sue

10449

size 221 x 224 mm
8.69 x 8.82 inches
2,608 x 2,645 pixels
resolution 300 ppi
mode RGB

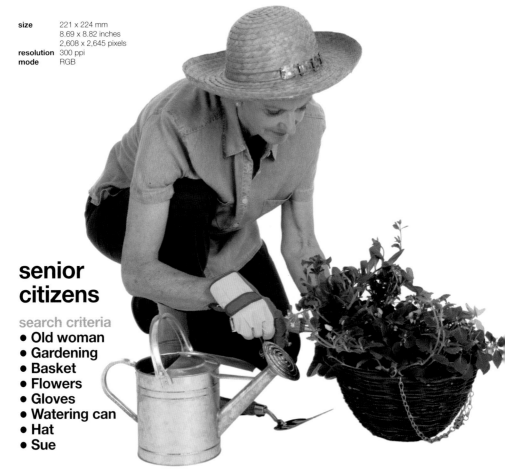

senior citizens

search criteria

- Old woman
- Gardening
- Basket
- Flowers
- Gloves
- Watering can
- Hat
- Sue

10450

size 137 x 213 mm
5.4 x 8.4 inches
1,619 x 2,520 pixels
resolution 300 ppi
mode RGB

senior citizens

search criteria
- Old woman
- Grandmother
- Grandaughter
- Shopping bag
- Holding hands
- Sally
- Sue

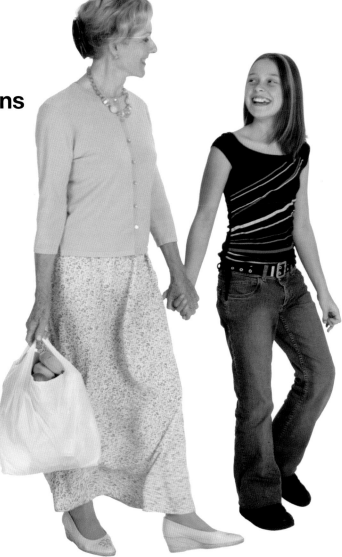

10451

size 230 x 214 mm
9.07 x 8.44 inches
2,722 x 2,532 pixels
resolution 300 ppi
mode RGB

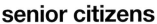

senior citizens

search criteria
- Old woman
- Old man
- Sitting
- Bench
- Smiling
- Walking stick
- Bert
- Sue

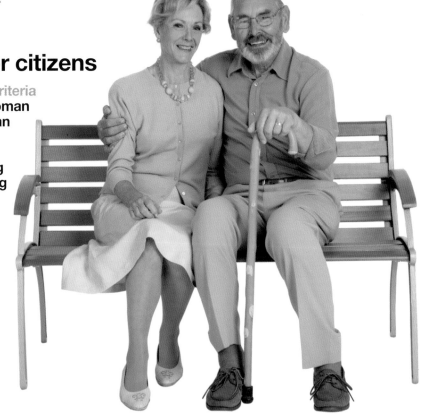

11452

size 164 x 329 mm
6.46 x 12.97 inches
1,938 x 3,891 pixels
resolution 300 ppi
mode RGB

musicians

search criteria
- Conductor
- Orchestra
- Baton
- Music stand
- Suit
- Bow tie
- Eric

11453

size 170 x 335 mm
6.70 x 13.19 inches
2,010 x 3,958 pixels
resolution 300 ppi
mode RGB

musicians

search criteria
- Musician
- Orchestra
- Trumpet
- Brass
- Suit
- Samuel

11454

size 179 x 179 mm
7.06 x 13.15 inches
2,118 x 3,946 pixels
resolution 300 ppi
mode RGB

musicians

search criteria
- Musician
- Orchestra
- Trombone
- Brass
- Suit
- Eric

11455

size · 148 x 324 mm
· 5.82 x 12.75 inches
· 1,746 x 3,826 pixels
resolution · 300 ppi
mode · RGB

musicians

search criteria
- **Musician**
- **Orchestra**
- **Saxophone**
- **Woodwind**
- **Suit**
- **Jazz**
- **Eric**

11456

size 160 x 319 mm
6.30 x 12.55 inches
1,890 x 3,766 pixels
resolution 300 ppi
mode RGB

musicians

search criteria
- Musician
- Orchestra
- Saxophone
- Woodwind
- Suit
- Jazz
- Side
- Eric

11457

size 171 x 339 mm
6.72 x 13.33 inches
2,016 x 3,999 pixels
resolution 300 ppi
mode RGB

musicians

search criteria
- Musician
- Orchestra
- Clarinet
- Woodwind
- Suit
- Eric

11458

size 166 x 338 mm
6.54 x 13.29 inches
1,962 x 3,987 pixels
resolution 300 ppi
mode RGB

musicians

search criteria
- Musician
- Orchestra
- Flute
- Woodwind
- Suit
- Samuel

11459

size 201 x 330 mm
7.90 x 12.97 inches
2,370 x 3,892 pixels
resolution 300 ppi
mode RGB

musicians

search criteria
- **Musician**
- **Orchestra**
- **Violin**
- **Strings**
- **Suit**
- **Samuel**

11460

size 207 x 315 mm
8.16 x 12.39 inches
2,448 x 3,718 pixels
resolution 300 ppi
mode RGB

musicians

search criteria
- Musician
- Orchestra
- Cello
- Strings
- Suit
- Eric

11461

size 205 x 330 mm
8.08 x 12.97 inches
2,424 x 3,892 pixels
resolution 300 ppi
mode RGB

musicians

search criteria
- Musician
- Guitar
- Acoustic
- Suit
- Chair
- Samuel

11462

size 224 x 292 mm
8.82 x 11.49 inches
2,645 x 3,448 pixels
resolution 300 ppi
mode RGB

musicians

search criteria
- **Musician**
- **Guitar**
- **Acoustic**
- **Bow tie**
- **Chair**
- **Samuel**

11463

size 160 x 330 mm
6.28 x 12.99 inches
1,884 x 3,898 pixels
resolution 300 ppi
mode RGB

musicians

search criteria
- **Singer**
- **Vocalist**
- **Microphone**
- **Stand**
- **Sunglasses**
- **Tie-dye**
- **Mary**

11464

size 181 x 335 mm
7.12 x 13.19 inches
2,136 x 3,957 pixels
resolution 300 ppi
mode RGB

musicians

search criteria
- **Singer**
- **Vocalist**
- **Microphone**
- **Sunglasses**
- **Tie-dye**
- **Mary**

11465

size 185 x 340 mm
7.28 x 13.37 inches
2,184 x 4,011 pixels
resolution 300 ppi
mode RGB

musicians

search criteria
- **Singer**
- **Vocalist**
- **Microphone**
- **Stand**
- **Suit**
- **Peter**

11466

size 147 x 330 mm
 5.78 x 12.97 inches
 1,734 x 3,892 pixels
resolution 300 ppi
mode RGB

musicians

search criteria
- **Singer**
- **Vocalist**
- **Microphone**
- **Stand**
- **Suit**
- **Peter**

11467

size 149 x 321 mm
5.86 x 12.65 inches
1,758 x 3,796 pixels
resolution 300 ppi
mode RGB

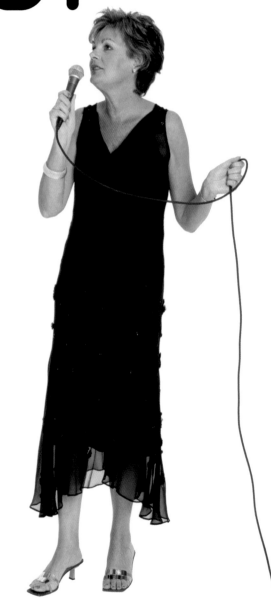

musicians

search criteria
- **Singer**
- **Vocalist**
- **Microphone**
- **Ball gown**
- **Song**
- **Penelope**

11468

size 202 x 336 mm
7.96 x 13.23 inches
2,388 x 3,969 pixels
resolution 300 ppi
mode RGB

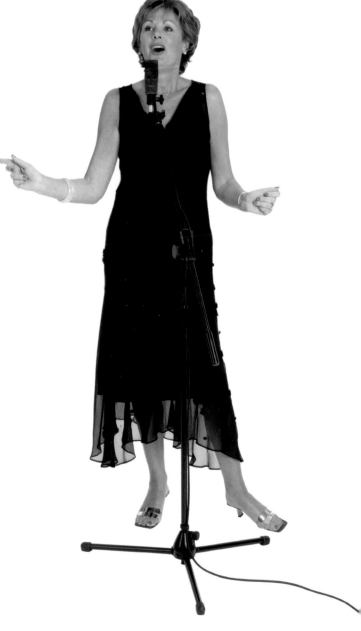

musicians

search criteria
- Singer
- Vocalist
- Microphone
- Stand
- Ball gown
- Song
- Penelope

12469

size 295 x 157 mm
11.61 x 6.20 inches
3,484 x 1,860 pixels
resolution 300 ppi
mode RGB

pin ups

search criteria
- **Brunette**
- **Pink dress**
- **Heels**
- **Feather**
- **Carla**

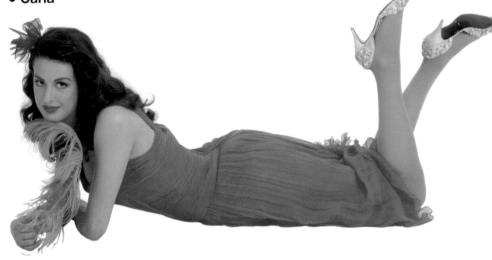

12470

size 299 x 214 mm
11.75 x 8.44 inches
3,526 x 2,531 pixels
resolution 300 ppi
mode RGB

pin ups

search criteria
- Brunette
- Pink dress
- Heels
- Bow
- Laughing
- Carla

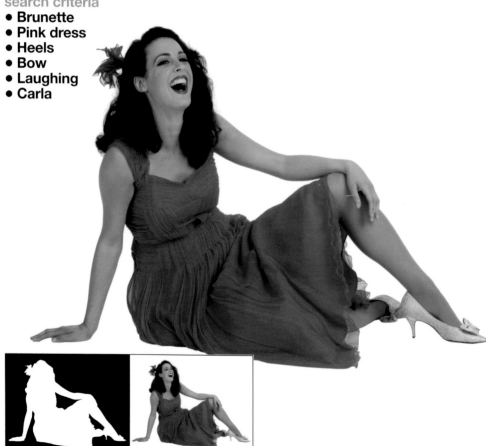

12471

size 147 x 337 mm
5.8 x 13.27 inches
1,740 x 3,981 pixels
resolution 300 ppi
mode RGB

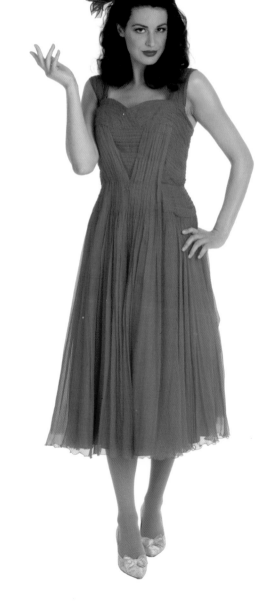

pin ups

search criteria
- **Brunette**
- **Pink dress**
- **Bow**
- **Heels**
- **Standing**
- **Carla**

12472

size 130 x 330 mm
5.1 x 12.99 inches
1,530 x 3,897 pixels
resolution 300 ppi
mode RGB

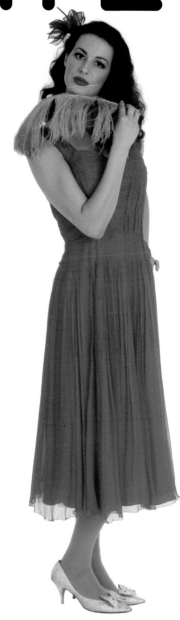

pin ups

search criteria
- Brunette
- Pink dress
- Bow
- Heels
- Feather
- Standing
- Carla

12473

size 229 x 344 mm
 9.01 x 13.55 inches
 2,704 x 4,064 pixels
resolution 300 ppi
mode RGB

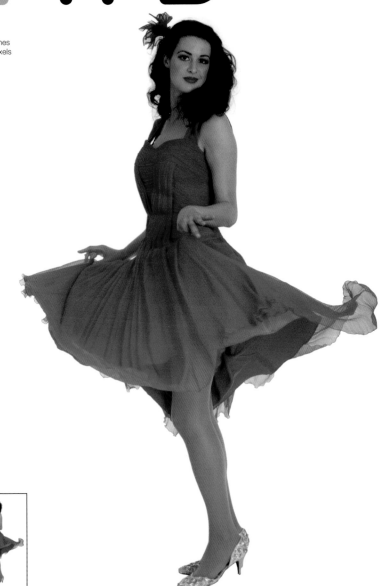

pin ups

search criteria
- **Brunette**
- **Pink dress**
- **Bow**
- **Heels**
- **Standing**
- **Twirl**
- **Carla**

12474

size 200 x 321 mm
7.87 x 12.65 inches
2,360 x 3,796 pixels
resolution 300 ppi
mode RGB

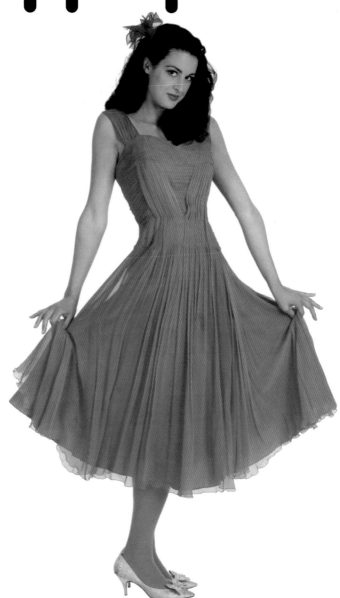

pin ups

search criteria
- Brunette
- Pink dress
- Bow
- Heels
- Standing
- Curtsey
- Carla

12475

size 119 x 344 mm
4.68 x 13.55 inches
1,404 x 4,064 pixels
resolution 300 ppi
mode RGB

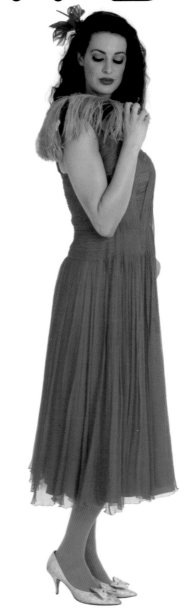

pin ups

search criteria
- **Brunette**
- **Pink dress**
- **Bow**
- **Heels**
- **Feather**
- **Standing**
- **Carla**

12476

size 165 x 333 mm
6.5 x 13.11 inches
1,950 x 3,933 pixels
resolution 300 ppi
mode RGB

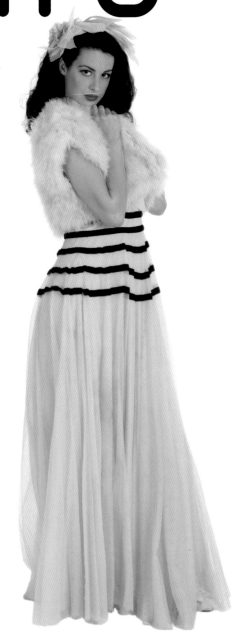

pin ups

search criteria
- **Brunette**
- **Pink dress**
- **Fur boa**
- **Stripes**
- **Bands**
- **Carla**

12477

size 152 x 340 mm
 6.98 x 13.37 inches
 1,794 x 4,010 pixels
resolution 300 ppi
mode RGB

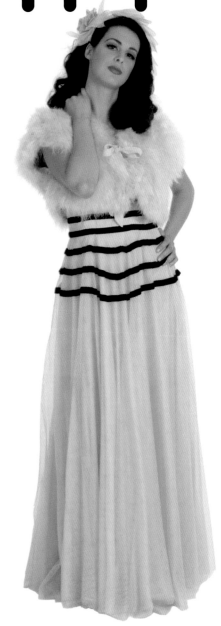

pin ups

search criteria
- **Brunette**
- **Pink dress**
- **Fur boa**
- **Stripes**
- **Bands**
- **Carla**

12478

size 145 x 331 mm
5.7 x 13.03 inches
1,710 x 3,910 pixels
resolution 300 ppi
mode RGB

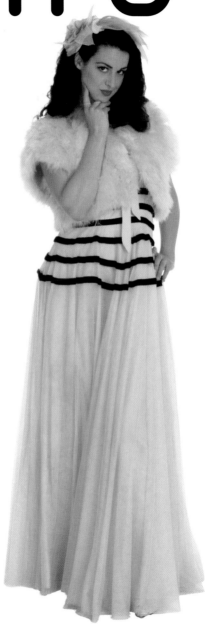

pin ups

search criteria
- Brunette
- Pink dress
- Fur boa
- Stripes
- Bands
- Coy
- Carla

12479

size 216 x 316 mm
8.5 x 12.45 inches
2,549 x 3,736 pixels
resolution 300 ppi
mode RGB

pin ups

search criteria
- **Brunette**
- **Pink dress**
- **Fur boa**
- **Stripes**
- **Bands**
- **Smiling**
- **Carla**

12480

size 294 x 190 mm
11.57 x 7.49 inches
3,472 x 2,248 pixels
resolution 300 ppi
mode RGB

pin ups

search criteria
- Brunette
- Red bikini
- Two-piece
- Beach
- String
- Reclining
- Coy
- Carla

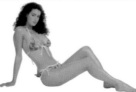

12481

size 229 x 344 mm
9.01 x 13.55 inches
2,704 x 4,064 pixels
resolution 300 ppi
mode RGB

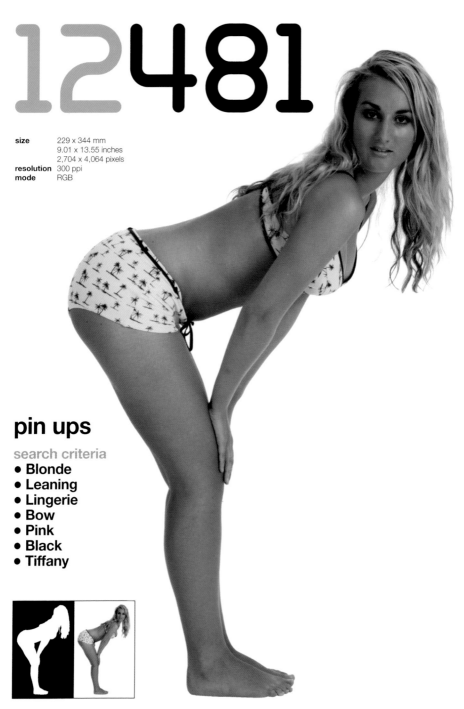

pin ups

search criteria
- **Blonde**
- **Leaning**
- **Lingerie**
- **Bow**
- **Pink**
- **Black**
- **Tiffany**

12482

size 132 x 339 mm
5.18 x 13.35 inches
1,554 x 4,005 pixels
resolution 300 ppi
mode RGB

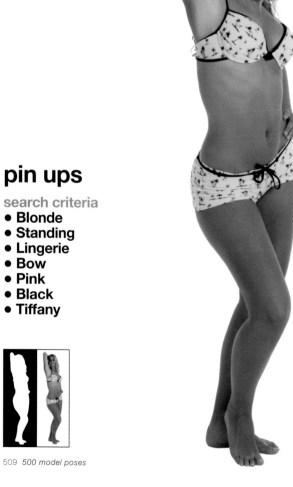

pin ups

search criteria
- **Blonde**
- **Standing**
- **Lingerie**
- **Bow**
- **Pink**
- **Black**
- **Tiffany**

12483

size 230 x 217 mm
9.05 x 8.54 inches
2,716 x 2,561 pixels
resolution 300 ppi
mode RGB

pin ups

search criteria
- Blonde
- Lingerie
- Bow
- Pink
- Black
- Sitting
- Coy
- Tiffany

12484

size 344 x 229 mm
13.55 x 9.01 inches
4,064 x 2,704 pixels
resolution 300 ppi
mode RGB

pin ups

search criteria
- **Blonde**
- **Lingerie**
- **Bow**
- **Pink**
- **Black**
- **Reclining**
- **Tiffany**

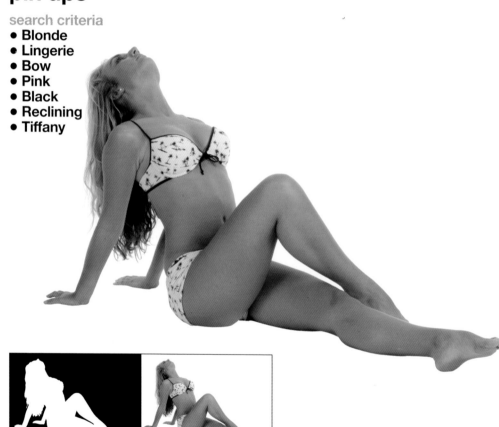

12485

size 309 x 215 mm
12.17 x 8.45 inches
3,652 x 2,536 pixels
resolution 300 ppi
mode RGB

pin ups

search criteria
- Brunette
- One-piece
- Swimsuit
- Reclining
- Carla

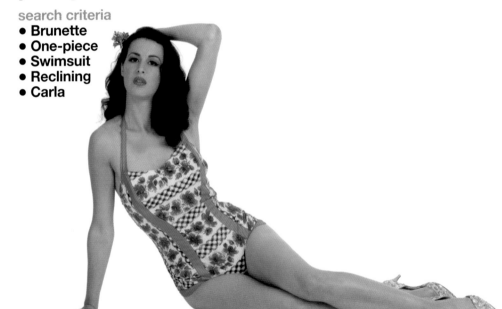

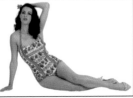

12486

size 344 x 229 mm
13.55 x 9.01 inches
4,064 x 2,704 pixels
resolution 300 ppi
mode RGB

pin ups

search criteria
- **Brunette**
- **One-piece**
- **Swimsuit**
- **Reclining**
- **Carla**

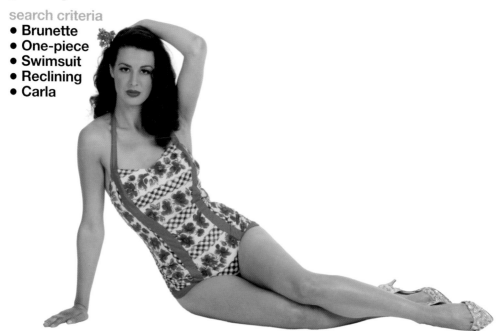

12487

size 344 x 229 mm
13.55 x 9.01 inches
4,064 x 2,704 pixels
resolution 300 ppi
mode RGB

pin ups

search criteria

- Brunette
- One-piece
- Swimsuit
- Reclining
- Cool
- Carla

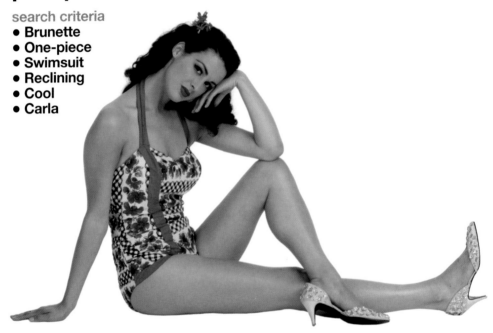

12488

size 278 x 225 mm
10.93 x 8.85 inches
3,280 x 2,656 pixels
resolution 300 ppi
mode RGB

pin ups

search criteria
- **Brunette**
- **One-piece**
- **Swimsuit**
- **Reclining**
- **Smiling**
- **Legs**
- **Carla**

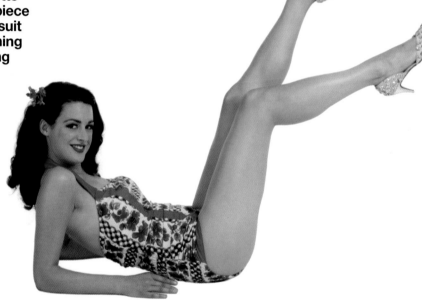

12489

size 229 x 344 mm
9.01 x 13.55 inches
2,704 x 4,064 pixels
resolution 300 ppi
mode RGB

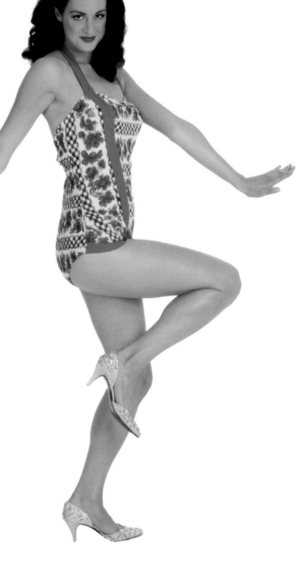

pin ups

search criteria
- **Brunette**
- **One-piece**
- **Swimsuit**
- **Standing**
- **Prancing**
- **Heels**
- **Coy**
- **Carla**

12490

size 142 x 335 mm
5.58 x 13.19 inches
1,674 x 3,957 pixels
resolution 300 ppi
mode RGB

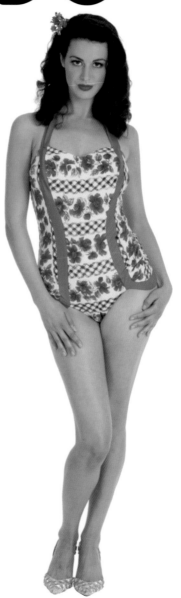

pin ups

search criteria
- **Brunette**
- **One-piece**
- **Swimsuit**
- **Standing**
- **Heels**
- **Coy**
- **Carla**

12491

size 121 x 324 mm
4.78 x 12.77 inches
1,434 x 3,832 pixels
resolution 300 ppi
mode RGB

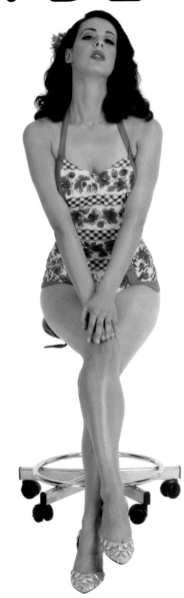

pin ups

search criteria
- Brunette
- One-piece
- Swimsuit
- Heels
- Sitting
- Stool
- Carla

12492

size 137 x 335 mm
5.38 x 13.17 inches
1,614 x 3,951 pixels
resolution 300 ppi
mode RGB

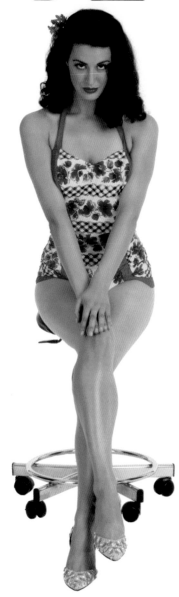

pin ups

search criteria
- **Brunette**
- **One-piece**
- **Swimsuit**
- **Heels**
- **Sitting**
- **Stool**
- **Coy**
- **Carla**

12493

size 229 x 344 mm
 9.01 x 13.55 inches
 2,704 x 4,064 pixels
resolution 300 ppi
mode RGB

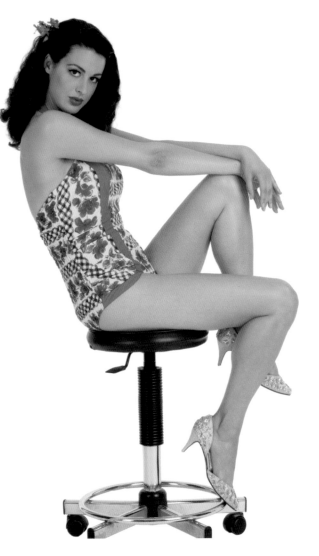

pin ups

search criteria
- Brunette
- One-piece
- Swimsuit
- Heels
- Reclining
- Stool
- Coy
- Carla

12494

size 213 x 243 mm
 8.4 x 9.56 inches
 2,521 x 2,868 pixels
resolution 300 ppi
mode RGB

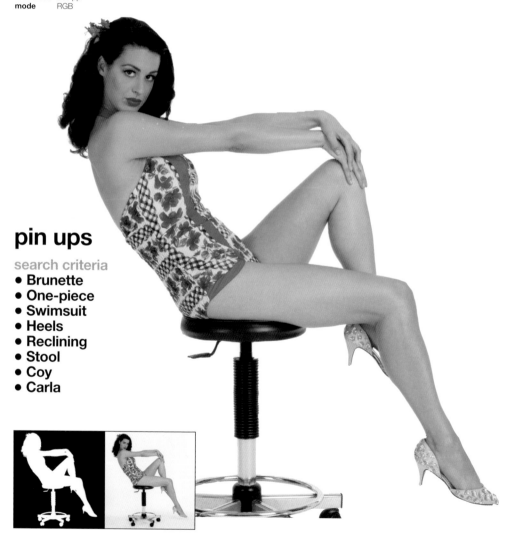

pin ups

search criteria
- Brunette
- One-piece
- Swimsuit
- Heels
- Reclining
- Stool
- Coy
- Carla

12495

size 229 x 239 mm
9.01 x 9.39 inches
2,704 x 2,818 pixels
resolution 300 ppi
mode RGB

pin ups

search criteria
- **Brunette**
- **Lingerie**
- **Black**
- **Bra**
- **Sitting**
- **Carla**

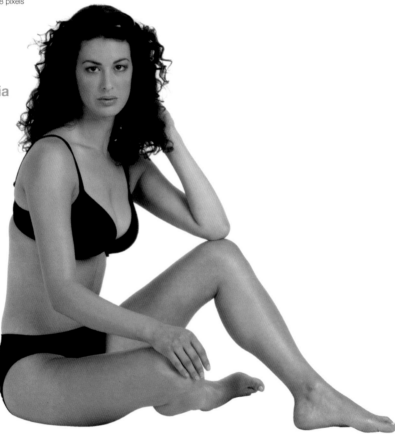

12496

size 344 x 170 mm
 13.55 x 6.7 inches
 4,064 x 2,010 pixels
resolution 300 ppi
mode RGB

pin ups

search criteria
- **Brunette**
- **Lingerie**
- **Black**
- **Bra**
- **Reclining**
- **Carla**

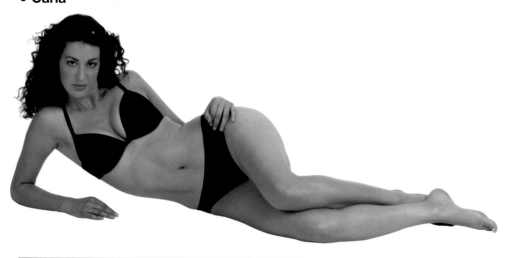

12497

size 177 x 335 mm
6.96 x 13.19 inches
2,088 x 3,957 pixels
resolution 300 ppi
mode RGB

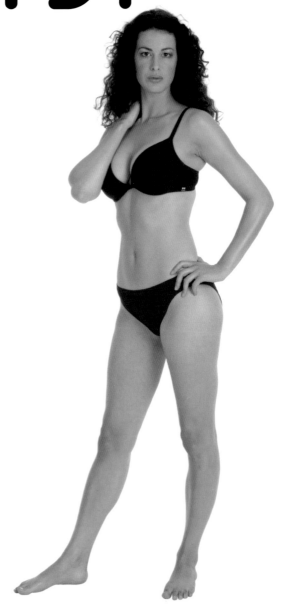

pin ups

search criteria
- Brunette
- Lingerie
- Black
- Bra
- Pout
- Standing
- Carla

12498

size 135 x 334 mm
5.32 x 13.15 inches
1,596x 3,946 pixels
resolution 300 ppi
mode RGB

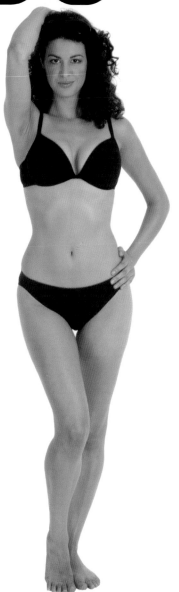

pin ups

search criteria
- **Brunette**
- **Lingerie**
- **Black**
- **Bra**
- **Standing**
- **Carla**

12499

size 126 x 344 mm
 4.96 x 13.55 inches
 1,488 x 4,064 pixels
resolution 300 ppi
mode RGB

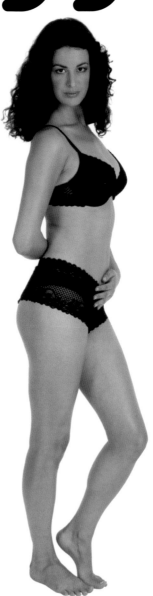

pin ups

search criteria

- **Brunette**
- **Lingerie**
- **Black**
- **Bra**
- **Lace**
- **French knickers**
- **Standing**
- **Back**
- **Carla**

12500

size 125 x 340 mm
4.94 x 13.37 inches
1,482 x 4,010 pixels
resolution 300 ppi
mode RGB

pin ups

search criteria
- **Brunette**
- **Lingerie**
- **Black**
- **Bra**
- **Lace**
- **French knickers**
- **Standing**
- **Back**
- **Carla**

Clip Art Image Gallery: 500 Model Poses License

The 500 Model Poses / Clip Art Image Gallery digitized photographic images ("The Images") on this CD-ROM disc ("The Disc") are licensed for use under the following Terms and Conditions, which define what You may do with the product. Please read them carefully. Use of The Images on The Disc implies that You have read and accepted these terms and conditions in full. If You do not agree to the terms and conditions of this agreement, do not use or copy The Images and return the complete package to The Ilex Press Ltd. with proof of purchase within 15 days for a full refund.

Terms and Conditions of Use
You agree to use The Images under the following Terms and Conditions:

Agreement
1. These Terms and Conditions constitute a legal Agreement between the purchaser ("You" or "Your") and The Ilex Press Ltd ("Ilex").

2. License
The copyright in The Images on The Disc and all rights throughout the world are owned by Ilex. Ilex grants You a non-exclusive, non-transferable license to use, modify, reproduce, publish, and display The Images provided that You comply with the Terms and Conditions of this Agreement.

3. You may, subject to the Terms and Conditions of this Agreement:
a) Use, modify, and enhance The Images (provided that You do not violate the rights of any third party) as a design element in commercial or internal publishing, for advertising or promotional materials, corporate identity, newsletters, video, film, and television broadcasts except as noted in paragraph 4 below.
b) Use, modify, and enhance the images as a design element on a web site, computer game, video game, or multimedia product (but not in connection with any web site template, database, or software product for distribution by others) except as noted in paragraph 4 below.
c) Use one copy of The Disc on a single workstation only.
d) Copy the images to Your hard drive.
e) Make a temporary copy of The Images, if You intend to output the images by means of an output device owned or operated by a third party, such as a service bureau image setter. Such copies must be destroyed at the end of the production cycle.

4. You may not:
a) Distribute, copy, transfer, assign, rent, lease, resell, give away, or barter the images, electronically or in hard copy, except as expressly permitted under paragraph 3 above.
b) Distribute or incorporate the images into another photo or image library or any similar product, or otherwise make available The Images for use or distribution separately or detached from a product or web page, either by copying or electronically downloading in any form.
c) Use the The Images to represent any living person.
d) Modify and use The Images in connection with pornographic, libellous, obscene, immoral, defamatory, or otherwise illegal material.
e) Use The Images as part of any trademark whether registered or not.
f) Transfer possession of The Images to another person either across a network, on a CD, or by any other method now known or hereafter invented. The property of The Images remains at all times that of Ilex.

5. Termination.
This license is in force until terminated. If You do not comply with the terms and conditions above, the license automatically terminates. At termination, the product must be destroyed or returned to Ilex.

6. Warranties.
a) Ilex warrants that the media on which The Images are supplied will be free from defects in material and workmanship under normal use for 90 days. Any media found to be defective will be replaced free of charge by returning the media to our offices with a copy of Your receipt. If Ilex cannot replace the media, it will refund the full purchase price.
b) The Images are provided "as is," "as available," and "with all faults," without warranty of any kind, either expressed or implied, including but not limited to the implied warranties or merchantability and fitness for a particular purpose. The entire risk as to quality, accuracy, and performance of The Images is with You. In no event will Ilex, its employees, directors, officers, or its agents or dealers or anyone else associated with Ilex be liable to You for any damages, including any lost profit, lost savings, or any other consequential damages arising from the use of or inability to use The Images even if Ilex, its employees, directors, officers, or its agent or authorized dealer or anyone else associated with Ilex has been advised of the possibility of such damages or for any claim by any other party. Our maximum liability to You shall not exceed the amount paid for the product.
c) You warrant that You do not reside in any country to which export of USA products are prohibited or restricted or that Your use of The Images will not violate any applicable law or regulation of any country, state, or other governmental entity.
d) You warrant that You will not use The Images in any way that is not permitted by this Agreement.

7. General
a) The Disc, The Images, and its accompanying documentation is copyrighted. You may digitally manipulate, add other graphic elements to, or otherwise modify The Images in full realization that they remain copyrighted in such modification.
b) The Images are owned by Ilex and are protected by the United States Copyright laws international treaty provisions and other applicable laws. No title to or intellectual property rights to The Images or The Disc are transferred to You. Ilex retains all rights not expressly granted by this license agreement.
c) You acknowledge that You have read this agreement, understand it, and agree to be bound by its terms and conditions. You further agree that it supersedes any proposal or prior agreement, oral or written, and that it may not be changed except by a signed written agreement.